DRAWING

DRAWING

Space,
Form,
Expression

Wayne Enstice
The University of Arizona

Melody Peters

Prentice Hall, Englewood Cliffs, New Jersey 07632

Library of Congress Cataloging-in-Publication Data

Enstice, Wayne (date)
 Drawing : space, form, expression / Wayne Enstice, Melody Peters.
 p. cm.
 Includes index.
 ISBN 0-13-219254-3
 1. Drawing—Technique. I. Peters, Melody (date). II. Title.
NC730.E65 1990

741—dc20

89-35430
CIP

Editorial/production supervision and
 interior design: Joseph O'Donnell
Cover design: Ben Santora
Cover art: *Search and Destroy*, 1967,
 Nancy Spero. Courtesy Josh Baer
 Gallery, New York.
Manufacturing buyer: Mike Woerner

© 1990 by Prentice-Hall, Inc.
A Division of Simon & Schuster
Englewood Cliffs, New Jersey 07632

Printed in the United States of America
10 9 8 7 6 5 4 3 2 1

ISBN 0-13-219254-3

Prentice-Hall International (UK) Limited, *London*
Prentice-Hall of Australia Pty. Limited, *Sydney*
Prentice-Hall Canada Inc., *Toronto*
Prentice-Hall Hispanoamericana, S.A., *Mexico*
Prentice-Hall of India Private Limited, *New Delhi*
Prentice-Hall of Japan, Inc., *Tokyo*
Simon & Schuster Asia Pte. Ltd., *Singapore*
Editora Prentice-Hall do Brasil, Ltda., *Rio de Janeiro*

To Dr. Robert W. McMillan

For his encouragement
and professional insights.

Contents

PREFACE

Drawing: Space, Form, Expression was written with the beginning college-level student in mind. It will also serve the aspiring artist who is studying outside of an academic setting.

The opening chapters address the needs of the absolute beginner. Gradually, the sequence of topics guides the student toward more sophisticated issues of drawing, design, and personal expression. While this is not a "projects book," selected exercises have been inserted at strategic points to direct the reader in applying knowledge gained from the text.

The Introduction reviews matters of drawing practice and history that will have general application for the student. The first five chapters stress the picture plane as the major unifying factor in pictorial art. Chapter One outlines basic methods for representing the illusion of three-dimensional space in a drawing. Concepts which are introductory to organizing the actual two-dimensional space of a drawing's surface are found in Chapter Two. Various proportioning methods are featured in Chapter Three; of particular use is the system of "triangulation," unique to this book. The rudiments of design are treated as a natural accompaniment to drawing in Chapter Four. Chapter Five provides a step-by-step analysis of the rules of linear perspective, including a discussion of this system's merits and shortcomings.

Chapters Six and Seven concentrate on ways to effectively comprehend and draw the world of three-dimensional forms. In Chapter Six, individual forms are analyzed as structural volumes in space; their surfaces and sculptural presences are interpreted through the play of light and shadow in Chapter Seven.

Sources of imagery and expression in pictorial art are explored in Chapters Eight through Eleven. Chapter Eight examines how time-honored themes associated with the major categories of subject-matter are being refreshed in the context of contemporary art. The correlation between a drawing's overall form, or composition, and its expressive power is discussed in Chapter Nine. Also covered are specific techniques for troubleshooting your drawings. Chapter Ten departs from concerns with depicting what is seen in order to address problems associated with drawing imagined, or visualized, images. Chapter Eleven surveys some of the major aesthetic and expressive issues in drawing today.

Two glossaries appear at the end of the book. The Glossary of Media lists

a range of dry and wet media and techniques, including a table of commonly used drawing papers. The Glossary of Terms is a quick reference for terminology used in the text.

Most drawing books prior to this one have divided the so-called "elements" of drawing (such as line, shape, value, and texture) into separate chapters. But since these elements take on meaning each time the student grapples with matters of space, form, and expression, we have incorporated this basic information throughout the book.

The old and new masterwork illustrations were chosen to clarify the text and to provide inspiration. Wherever possible, contemporary examples have been used to confirm that drawing remains vital and open ended for artists of every aesthetic persuasion.

Acknowledgments

The demands of preparing a textbook did not fall on our shoulders alone. First and foremost, we are indebted to our respective families for their indomitable good will and patience throughout. Undoubtedly, this book would not have been possible without the tireless contributions of Marie Enstice, who spent prodigious hours at the keyboard of a word processor and regularly leavened our spirits during the more frustrating stages of translating ideas for the printed page. Our thanks and appreciation also go to Dorothy and Joyce Verran, for their gracious support; and to Bud Therien, our acquisitions editor, and Joe O'Donnell, our production editor, for their expert guidance.

The inspiration for this book may be traced in part to the numerous graduate teaching assistants with whom we have had the pleasure to work over the years. Certain of them have provided us with student work from their classes to use as illustrations: Nancy Hall Brooks, Gary Buhler, Linda Caputo, Lynn Charron, Maureen Ciaccio, William Greider, Charlie Hacskaylo, Catherine Nash, Sheila Pitt, Carol Saarinen, and D. P. Warner.

We extend our gratitutde to the students who follow whose drawings appear in this book: Kurt Barr, Melissa Bartell, Stacey Lynn Benton, Kendra Bock, Steven Penn Bryan, Daren Clary, J. David Corbin, Damion Deblas, Jack Dow, Carmen Farre, Janet Gallante, Patricia F. Gallo, Veronica Gibson, Bobbette Gilliland, Bob Graham, Paul S. Grenz, Teresa L. Griffith, Jim Hawks, William Holton, Sherilyn Hulme, Lisa Kaiser, William Kesterson, Kevin Kidney, Kristen Kiger, Rena Allen Klingenberg, Andy Kunde, Cheryl Lemaux, Julie A. Malecha, Robert K. McEwen, Amy McLaughlin, Rudy Nadler, Giri Oei, Daniel F. Petagno, Melissa Peterson, Ken Riley, Karen Roman, Lisa Sheldon, Kristen Sifert, Bertha Sotelo, and Michael R. Spiewak

Finally, we would like to thank the following colleagues for their helpful reviews of our manuscript: James Mitchell Clark, Blackburn College, Carlinville, Illinois; Paul H. Davis, University of Utah; Marco DeMarco, Cleveland Institute of Art; Michael A. Dorsey, Mississippi State University; Robert Jones, Northeast Missouri State University; Heather Ryan Kelley, McNeese State University, Lake Charles, Louisiana; Merrill Shatzman, Duke University; Adrian R. Tio, Bowling Green State University, Bowling Green, Ohio; and Richard Zauft, University of Wisconsin, Milwaukee.

Wayne Enstice
Melody Peters

DRAWING

Introduction

Learning to draw is an exciting activity. As you learn to draw you will be challenged and inspired, and you will learn a great deal about yourself.

Learning to draw will put you in touch with a long and respected tradition that begins in Prehistoric times (Fig. 0–1). Every civilization since then has produced drawings. In our own time, often identified by its mass-produced images, the tradition of drawing has not lost its power. Drawing remains a natural way for creative people to visually express their attitudes about the world around them.

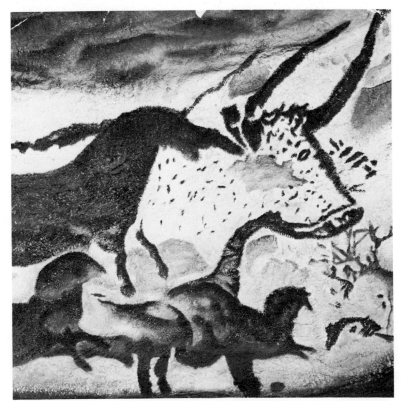

FIGURE 0–1
Prehistoric Art
Cave Painting of Great black bull and red horse at Lascaux, France
Courtesy SEF/Art Resource

1

This chapter is meant to serve as an introduction to aspects of the drawing tradition and its practice. We begin by tracing the impact that Renaissance attitudes have had in shaping the role of drawing within the visual arts. Included is a review of developments in drawing today, which will help you relate your daily pursuits in the medium to the larger historical mainstreams of drawing activity.

The remainder of this introductory chapter centers on advice we customarily give our beginners to smooth their entry into the world of drawing, which, for all its excitement, may at times seem a bit overwhelming. The benefits of much of this advice will become more apparent as you progress; in the meantime, the counsel you receive here will help you get an early start in developing good drawing habits.

The Legacy of Drawing

We think of drawing as the primary field of study for the aspiring artist since it is the most expedient way of training the eye to observe accurately. This is of enormous benefit to anyone who wants to be involved with representing perceived reality. Practice at drawing and close observation will also prepare you to visualize things that exist only in your imagination.

Our interest in making accurate representations of visual reality has its foundation in Renaissance art. Prior to that time, artists were more concerned with the symbolic import of their subject matter. And in most cases, conventions for representing common subjects eliminated the necessity for the artist to engage in firsthand observation of natural appearances.

In the Renaissance, scholars began to redefine the relationship between the secular and spiritual worlds. This allowed artists for the first time to feel justified in taking more interest in the material world around them.

As a result, Renaissance artists disciplined themselves to look and think about what they saw in a manner that would have been foreign to previous generations of artists. And, for the first time, Western artists devoted a great deal of rational thought to the problems of form and space. They also had to work hard to sharpen their perceptual skills. This reliance on personal observation backed up by rational thought informed a new spirit of drawing, as we may see in the Leonardo da Vinci (Fig. 0–2).

The increased use of paper in Europe during the fifteenth century did much to encourage the practice of drawing. Prior to this time, the cost of drawing materials, such as parchment or prepared wooden panels, limited the rise of experimental drawing. But, with the advent of paper, the artist could afford to draw in an exploratory way, making many studies of one subject before settling on a final image. Because of its new investigative role, drawing in the Renaissance gained the prestige of a science. This spirit of investigation has been with the study of drawing almost ever since and accounts for the existence of art programs in universities today.

In the two centuries following the time of da Vinci, the radical scrutiny of human anatomy as practiced by Renaissance artists became conventionalized. As an example, let us look at a life drawing (or *academie* as it was called) by the eighteenth-century sculptor and academician, Bouchardon (Fig. 0–3). Note that in this drawing there is a very systematic way for representing the figure in its environment. The artist employs only three categories of marks. A pattern of lines is used to indicate the background; short, scarcely visible strokes are used for the surface of the body. The most varied stroke is reserved for the outside edges. This conventional use of line was common practice in life drawing of the period. To enhance the presence of the figure, artificial light was used, which had the effect of throwing the anatomy into sharp relief while letting the background drop away.

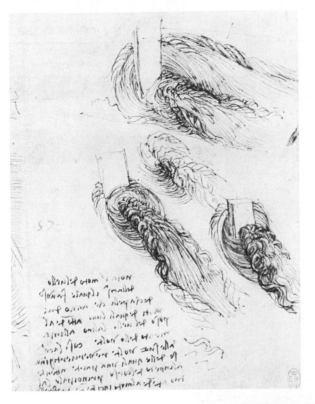

FIGURE 0–2
Leonardo da Vinci
Studies of Water
Portion of drawing, pen and ink
Courtesy of the Royal Library, Windsor Castle

FIGURE 0–3
Edme Bouchardon
Standing Male Nude with Staff
Red crayon on paper, 31¾ × 20½
inches
*Courtesy of the Santa Barbara Museum of Art,
Museum purchase*

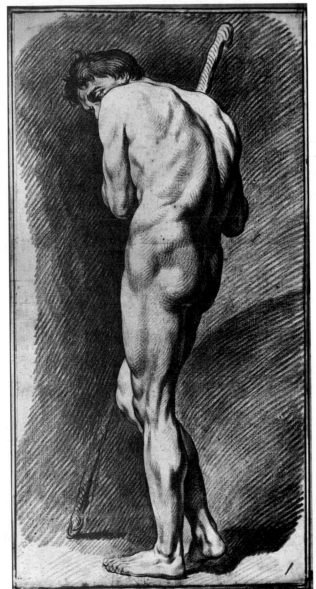

FIGURE 0–4
J.A.D. INGRES
Portrait of Barbara Bansi
Courtesy the Louvre, Paris

It is instructive to compare the Bouchardon with a work made a generation later (Fig. 0–4). In this drawing Ingres *does not* dramatically set the figure apart from the background. The same natural light that illuminates the lively features of the sitter also brightens the haze below and is a harbinger of the increased role that nature would play in French art during the rest of the nineteenth century.

How very different is the attitude towards light, form, and space in the self-portrait by Courbet (Fig. 0–5). Here light is not that flattering, all-pervasive entity that it is in the drawing by Ingres. Instead it is harsh and reveals the

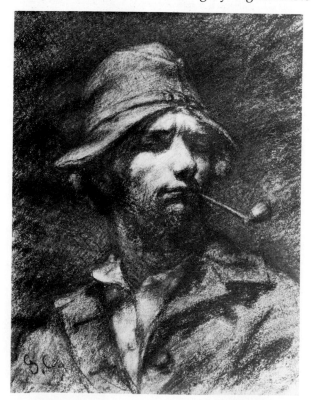

FIGURE 0–5
GUSTAVE COURBET
Self Portrait (The Man With the Pipe),
1847
Charcoal, 29.2 × 22.1 cm (11½ × 8¾ inches)
Wadsworth Atheneum, Hartford,
gift of James Junius Goodwin

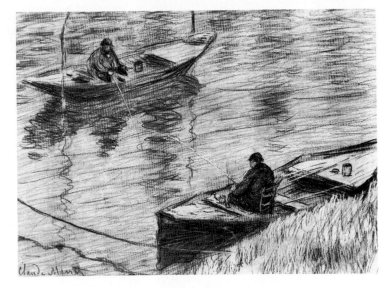

FIGURE 0–6
CLAUDE MONET (1840–1926)
Two Men Fishing
Drawing, French, 19–20th c. Black
crayon on paper coated with gesso
and incised with fine vertical lines
for reproduction by "guillotage" 10
× 13½ inches, 256 × 345 mm
*Courtesy of The Harvard University Art Museums
(Fogg Art Museum), bequest of Meta and Paul J.
Sachs*

forms of the artist's face roughly and imperfectly. The parts of the face obscured by shadow merge with the gloom that envelops the figure. As a realist, Courbet demonstrated that the natural tendency of strong light is not to separate the figure from the background, but rather to break up form so that parts of it become indistinguishable from the space around it. By observing the impartiality of natural light, the artist effects a brutish realism. Once again the investigative potential of art is fully present, and objective observation is seen as an end in itself.

Later in the century, the Impressionists achieved a directness in their use of media that was unprecedented. In paintings and drawings, they asserted the actuality of their media to recreate the ephemeral aspects of constantly changing moments in the natural world.

Let us look at a drawing by Monet (Fig. 0–6) and compare its inventive use of marks to the more convention-bound approach of Bouchardon (Fig. 0–3). Note how in the Monet, many of the marks achieve a physical presence that recalls our experience of actual objects. One kind of mark stands for the fishermens' rods, another for the twisted cable, and yet another for the wavering reflections of the cable. Also note the absence of outlines in the Monet. The Impressionists often did away with them, reasoning that no such lines may be observed in nature.

Impressionist artists were dedicated to expressing with immediacy their experiences of the natural world. But in contradistinction to earlier artistic traditions, the Impressionists, and many of the modern artists that followed, let the actual stuff of their media stand as a metaphor for the physical reality they described on paper and canvas. In works of this kind, every mark exerts a material presence of its own, rather than imitating the surface appearance of natural things. For this reason, the Impressionist period marks a decline in the prevalence of the Renaissance tradition of illusionistic realism.

Extending the Definition of Drawing

Drawing today is firmly established as a medium in its own right. Drawings now have an aesthetic and commercial value that gives them a stature equivalent to that of painting and sculpture. But this has not always been the case.

Renaissance concepts about the role of drawing within the visual arts were deeply influential for a long time. During the Renaissance, skill at drawing was highly valued and was in fact considered the most precious tool at the artist's command. Nevertheless, drawings themselves were not accorded the status of

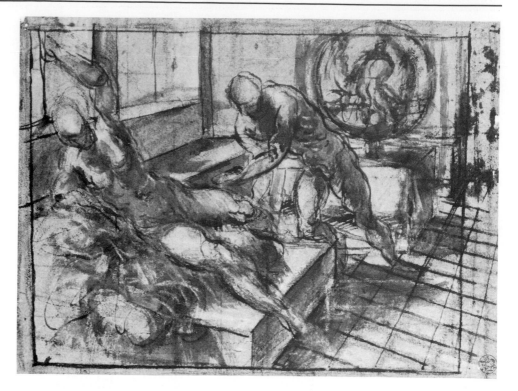

FIGURE 0–7
Tintoretto
Venus and Vulcan, c. 1550
Pen and brush, black ink and
wash, heightened with white on
blue paper
Kupferstichkabinett Berlin; Staatliche Museen
preussischer Kulturbesitz

a legitimate art form, but were regarded as merely preparatory studies for painting and sculpture.

For centuries after the Renaissance, drawing had two functions. First, it was the customary means of training young artists. Second, drawing became a way for more established artists to try out ideas before embarking upon their more ambitious work, as we may see by comparing the study and final painting by Tintoretto in Figures 0–7 and 0–8.

Today, drawing continues to fulfill both these functions. It remains the accepted foundation for aspiring artists, and the use of drawing to work out ideas persists unabated. In fact, the preparatory studies, or *working drawings*, that artists make are frequently held in high esteem by the art-viewing public. Let us examine why.

FIGURE 0–8
Tintoretto
Venus, Vulcan and Mars
Oil on canvas
Munchen, Alte Pinakothek

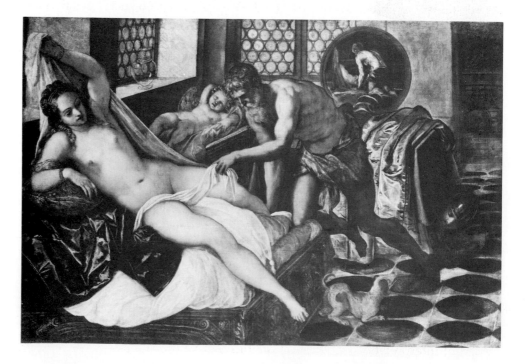

FIGURE 0–9
BARRY LE VA
*Drawing Interruptions: Blocked
Structures # 4*
Mixed/media 48 × 72 inches
Courtesy, Sonnabend Gallery

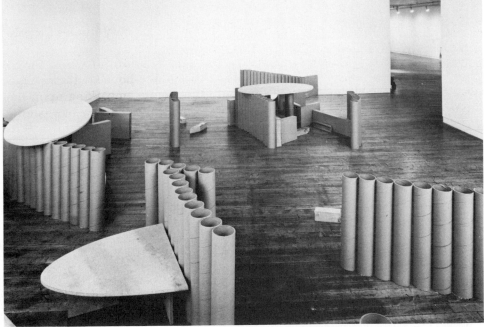

FIGURE 0–10
BARRY LE VA
*Twisted Chain (of Events): Sketching a
Possibility*
Particle board, homosote, wood,
cardboard tubing, dimensions
variable; installation Sonnabend
Gallery, New York City, 1981
Courtesy, Sonnabend Gallery

Among all visual art forms, preparatory drawings put the viewer most in touch with what an artist thinks and feels. This opportunity for an intimate look at the origins of a work has a special attraction for viewers and has given rise to numerous exhibitions of artists' working drawings. Compare, for example, the drawing by Barry LeVa (Fig. 0–9) with one of his works as it appeared installed in a gallery (Fig. 0–10). The representation of space in the graphic work is surprisingly different from the effect of the installation. The drawing has a sense of interior, psychological space and as such lends an unexpected romantic slant to what otherwise appears to be a matter-of-fact assembly of objects on a floor.

In addition to the popularity of working drawings, a finished drawing by an artist is today regarded as a complete and independent art form. Accompanying this loosening of the Renaissance concept of drawing has been a profusion of interpretations as to what defines drawing in the twentieth century.

FIGURE 0–11
ED RUSCHA
Honk, 1964
Gunpowder on paper, 14½ × 23 inches

© Ed Ruscha, courtesy Leo Castelli Gallery, New York City, photographer Dorothy Zeidman

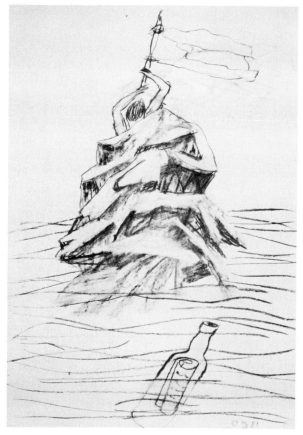

FIGURE 0–12
CHARLES GARABEDIAN
Farewell to H.C. Westerman, 1982
Charcoal on paper, 25 × 15⅛ inches

Courtesy, Hirschl and Adler Modern

Particularly today, in an age marked by aesthetic "pluralism," the diversity of drawing styles seems unlimited (Figs. 0–11 and 0–12).*

In the midst of this unprecedented wealth of drawing styles, two tendencies may be seen to prevail in contemporary drawing. On the one hand, the Renaissance concerns for representing forms in space continue to thrive (Fig. 0–13). Simultaneously, a more modern bias toward the actuality of media has emerged as a viable alternative (Fig. 0–14). Less predictable is the genre of works that challenge conventional beliefs about drawing, such as Walter DeMaria's "Mile-Long Drawing" (Fig. 0–15), which consists of two parallel mile-long lines of chalk drawn twelve feet apart in the Mohave Desert.

*For further examples and a discussion of contemporary drawing styles, see the final chapter, "A Portfolio of Contemporary Drawings."

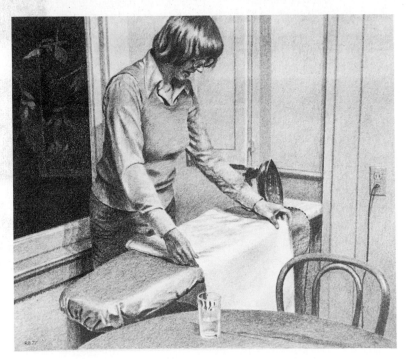

FIGURE 0–13
ROBERT BECHTLE
Nancy Ironing, 1977
Pencil drawing, 12⅞ × 15 inches
Courtesy of the San Diego Museum of Art

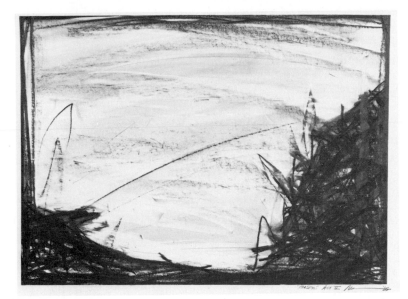

FIGURE 0–14
ROBERT WILSON
Parsifal, Act II, 1985
Graphite on paper, 22¼ × 30
inches (RW458)
Courtesy, Paula Cooper Gallery

FIGURE 0–15
WALTER DE MARIA
Mile Long Drawing, 1968
Two parallel chalk lines on desert
dry lake. One mile long, lines 12
feet apart and 3 inches wide, artist
lying on the desert floor.
Copyright © 1969 Walter De Maria

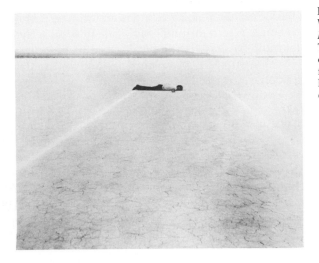

The Student and Master Drawings

Presumably, we all look at master drawings for enjoyment. That enjoyment might include anything from the simple wonder that an artist could achieve so realistic a likeness of a particular thing, to the more sophisticated appreciation of an inventive use of composition and imagery.

By looking at master drawings you will also become more familiar with the basic principles of drawing and gain a sense of how and why those principles have been manipulated to meet specific ends. Moreover, spending time with drawings from various phases of art history will help you to see the relationship between past and present drawings. You also will find countless instances when new forms of expression coexisted with older drawing practices. Indeed, even the most startlingly reshaped concepts have never invalidated drawing in traditional terms.

The Issue of Talent

When you look at works by esteemed masters, you may find yourself in awe of their virtuosity. Your admiration for these works may lead you to wonder if you have sufficient talent to undertake a serious study of drawing. This question is frequently expressed by beginners and usually results from a misunderstanding about what it takes to learn to draw.

Learning to draw is an acquired skill. The fundamentals of drawing form a body of knowledge well within the reach of the college-level student. This body of knowledge is imparted through concepts that are often easy to grasp but require repeated application to fully comprehend. Through consistent application, you will obtain a set of measurable skills that you will use as if by second nature.

Learning to draw is also based on desire. Talent, viewed in this way, is more a matter of inclination than anything else. Someone with the ambition to draw well can learn to excel. Ultimately, the person possessing sound basic skills and a zeal for visual expression will be equipped to do work of a more serious and personal nature.

The Public Side of Drawing

The bulk of your learning will take place when you are drawing. In this respect, learning to draw is like learning to ride a bicycle. The theory of what to do can only be imperfectly explained. Actual understanding must be gained from the experience of getting onto the bike or applying marks to paper.

At first, many students are uncomfortable when drawing in the presence of others. After all, drawing is an intimate activity, and what you make is always to some extent autobiographical. Ironically then, the most common setting for learning to draw is the *public arena* of the classroom.

Fortunately, your participation in the drawing process will ease all such anxieties. You will find that the challenge of drawing requires such concentration that you will become oblivious to the presence of other people in the classroom. And, attaining this level of concentration will make it easier for you to draw, unhampered by the insecurities of working in a relatively public setting.

Seeing Versus Naming

Achieving feelings of privacy while drawing in a crowded classroom is the result in large part of switching your thinking from the usual verbal mode to a nonverbal mode. Whenever you concentrate on a nonverbal task, such as drawing,

you will be inclined to block out verbal distractions, such as a conversation taking place in the same room. However, this nonverbal state of mind has another, and even more important, role to play in your drawing practice since it encourages you to focus upon the *visual* character of your subjects rather than relating to them only on the basis of their *names* and *uses* in our everyday world.

Since our main form of daily communication is verbal, or symbolic, we tend to deal with the world on the basis of objects we can name: telephone, car, dog biscuits. In drawing, this situation is almost reversed since we attribute meaning to our subjects more fully on a visual basis. Correspondingly, their worldly associations are deemphasized. Or at least, they should be.*

But beginners often feel more secure if a subject is loaded with meaning, in the verbal sense, or has an abundance of nameable parts. The more nameable parts, they feel, the more likely the drawing will succeed as a recognizable image.

For example, let us say a beginner was asked to draw a still life containing an old boot and some draped cloth. Attracted to the boot because of its more specific cultural identity, the beginner will record individual details much as an itemized grocery list is compiled: two broken laces, twelve hooks and eyelets, one stiffened tongue, and so on. Less scrutiny will be given to the general form and structure of the boot and far less information given about the draped fabric. This tendency to draw each unit of the subject separately arises from the habit of naming and usually results in a drawing that looks fragmented and superficial in its treatment of subject matter.

On the other hand, beginners who emphasize a subject's visual character are able to see its wholeness and the way each part is integral to that whole. In a visually oriented state of mind, the beginner might find the play of light and shadow on the folds of the cloth far more intriguing than the boot. And the boot, if seen instead of named, might emerge as a dark, twisted mass in contrast to the cloth's billowy movements and gentle gradations of light and shadow.

So, seeing means to stress a *visual* interpretation of the subject to be drawn. Your ability to overcome the tendency to name what you see (three pencils on a table top) and depend instead on visual insight (three diagonals on a flat surface) may take some practice to develop. But a visual approach yields far more satisfactory drawings than one that accentuates a subject's everyday identity and symbolic connotations.

Drawing as a Process

Making a drawing is like participating firsthand in the development of an organism. This development is a natural process, from the drawing's genesis to its completion.

In this regard, consider that making a drawing is a process of *forming* something; it is a way for the artist to materialize responses to things that are real or imagined. Although process is integral to the realization of any artwork, its visual traces are usually obliterated by the time a work is completed. However, we are afforded insights into the developmental process of a work of art when different states are preserved, as in Figures 0–16 and 0–17 where two successive impressions of the Rembrandt print "Christ Presented to the People" show, among other changes, the crowd in front of the podium replaced by two rusticated arches. Serial images may also provide evidence of an artist's process, as in Figures 0-18 through 0-20, which showcase Picasso's mastery of form improvisation.

So, like any organic thing, a drawing must be permitted to grow and change. And the process of making a drawing is most successful when the artist is alert and responsive to this potential for change as the drawing is being formed.

*This is not to deny the cultural content in subject matter. At this stage, however, the *visual* content of what we draw cannot be overemphasized. For further discussion of content that is culturally based, see Chapters 8 and 11.

In practical terms, this means that your drawing method should not be limited to only up-close, detailed work. Working up close does have its benefits since you can concentrate on detail and enjoy the sensuality of applying drawing media to paper. But, working at arm's length or less may make it difficult to see how all the parts of a drawing fit together.

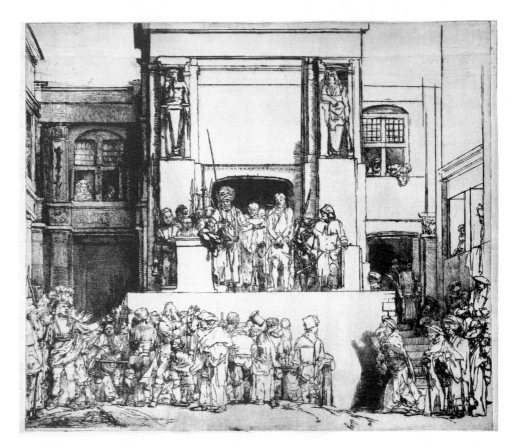

FIGURE 0–16
HARMENSZ VAN RYN REMBRANDT
(1606–1669)
Christ Presented to the People, first state
Etching
The Metropolitan Museum of Art, gift of Felix M. Warburg and his family, 1941

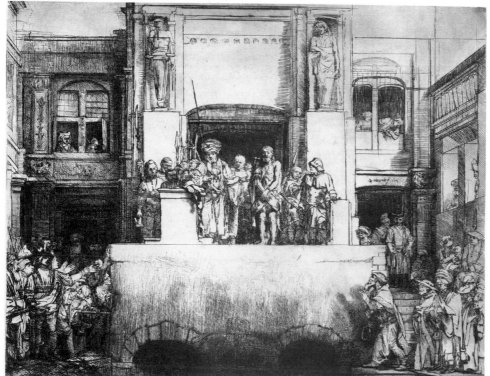

FIGURE 0–17
REMBRANDT
Christ Presented to the People, last state
Etching
The Metropolitan Museum of Art, gift of Felix M. Warburg and his family, 1941

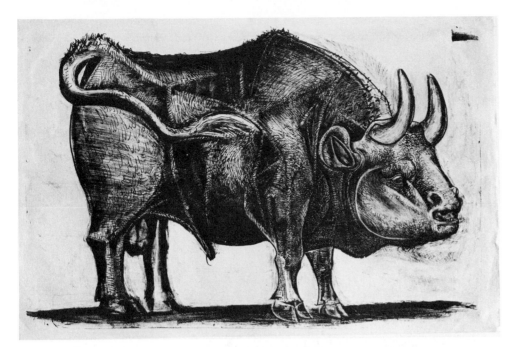

FIGURE 0–18
PABLO PICASSO
Bull, State III (December 18, 1945)
Lithograph, printed in black,
composition, 12⅜ × 18¹⁵⁄₁₆ inches
Collection, The Museum of Modern Art, New York,
Mrs. Gilbert W. Chapman Fund

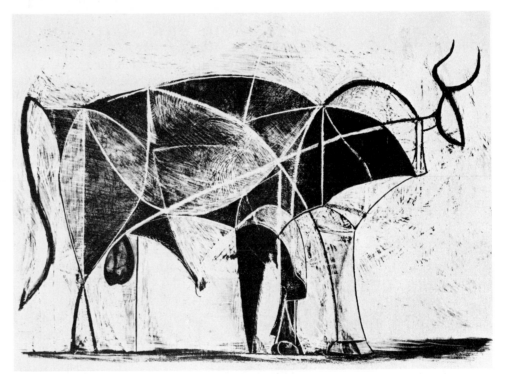

FIGURE 0–19
PABLO PICASSO
Bull, State VI (December 26, 1945)
Lithograph, printed in black,
composition, 12 × 17⁷⁄₁₆ inches
Collection, The Museum of Modern Art, New York,
Mrs. Gilbert W. Chapman Fund.

In order to fully gather in the whole effect of a drawing, it will be necessary to "shift your perception" away from the representation of subject-matter detail. One means for doing this is to turn the drawing upside down or view it in a mirror to reverse the image. Another way is to move physically back—several paces from your drawing—to gain an overview of its progress. These simple strategies help in diagnosing problems that might otherwise escape your notice. And they also place you in a better position to see, and take advantage of, new possibilities emerging in a drawing.

Regularly taking stock of your work has the added value of helping you appreciate a drawing's identity as an independent, created object. You will become more accustomed to the fact that all drawings, even those filled with convincing descriptions of things, have their own logic quite apart from those properties of illusion or imitation of the natural world.*

*For more on the drawing process, see "Troubleshooting Your Drawings" in Chapter 9.

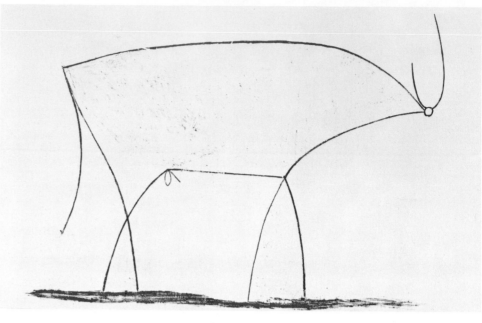

FIGURE 0–20
PABLO PICASSO
Bull, State XI (January 17, 1946)
Lithograph, printed in black,
composition, 11⅜ × 16⅛ inches
*Collection, The Museum of Modern Art, New York,
acquired through the Lillie P. Bliss Bequest*

The Merits of a Sketchbook

A sketchbook is a handy means for accelerating your progress in drawing. Bound sketchbooks may be purchased at any art supply store, although some artists prefer to bind their own so that they may insert papers of different weights, surfaces, and colors. Media of all kinds are suitable for a sketchbook; indeed, part of the pleasure of keeping a sketchbook is experimenting with media not commonly used in the classroom, such as a ballpoint pen, magic markers, or collages made with available materials like leaves and match books.

For many artists, the sketchbook is a constant companion. Its empty pages encourage the artist to take possession of the world through drawing, and it is ideal for transferring direct-life experiences with immediacy (Fig. 0–21). Much

FIGURE 0–21
Student sketchbook drawing

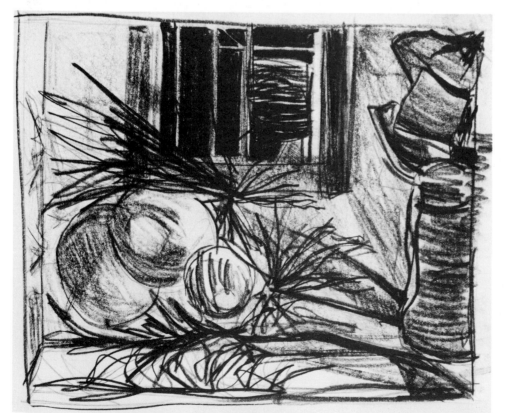

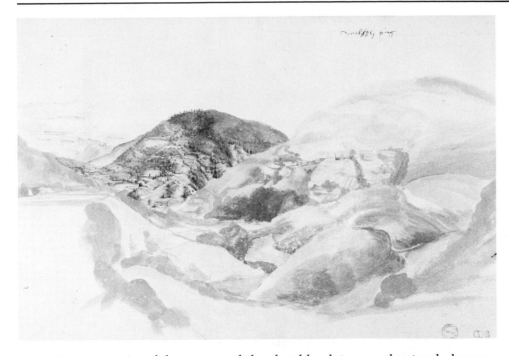

FIGURE 0–22
ALBRECHT DÜRER
Alpine Landscape
210 × 312 mm
Ashmolean Museum, Oxford

as the itinerate artist of the past used the sketchbook to record natural phenomena in distant lands (Fig. 0–22), the contemporary artist uses it to extend the processes of search and discovery beyond the studio.

Often considered an artist's personal diary, the sketchbook is an excellent context for written and visual impressions of things seen, remembered, or imagined (Fig. 0–23); for sorting out ideas; and for making analyses of works of art. And you will notice that as a well-kept sketchbook fills, its significance as a special object will also increase. Carrying it about tucked under your arm, or leafing through earlier sketches, you will begin to appreciate your sketchbook as a concrete record of your developing visual identity.

FIGURE 0–23
Pages from a
student's sketchbook

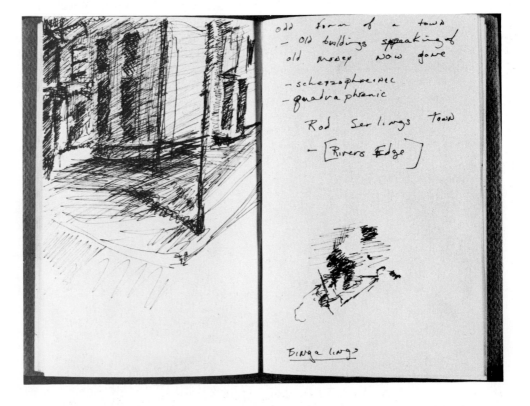

1

The Three-Dimensional Space of a Drawing

When was the last time you dragged your finger across the condensation on a car window? Or had the urge to make your mark on the surface of a building, an underpass, or a freshly leveled sidewalk?

As kids, most of us loved to make marks on available surfaces. As adults, some of us still do, using art as a common outlet for these energies. If improperly directed, however, this drive may lead to the form of vandalism known as graffiti. Curiously, in recent times, radical street artists have been adopted by the more established art market, with the result that "spray-can graffiti art" has become one of the recognized styles of the eighties (Fig. 1-1).

This chapter invites *you* to explore mark-making anew and with a refreshed purpose. You will observe how the marks you make suggest space in a drawing; and you will learn the organizational principles behind this phenomenon, principles that will be fundamental to your growth in descriptive drawing.

FIGURE 1–1
A-ONE
Ambush in the I
Spray paint on linen, 63¾ × 115½ inches
Courtesy, Sidney Janis Gallery, New York

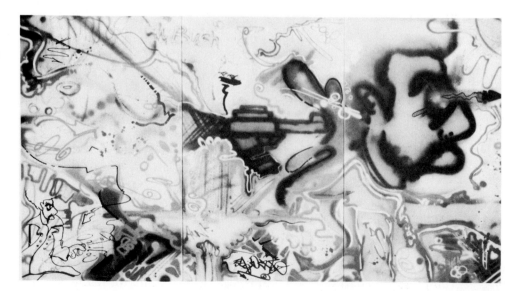

16

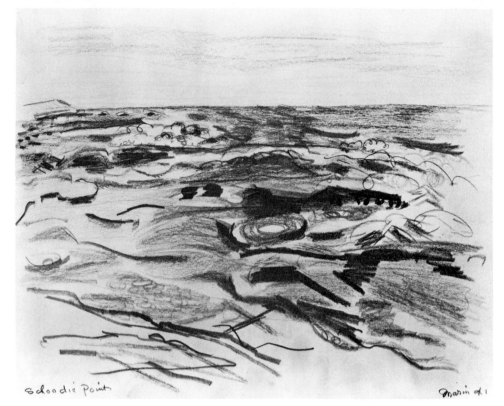

FIGURE 1–2
JOHN MARIN (1870–1953)
Schoodic Point, 1941
Crayon on paper, 10½ × 13½
inches
Courtesy of Kennedy Galleries, Inc., New York

Making Your Mark

The word mark as we have been using it has three major ramifications in regard
to artistic expression:

1. Its primary meaning is a trace or blemish left upon a surface. As such, it may
 be a scratch, dent, hole, stain, or deposit. In shape it may range from that
 of the meaningless smudge, spot, tick, or line to the more meaning-laden
 forms of punctuation marks, letters of the alphabet, or corporation logos.

2. A mark also records the presence of the agent that made the mark. The graffiti
 artist who sprays a cryptic sign or tag on a subway train is in effect indicating
 a territorial claim to a piece of corporate property. Likewise, the manufacturer
 stamps a trademark on the product not only to indicate its origin, but also
 to stake a claim upon the public's consciousness.

3. Finally, a mark is often used as an indicator of spatial quantities: Spatial
 distance may be indicated by road markers; area by boundary markers; and
 volume by calibrations such as those found on a measuring cup.

 The use of a mark in a drawing may take into account all three meanings.
First of all, artists are generally concerned about the quality and range of marks
they make on the surface of their paper. Secondly, a mark is a record of the
action taken by the artist who made it. Thirdly, the artist, as one who is interested
in also making visual representations of nature, will use marks to measure
relative spatial quantities in the world (Fig. 1–2).

The Mark Versus the Line

The conception that most people have of a drawing is that of a picture made
with line. The use of flowing line is particularly suited to the portrayal of subjects
of great complexity, but a line is only one kind of mark, and for many artists,

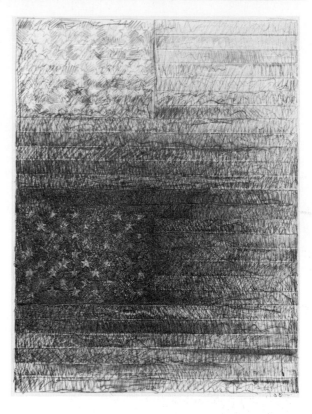

FIGURE 1–3
JASPER JOHNS
Two Flags, 1980
Ink and crayon, 45¼ × 31½ inches
© Jasper Johns, courtesy of Leo Castelli Gallery,
New York City, photographer Bevan Davies

a much larger repertoire of marks is in order. Many other kinds of marks are the result of short, direct gestures. They are, therefore, relatively abrupt in appearance. Such marks are seldom used for full-blown representation. Instead, they most often function as spatial indicators in a drawing, as in their verbal counterpart, "mark that spot." Look, for example, at the Jasper Johns' drawing "Two Flags" (Fig. 1–3). Although apparently about a specific object, the real subject of the drawing is the profusion of marks that seem to move back and forth between the surface of the drawing and the sketchy image of the flags.

Figure–Ground

As soon as you put a mark on a surface, you set up a figure–ground relationship.

To clarify this, place a blank sheet of drawing paper in front of you. Consider it carefully. It has a particular tone (in most cases, white or off-white), a particular shape (usually, rectangular), and a particular size and texture. This clean, flat surface is the *ground* of your drawing.

Make a single mark on this ground, and you have created a thing of visual interest, or what we call a *figure*. A figure in a drawing may represent a recognizable object, or it may be a nonrepresentational shape; but in either case, it is something that may be readily distinguished from its visual context. The term figure, as used here, is not limited to the human body. A figure may be, for instance, the representation of a tree, an invented symbol (Fig. 1–4), or a letter of the alphabet.

This first mark (or figure) you make will heighten your awareness of the area of your ground by making the vertical and horizontal dimension of the drawing paper more apparent (Fig. 1–5). It will be as if a magnetic attraction exists between the mark and the edges of your paper.

Now, let us return to our example of a blank sheet of paper. Looking at this paper with a different intent, you can probably conceive within its emptiness the existence of an amorphous and relatively infinite space. Imagining this space

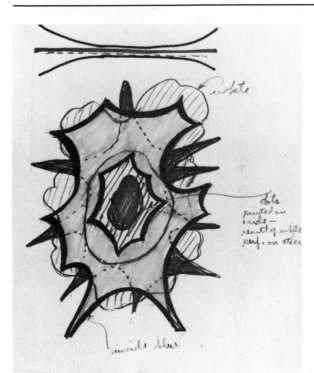

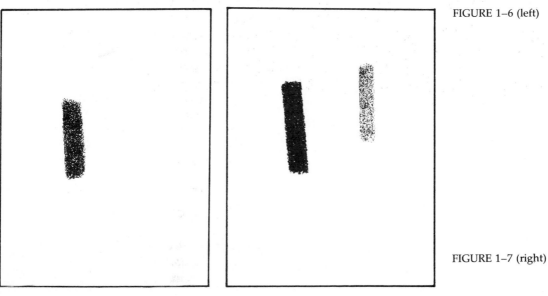

FIGURE 1–4
Roy Lichtenstein
Study for Desk Explosion, 1965
Pencil and ink on paper, 10⅝ × 8¼
inches (RLD-220)
© *Roy Lichtenstein, courtesy Leo Castelli Gallery,*
New York City

FIGURE 1–5

will take an act of will on your part. Experiencing it will be somewhat akin to staring at a patch of clear blue sky—there is no beginning, middle, or end.

One mark dramatically alters this perception of space (Fig. 1–6). It is now as if a solitary bird has appeared in that blue sky giving you a single point of spatial reference. This first mark on a page changes the formless character of the space into a more defined and tangible volume. In a sense, the mark creates the space in which it exists.

A second mark of a lighter or darker tone than the first will increase the illusion of a specific spatial volume (Fig. 1–7). Appearing to be at a measured distance from the first, it provides a second point of reference in the space of the drawing. Each mark thereafter will add another station to the space, thereby increasing its structural definition.

So, the first two marks on your paper may be seen as figures against a ground, in which case they make the physical presence of the ground easier to grasp. They may also be seen as two spatial points in your drawing, thus opening up the ground illusionistically.

FIGURE 1–6 (left)

FIGURE 1–7 (right)

FIGURE 1–8
MICHAEL SINGER
Ritual Balance Study, 1974
Mixed media on paper (collage,
charcoal, chalk) 43⅝ × 83½ inches
*Purchased with funds contributed by Mr. and Mrs.
Rudolf B. Shulhof. The Solomon R. Guggenheim
Museum, New York. Photographer Robert E. Mates.*

Artists will frequently play one mark against another in order to create spatial tension. In this regard, let us look at the Michael Singer drawing pictured in Figure 1–8. You will note that, in general, the marks are different in some way from one another. It is that difference, what we might call the distinguishing character of a mark, that influences how we read a mark's position in space. And by extension, it is the range of differences in the accumulated marks that expresses the kind of space in total that is portrayed.

The Picture Plane

The space represented in a drawing is a semi-enclosed volume. Except for the potential of unlimited depth, the illusion of three-dimensional space in your drawing is bounded on all four sides by the edges of your paper and in front by the transparent "wall" we call the *picture plane*.

Common usage has given the term picture plane two meanings. First, it refers to the actual flat surface, or opaque plane, on which you draw. Second, the picture plane is often regarded as an imaginary, transparent "window on nature" that represents the format of your drawing mentally superimposed over the subject you wish to draw (Fig. 1–9).

The act of drawing links the two meanings of the term picture plane. When drawing, you look through the imaginary picture plane to gather information about the space and form of your subject, and you transfer this information to the actual picture plane of your drawing surface. So, as a result of this process, your drawing paper is virtually equivalent to the window on nature that you have imagined.

Of course the imaginary picture plane does not actually exist except as an abstract concept to assist the artist in depicting things as they appear. Looking through this artificial plane may be compared to sizing up a subject through the viewfinder of a camera: you are framing, or selecting that portion of the subject you wish to draw from the visual field before you. In so doing, you have taken the first step in organizing the three-dimensional space of your drawing.

This concept was developed (actually rediscovered) in the early Renaissance, at which time artists were becoming increasingly involved in duplicating

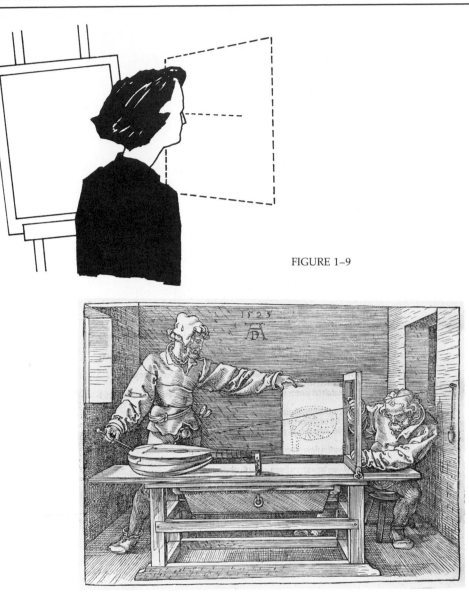

FIGURE 1–9

FIGURE 1–10
ALBRECHT DÜRER
The Artists' Treatise on Geometry
(1525)
Woodcut
*The Metropolitan Museum of Art, Harris Brisbane
Dick Fund, 1941*

natural appearances. Not only did they develop the idea of the picture plane as a mental device, but they also experimented with ways of transferring points located on actual objects in space onto the flat surface of the picture plane (Fig. 1–10).

The Picture Plane Begins Your Space

To reinforce your understanding of the concept of the picture plane, we offer the following scenario.

Imagine that you are looking through a picture window at a gorgeous meadow backed by rolling hills. All of a sudden, a large and colorful insect lands with a smack on the pane of glass. Made aware of the window's presence, you would no longer be looking through the glass, but *at* it. And the thought may even have struck you that this window was the beginning of the space that opened up before you.

The picture plane in a drawing may be thought of in the same way. In fact, if we interpret the atmosphere of natural space as a series of receding, planes, we are ready to regard our "transparent" picture surface as the first plane in the series. With this in mind, let us look at two illustrations.

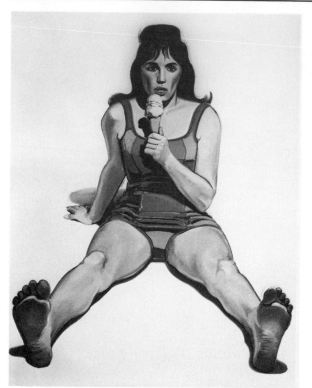

FIGURE 1–11
WAYNE THIEBAUD
Girl with Ice Cream Cone, 1963
Oil on canvas, 48 × 36 inches
Collection of Mrs. Edwin A. Bergman

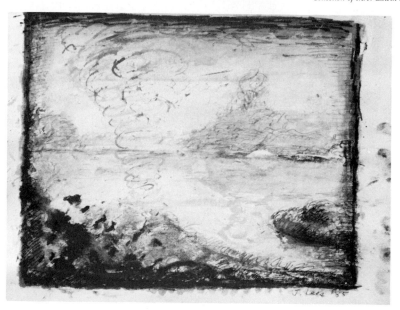

FIGURE 1–12
JOHN LEES
Study for a Landscape, 1985
Pencil, ink, gouache on paper, 12
× 15 inches
Courtesy, Hirschl and Adler Modern

The female figure in Wayne Thiebaud's painting (Fig. 1–11) sits securely in a shallow space. Yet we cannot help but notice the illusion that her big toes are pressed against the back of the picture plane. In Figure. 1–12 the inner rectangle has a slab-like appearance. This effect gives the picture plane a more immediate physical presence (it seems more real than the actual paper margins) and makes it clearly the initial contact point through which an atmospheric vista unfolds.

In each case then the picture plane's primary position in the spatial illusion has been declared, whether by pressure against its surface (Thiebaud), or by heightening its physical palpability (Lees).

Exercise 1A *These exercises will enable you to transform your sheet of paper into an imaginary space of unlimited depth. You will need the following drawing media: vine and compressed charcoal; conte crayon; graphite stick; kneaded and artgum erasers.*

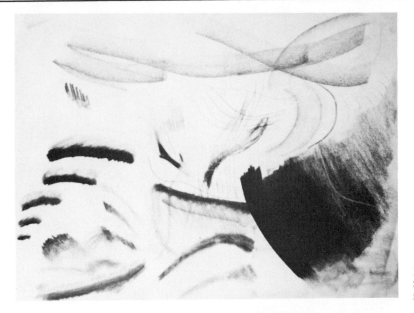

FIGURE 1–13
Student drawing with varied
marks to represent space

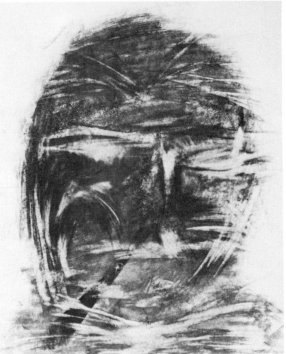

FIGURE 1–14
Student eraser drawing

Drawing 1. *To create your spatial illusion, use a variety of marks. These marks should not be descriptive of objects. Instead each mark should simply indicate a distinct physical point in the illusion of space you are making. Do your best to vary your marks in terms of size, tone (lightness and darkness), and clarity in order to create the illusion that they are set at different depths in a spatial field (Fig. 1–13). Use your fingers, chamois, or side of your hand to blur some of the marks. Maneuver about so marks are distributed at various places across and up and down your paper. Apply some marks with heavy pressure using the motion of your entire arm; arrive at others by merely flicking your wrist. Make some fast, some slow.*

Experiment freely with your media. And do not forget to explore the mark-making possibilities of your erasers. By erasing into dark areas you can make white lines and marks which seem to glow from a brilliant inner light. Also, try smearing heavy deposits of media with your erasers, or scumbling over them (this means to rub lightly, or "feather" an area). Both of these techniques will soften dark marks, making them appear more hazy, or atmospheric (Fig. 1–14).

Drawing 2. *Your objective here is to make a more finished looking drawing. Begin by once again using marks to represent a space. But as your drawing develops, consolidate your marks*

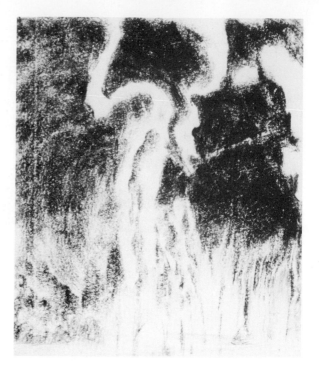

FIGURE 1–15
Student drawing

until more definite areas of light and dark appear. Also heighten the mood or emotional impact that is emerging in your drawing, as in Figure 1–15 which may elicit feelings of fear and foreboding.

Fundamental Methods for Creating Three-Dimensional Space

What you will have observed thus far is that although any collection of marks on a page will imply a space of some sort, strong differences in the character of marks intensify a drawing's spatial impact. Our next step is to support this observation with basic information about how you can more decisively create and control an illusion of three-dimensional space in your drawings.

Most of the methods we describe below for creating space were used by artists before the advent of linear perspective in the fifteenth century. Although these devices were eventually united with linear perspective, they remain viable outside the strictures of that highly rationalized system.*

RELATIVE POSITION

In a spatial illusion, things located on the lowermost portion of the picture plane generally will appear closest to the viewer. Conversely, the higher something is placed on the picture plane the farther away it will appear. Note, for instance, that the figures of Christ and the two Old Testament prophets in the upper section of Figure 1–16 are read as farther back in space by virtue of their position on the picture plane relative to the three kneeling Apostles below. A similar phenomenon occurs in the Thiebaud drawing (Fig. 1–17), where the gradual upward disposition of the pastels suggests increasing amounts of depth.

DIAGONALS TO CREATE DEPTH

The diagonal is a simple but effective means for creating the illusion of depth in a picture. Its effect is, in part, derived from the implication that similar objects receding diagonally into space will appear to diminish in size, as may be seen in Figure 1–18. But to best understand the diagonal's power we must compare

*A full discussion of the rules of linear perspective appears in Chapter 5.

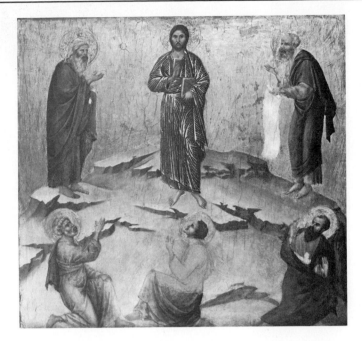

FIGURE 1–16
Duccio
Transfiguration
Courtesy National Gallery, London

FIGURE 1–17
WAYNE THIEBAUD
Pastels, 1972
Pastel, 22⅛ × 30 inches
The Saint Louis Art Museum, purchased through the Eliza McMillan Fund

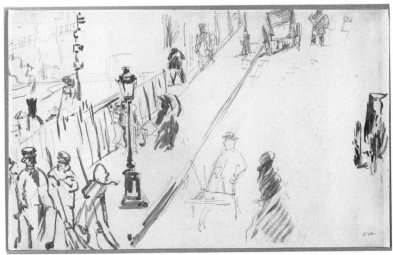

FIGURE 1–18
EDOUARD MANET
La Rue Mosnier, C. 1878
Graphite with brush and India ink,
10¹⁵/₁₆ × 17 ⅜ inches

Copyright 1989 The Art Institute of Chicago. All rights reserved. Gift in memory of Tiffany Blake by Mrs. Alice H. Patterson, 1945.15

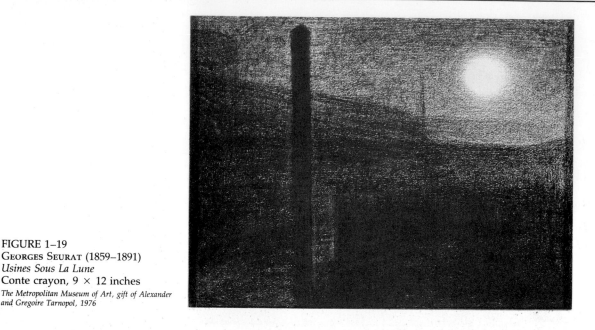

FIGURE 1–19
GEORGES SEURAT (1859–1891)
Usines Sous La Lune
Conte crayon, 9 × 12 inches
*The Metropolitan Museum of Art, gift of Alexander
and Gregoire Tarnopol, 1976*

it with its directional counterparts in two-dimensional art, the vertical and the horizontal.

The vertical mark echoes our vertical condition as human beings, so we most readily identify with it (Fig. 1–19). A related issue is the somewhat confrontational effect of a vertical mark. It may function as an obstacle as well as a marker in our spatial field.

The horizontal mark opposes our orientation and thereby gives refreshed emphasis to our verticality. The thrill we experience before a sweeping landscape or ocean vista is due in part to the horizontality of its lines and planes. The horizontal line often elicits a feeling of calm associated with an uninterrupted flow of space.

Additionally, it is important to realize that vertical and horizontal marks, aside from their direct relation to our human posture, also repeat the vertical and horizontal axes of the paper on which we draw (Fig. 1–20). By virtue of this harmony, vertical and horizontal marks lend our drawings a feeling of

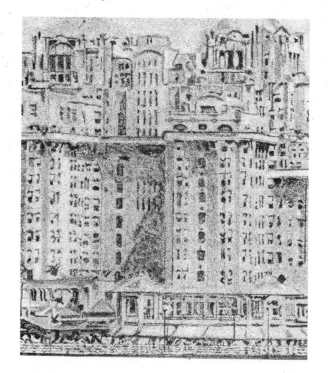

FIGURE 1–20
RICHARD ARTSCHWAGER
Destruction I, 1972
Acrylic on Celotex, 36 × 30 inches
*Photograph courtesy Leo Castelli Gallery,
photographer Rudolph Burckhardt*

FIGURE 1–21
JOHN MARIN
Lower Manhattan, 1920
Watercolor, 21⅞ × 26¾ inches
Collection, The Museum of Modern Art, New York, the Philip L. Goodwin Collection

structural stability. We may validly sense, then, a relationship between our vertical condition, the rectangular or square orientation of our drawing paper, and the vertical and horizontal marks we make.

In contrast, the diagonal mark is more dramatic and suggestive of action. It is antagonistic to the stability of our bodily orientation and the orientation (horizontal and vertical) of our drawing surface. Lacking an axial equivalent, the diagonal mark creates tension as it transports us with great immediacy into an illusion of space (Fig. 1–21).

OVERLAPPING

Overlapping occurs when one object obscures from sight part of a second object. Overlapping was a very common and effective strategy for organizing space in art that preceded the invention of linear perspective, as may be seen in (Fig. 1–22).

The phenomenon of figure-ground, as discussed earlier in this chapter, is made more complex by overlapping. When forms are overlapped, the relative nature of figure to ground becomes evident. In Charles Sheeler's "Of Domestic

FIGURE 1–22
Anonymous Netherlandish (xiv century)
The Death of the Virgin, 1390
Silver point on blue-green prepared paper, 11½ × 15¾ inches
Courtesy National Gallery of Art, Washington, DC, Rosenwald Collection, GD

FIGURE 1-23
CHARLES SHEELER
Of Domestic Utility, 1933
Conté crayon, 21¾ × 15⅞ inches
Collection, The Museum of Modern Art, New York,
gift of Abby Aldrich Rockefeller

Utility'' (Fig. 1–23), for instance, the forms moving sequentially back into space may be seen to alternate their roles as either figure or ground. The circular pan, sandwiched between two logs, serves as a ground for both the pitcher and the log that are foremost in our field of vision. In its turn as figure, the pan is seen against a variable ground which includes the distant log plus floor and wall planes. Even the body of the pitcher may be seen as a ground, for against it we observe the form of the handle. This type of progression, where figure and ground are relative designations, is often referred to as *figure–ground stacking*.

ATMOSPHERIC PERSPECTIVE

Atmospheric perspective (also called aerial perspective) has been employed by artists for a long time (the Chinese had mastered the technique by the tenth century). It is based on what any of us may observe by looking out the window: objects close at hand are crisply defined; those at a greater distance lose their definition appreciably.

Technically, it is the moisture and particles of dust in the air that obscure our vision of distant things. The greater the amount of air between us and the forms we observe, the less clearly are we able to perceive them. So, in general, atmospheric perspective is most apparent when we are confronted with deep space (Fig. 1–24) or when the atmosphere is made more dense by mist or fog (Fig. 1–25).

To be more specific, the effects of atmospheric perspective may be achieved in a drawing by paying attention to these two principles:

1. The clarity of forms diminish as they recede into the distance. Surface detail and texture are less apparent; with very distant forms, detail and texture may disappear altogether.

2. When objects are viewed in deep space, the contrast between light and dark tonalities is reduced. Medium and dark tones often become lighter and may even blend into a uniform light gray.

FIGURE 1–24
ALEXANDER COZENS
A Mountain Lake or River among the Rocks, 1775–80
Brush and black ink wash
Courtesy, Courtauld Institute Galleries, London

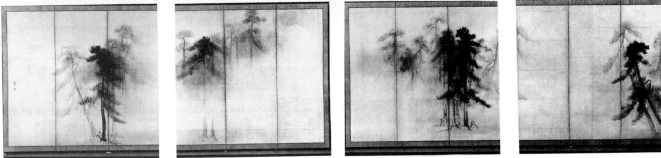

FIGURE 1–25
HASEGAWA TOHAKU
Pine Wood (1539–1619) four details from a pair of six-fold screens
Ink on paper, height 61 inches
Tokyo National Museum, Japan

Sometimes this second principle misleads students into believing that only forms close to the picture plane may be drawn with the darkest tones. This is incorrect since there will be occasions in nature when the perceived tone of a more distant form will approach, equal, or even exceed the darkness of forms that are nearby. In this case, remember that it is the tonal contrast of a form (relative to its context) in comparison to other areas of a drawing that helps determine spatial position.

ORGANIZING A DEEP SPACE

The volume of air, or atmosphere, between us and the forms we perceive in the distance may be understood as a series of receding planes (as we discussed in the section on the picture plane). A convenient system for organizing these planes is to group them into three distinct zones of illusory space: foreground, middleground, and background.

In the Everett Shinn drawing (Fig. 1–26) all three zones are clearly present, and coordinated with the illusion of atmospheric perspective.

RELATIVE SCALE

The concept of relative scale is closely allied to notions of foreground, middleground, and background. Things that are larger in scale usually seem to be in the foreground, or closer to us. Conversely, when there is a relative decrease in the scale of forms, we judge them to be receding farther into the background.

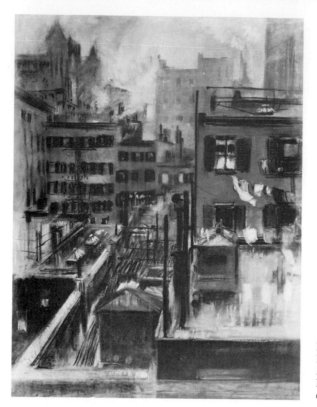

FIGURE 1–26
EVERETT SHINN
Eastside Apartment Buildings, 1898
Pastel, 29½ × 21½ inches
Courtesy, Hirschl and Adler

Note, for instance, the drawing by Emil Nolde (Fig. 1–27). The marks are uniformly black, and Nolde's broad approach expresses only a general impression of his subject. And yet the pronounced scale changes of the marks guide us convincingly through a deep space.

The use of relative scale is particularly effective when the forms that diminish are understood to be of similar size, as in the Goya drawing (Fig. 1–28). Consider as well Goya's use of relative position, atmospheric perspective, and the diagonal to achieve a convincing sense of space.

FIGURE 1–27
EMIL NOLDE
Harbor Scene, Hamburg, c. 1910
Brush with black ink, on tan
colored Japan paper, 32.3 × 46.5
cm

*© The Art Institute of Chicago, all rights reserved,
gift of Mr. and Mrs. Stanley Freehling, and Joseph
R. Schapiro, 1965.245*

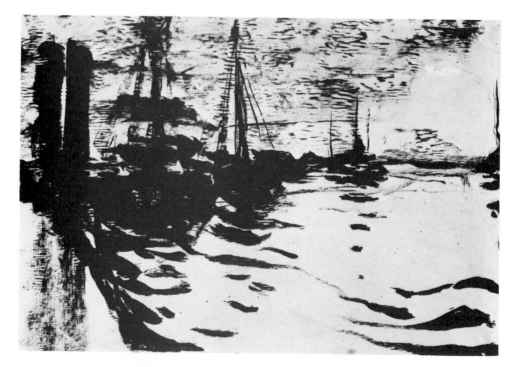

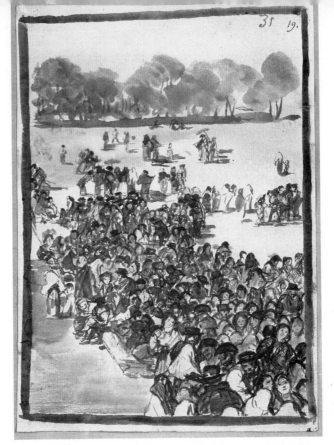

FIGURE 1–28
Francisco de Goya (1746–1828)
A Crowd in a Park
Brush and brown wash, 8⅛ × 5⅝
inches

*The Metropolitan Museum of Art, Harris Brisbane
Dick Fund, 1935*

Armed with an increased knowledge of spatial concepts, you are now ready to represent, ***Exercise 1B***
however basically, what you see in front of you.

Set up to draw on one side of the largest room available to you. Spend a few moments
letting your eye travel from point to point within this space. At this time you might also try
to imagine your drawing paper as a transparent window superimposed over your subject.

Now, select an object in the midst of this interior and put a mark on your paper
representing it. Do not attempt to outline the object or depict any of its detail; your concern
should be only with that object's location in space. Next select an object or point that lies
behind the first one. Indicate its position with another mark. You will probably wish to make
this mark lighter in tone, or at least more diffuse, in order to have it appear farther away.
Note also its relative position on the page. Is it closer to the top?

Next, look at an object that is close to you. Using a bolder and sharper mark, indicate
this object. Continue to add marks to the page showing the relative locations of other objects
in the room. Be sure to consider the intensity and clarity of your marks and their relative
position and scale; make use of any naturally occurring overlaps to reinforce your illusion of
space.

Figure 1–29 is an example of marks used to create a feeling of space in a room.

FIGURE 1–29
Student drawing with marks
representing the spatial positions of
objects in a room

Looking at Space

Now that you have some experience with the very basics of spatial illusion, let us go on to investigate the various conceptions we have of space.

Science tells us that space is the dominant medium whether we consider the ample spaces seen from a mountaintop or the microscopic dimensions of space within each atom. Perhaps the most basic idea of space is as an expanse of "empty" air. But this fundamental conception may be experienced and interpreted in ways that fall into three broad categories: distance, area, and volume.

Standing in a Kansas wheat field and looking at a corn silo on the horizon, you will experience a sense of distance, or what we might call a one-dimensional measure of space. But, people most often experience space with boundaries of some sort. The space of your street, for instance, or by extension your town as a whole, can be thought of as a particular area of space. Each has boundaries, definite or implied, that delineate its length and width; and each is divided into space-sections by such things as city parks, buildings, and highways (note the term "subdivision" in the builders' lexicon). As an example, look at the drawing by Sidney Goodman (Fig. 1–30) where the sensation of a bounded spatial area is heightened by the row of massive and dramatically represented trees.

Two interesting variations on the themes of area and distance are provided by Figures 1–31 and 1–32. The Joan Nelson drawing makes a dramatic visual statement by contrasting the limited security of a barricaded pier-like platform in the face of a formidable expanse of ocean. The Rackstraw Downes affords an aerial view of the partitioned areas, or zones, of a modern urban landscape.

Moving down the ladder of magnitude from the Kansas wheat field and city park, our next stop is the interior space of a room. In a typical room, the space is enclosed on six sides, creating a spatial volume.

In order to develop an awareness of space as volume, you must learn to treat it as though it were a palpable substance. It may help to imagine the air in a room you occupy as tinted with a color, clouded with smoke or vapor, or replaced with a substance such as water or oil. Notice, in this regard, the density of atmosphere portrayed in the work by Elyn Zimmerman (Fig. 1–33).

The sensation of spatial volume is maximized when objects divide a space

FIGURE 1–30
SIDNEY GOODMAN
Wald Park, 1970
Charcoal, 23½ × 41¼ inches
#71.05.13

Acquisition Fund Purchase, Collection Minnesota Museum of Art, St. Paul

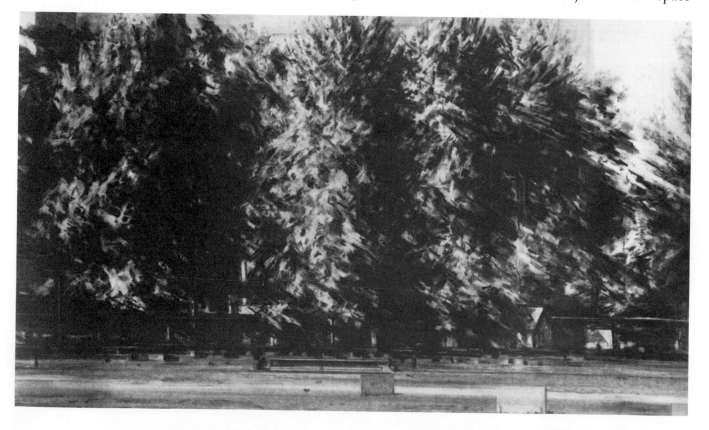

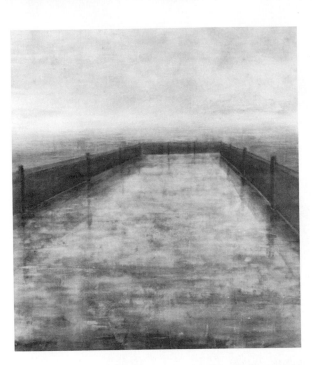

FIGURE 1–31
JOAN NELSON
Untitled, 1985
Pigment and wax on hardboard,
17 ⅞ × 15⅞ inches #3333

Solomon R. Guggenheim Museum, New York.
Exxon Corporation Purchase Award, 1985. Photo:
David Heald

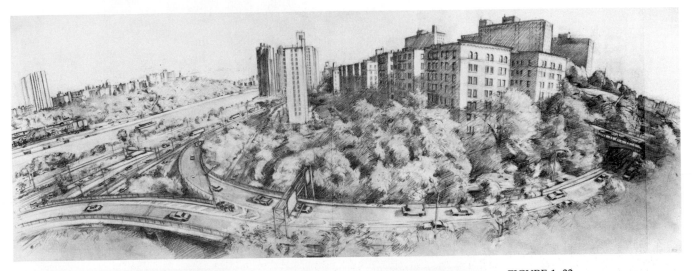

FIGURE 1–32
RACKSTRAW DOWNES
The View Looking North-West from the
Washington Bridge, 1983
Graphite on paper, 19 × 50¾
inches
Courtesy, Hirschl and Adler Modern

FIGURE 1–33
ELYN ZIMMERMAN
Untitled, 1976
Powdered graphite, 14¼ × 19¾
inches
Courtesy of the artist

FIGURE 1–34
WILLIAM WILEY
Studio Space, 1975
Acrylic and charcoal on canvas, 83
× 80¾ inches
Collection of Robert A. Rowan

into yet more visually manageable and intimate volumes. As an example, look at the drawing by William Wiley (Fig. 1–34) where the depicted volume of space is pronounced. We want to poke about in the array of spaces scaled for human activity; but, as we do so, we are simultaneously rebuked by the centrally placed square, which serves as a reminder of the picture plane.

Our experience of space as a volume need not be limited to rooms designed for personal use. The presence of monumental masses of air pressing against the architectural framework of large halls, church and theatre interiors, and the like can fill us with awe (Fig. 1–35). And this is not to say that our awareness

FIGURE 1–35
PIRANESI
Large Architectural Interior
The Pierpont Morgan Library, New York, 1959.14

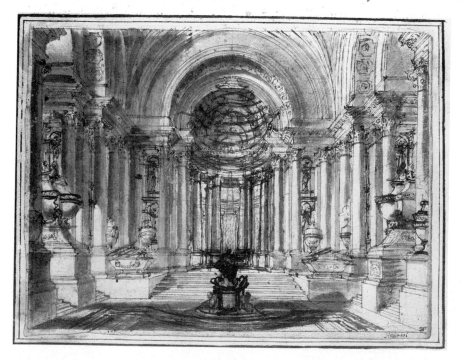

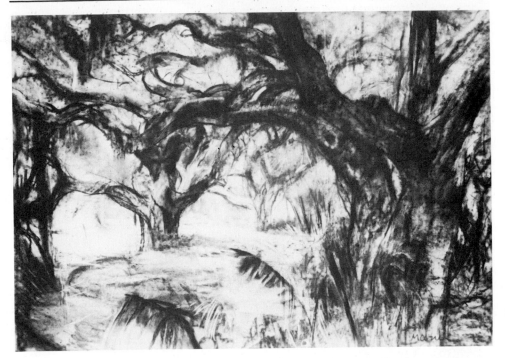

FIGURE 1–36
MICHAEL MAZUR
Untitled, 1985
Charcoal #4500, 42½ × 60 inches
Courtesy Barbara Krakow Gallery

of spatial volume cannot be stirred in an exterior setting. In Mazur's untitled landscape drawing (Fig. 1–36) a volume of space is powerfully implied in the center, formed by the arching canopy of tree branches.

We urge you to take account of the different spaces you encounter in daily life. A good, "out of the classroom" exercise is to determine whether the spaces you see may be classified by their distance, area, or volume. How about combinations? We have provided examples of area and distance combined; can you find spaces that seem poised between, let us say, area and volume?

Concentrating on spaces, instead of things, will probably mean reversing your normal visual habit. It is suggested you do this so you may intensify your awareness of space. But this sort of activity will have an even broader application, because when you shift your attention from what you are accustomed to seeing, you help yourself develop a new vocabulary of expectations and responses. This may be awkward at first, and it definitely takes practice. But it is good to break visual habits. It makes you more receptive to, and eventually eager for, the challenge of new visual perceptions.

Gesture Drawing as a Means to Capture Space

If you wish to address the essence of a set of spatial relationships with directness and immediacy, you will do a *gesture drawing*.

In general, the term gesture refers to the expressive posture of a human being. For artistic purposes, however, gestural characteristics may be interpreted from most of what we observe. For example, the nose of the helicopter in Figure 1–37 appears to point like a giant forefinger to the target below, mimicking a common human gesture.

Gesture drawing is a rapid sizing-up of the primary physical and expressive attitudes of an object or a space (Fig. 1–38). Description in the gesture drawing is limited to the essentials of a subject which are searched out intuitively. In Mark di Suvero's preliminary drawing for a sculpture (Fig. 1–39) the image has been rendered in its most simple and general aspect, and its total gesture visualized in relation to the space it will occupy.

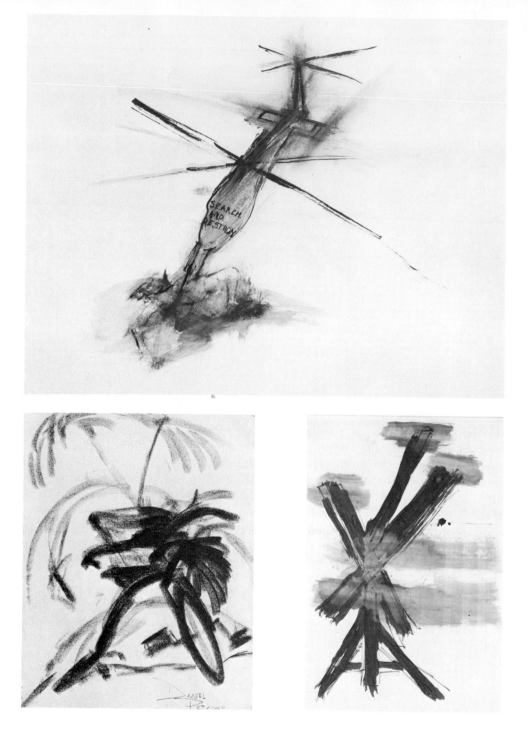

FIGURE 1–37
Nancy Spero
Search and Destroy, 1967
Gouache, ink, 24 × 36 inches
Courtesy the artist and the Josh Baer Gallery

FIGURE 1–38 (left)
Student gesture drawing of a tricycle

FIGURE 1–39 (right)
Mark di Suvero
Study for sculpture at the University of Nevada
Ink on paper, 39½ × 27½ inches
The Metropolitan Museum of Art, funds from The National Endowment for the Arts, 1978.92

Quick by definition, gesture drawing urges the artist into a frame of mind where details are ignored in favor of a subject's basic visual character. For this reason, artists often do gesture drawings to "warm-up" prior to an extended period of work.

Gestural exploration may also serve as the basis for a drawing that is meant to be developed into a finished work.* But, regardless of how gesture drawing is used by the artist, it is not, in itself, usually accorded the status of a "product," or final artwork. Instead, the emphasis is on process—a process of search and discovery wherein immediate visual experiences are translated into the medium of drawing.

The more specific term, *spatial gesture*, may be defined as the gestural movement implied by an imagined linkage of objects distributed in space. This approach may be seen in the drawing by Piet Mondrian (Fig. 1–40) where the sweeping, full-page gestures forego detailed description so as to capture the

*For information about the relationship of gesture drawing to design see Chapter 4.

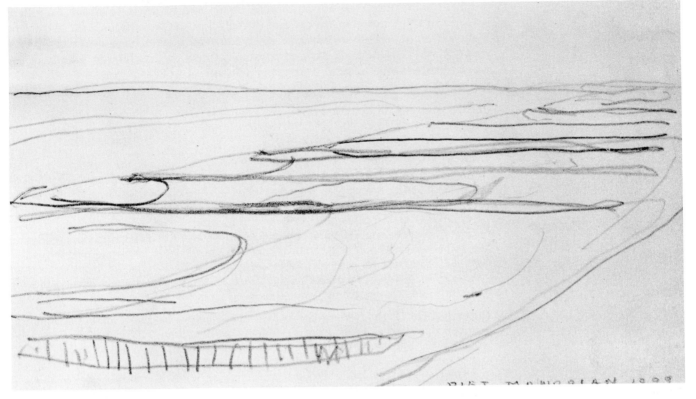

FIGURE 1–40
PIET MONDRIAN (1872–1944)
Dunes and Sea, 1909
Pencil, 10.2 × 17.1 inches
© *Estate of Piet Mondrian/VAGA, New York, 1989*

spatial essence of the subject. In Giacometti's drawing (Fig. 1–41), a network of spatial linkages is created by lines that career from one point to another in the depicted interior setting.

Seeing in terms of spatial gesture will take practice. Let us suppose that you are in a room that is filled with objects. In order to see a gesture in this room, let your attention bounce around from object to object. You may be immediately struck by a spatial relationship among some of these objects. You

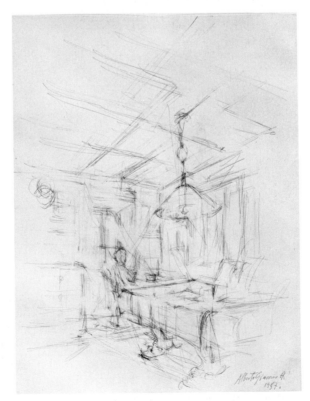

FIGURE 1–41
ALBERTO GIACOMETTI
Interior, 1957
Pencil on paper, 35¾ × 19¾ inches
*Solomon R. Guggenheim Museum, New York,
photographer Robert E. Mates*

might, for instance, see how a bicycle, chair, and birdcage form an arc when viewed in sequence across a portion of the room. Now, although these objects have different names and uses in everyday reality, you have found a way to group them. You have discovered a visual connection that hinges entirely upon your personal organization of the space in the room before you.

Exercise 1C *The two drawings suggested in this exercise ask you to concentrate upon a particular linkage of objects in a room. The purpose is to heighten your awareness of how space may appear to gesturally unfold.*

__Drawing 1.__ From your easel or drawing table, choose a path through the objects in the room space before you. Take your drawing tool and recreate that path on your paper using a simple meandering line. It is advisable to look as much out at the space which you are trying to represent and as little at your paper as possible. (Line drawings made without looking at the paper are frequently referred to as blind-contour drawings.)

As you draw, you should be convinced that you are steering your line into the space. Use sound effects as you (SQUEAL!) veer around one object to get to the next; or as you (GRUNT!) have to make several hard passes with your drawing media to get beyond an "obstacle" that is especially large, heavy, or dark in color (as in Fig. 1–42 in which a gathering of marks around a central form indicates the weight and solidity of its mass).

__Drawing 2.__ Do a second gesture drawing using the same spatial route. But this time look at your paper and make an even more varied set of marks to express the character of what you see along this path and the feelings that are aroused in you as you proceed.

Work quickly, but be alert to the need for exerting differing pressures on your media to suggest weight, scale, and speed changes along your journey. Remember that by thinking of objects as things that slow down and divert your course through space, you will naturally become more aware of the space between these objects.

When you are finished, the expressiveness of these drawings might surprise you. But think of the personal decisions you had to make during the process. First you singled out objects that divided the space in an interesting way, and then you had to choose what kind of marks would best express the responses you had as your eye followed along your selected path.

FIGURE 1–42
IDA KOHLMEYER
Tokens of Identity #4, 1981
Mixed media on canvas, 64½ × 65 inches
Courtesy of the artist, photo by Charles Wolff III

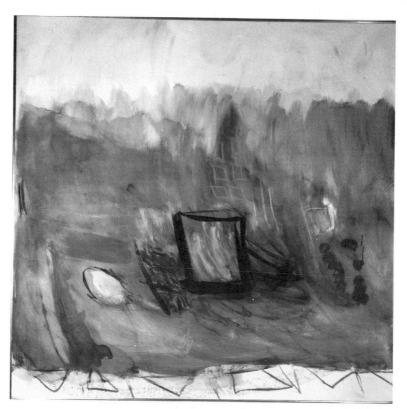

2

The Two-Dimensional Space of a Drawing

In Chapter 1 we explored ways to create the pictorial illusion of three-dimensional space. The picture plane in this case was conceived as a window on nature. We also considered that the second definition of the term picture plane is the flat surface upon which a drawing is made. That flat surface, usually a sheet of paper, represents the *actual* space of your drawing.

More specifically, this actual space of your drawing is two-dimensional. It is the *area* of your drawing, the product of the length times the width of your paper. And it is a space limited to your paper's surface and bounded by its edges.

So, flatness of surface is the fundamental property that will link all the drawings you make. Indeed, even when you are concerned primarily with depicting an illusion of three-dimensional space, you will also need to consider how best to layout or divide the area of your page. This chapter stresses the primacy of the flat picture plane and introduces ways to address its two-dimensional space.

Two-Dimensional Space and Modern Art

Many twentieth century artists have emphasized the actual, two-dimensional space of their picture plane over its potential for three-dimensional illusion. Wishing to avoid what might be termed the "artificial" nature of illusionistic space, these artists have exploited the flat character of the drawing surface with the intention of "preserving the integrity" of the picture plane (Fig. 2–1).

Other artists have chosen to extend their images *out* from the picture plane into the spectator's space. Collage, assemblage, and relief (Fig. 2–2) are some of the ways artists have opted to incorporate the space in front of the picture plane into their two-dimensional art forms.

FIGURE 2–1
ROY LICHTENSTEIN
Electric Seascape #1, 1966
Collage on paper, 22 × 28 inches
#2528

*Solomon R. Guggenheim Museum, New York. Gift
Mrs. Louis Sosland, photographer Robert E. Mates*

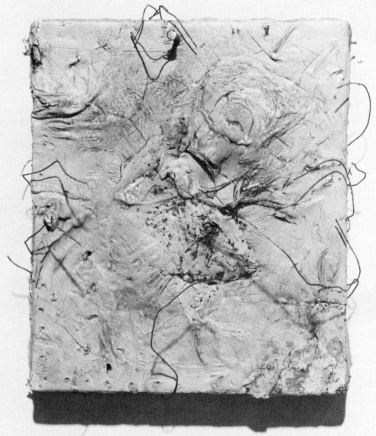

FIGURE 2–2
BRUCE CONNER
Untitled
Mixed media (oil, wire, nail) on
canvas, 9¾ × 8⅛ inches

*Solomon R. Guggenheim Museum, New York. Gift,
James J. Hanafy, photographers Robert E. Mates and
Mary Donlon*

Later in this chapter we will discuss other ways in which modern artists have asserted the integrity of the flat picture plane,* but first we must define more fully the two-dimensional character of a drawing. We begin by emphasizing the shape of the surface upon which we draw.

*See the discussion, "Ambiguous Space," in this chapter.

The Shape of Our Drawing

The paper we draw on has a shape. (By "shape" we mean a flat area with a particular outer edge, or boundary.) Since our paper is itself a flat shape, it follows that any image we draw on it will be, first and foremost, a shape. Let us take, for example, the drawing of a banana flower by Georgia O'Keeffe (Fig. 2–3a). It looks quite "real," suspended in space and thrown into relief by strong lighting. And yet, common sense tells us that a banana flower does not really exist on that page. Instead, we respond to a drawn image of that object; an image that is convincingly modeled with charcoal to look round, but is, nevertheless, in its truest physical definition a flat shape.

Positive and Negative Shape

From an artistic standpoint, subjects in the real world consist of two basic realities: The *positive forms* of objects, and the *negative spaces* surrounding these forms or contained by them (such as the space between the handle and body of a coffee cup).

When you draw, the positive forms and negative spaces of your subject are converted into their pictorial counterparts on a flat surface: *positive* and *negative shapes*. To clarify this, let us look at Figure 2–3b (in which we have reduced the drawing by Georgia O'Keeffe to its simplest shape state), and consider the following two points:

1. The entire rectangular surface of the O'Keeffe drawing is divided into two distinct shape areas: No. 1 (positive shape) and No. 2 (negative shape);

2. The illusion of the banana flower as a positive, sculptural volume and the space that surrounds it occur within the actual shape divisions of the flat picture plane.

In truth, then, whenever we represent an object or a space on our page we are creating a shape. And the first shape that is made automatically creates one or more additional shapes from the area of our drawing sheet. These shapes are designated as either positive or negative.

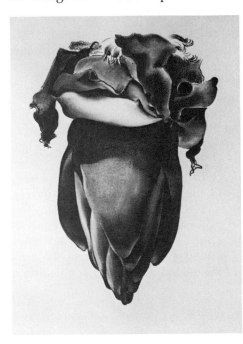

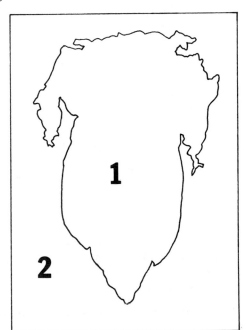

FIGURE 2–3a (left)
GEORGIA O'KEEFFE
Banana Flower, 1933
Charcoal, 21¾ × 14¾ inches
Collection, The Museum of Modern Art, New York. Given anonymously (by exchange)

FIGURE 2–3b (right)

Implications of the Term Negative Shape

Implications connected with the term negative shape may interfere with an appreciation of positive and negative relationships in a drawing. Unfortunately, negative shapes are sometimes defined as the empty, or passive areas of a picture that remain after the positive image has been drawn. This may lead students to believe that negative shapes are somehow "second-class" and thus do not require the attention given to positive areas.

A related problem is the tendency for students to label as "background" all the areas of their drawing that lack prominent object symbols.* Referred to in this way, background really means "backdrop," or the subsidiary part of a drawing against which the positive image stands out. This tendency is due in large part to the material conditioning of our culture; those things we can name usually take precedence in our minds.

But negative shapes aren't simply a backdrop, or what's left over when a positive image is drawn. *They are an integral part of a drawing.* Enlarging upon this, consider that when you begin a drawing the *entire* shaped area of your empty sheet of paper is important. So it follows that *all* the shapes resulting from a division of that surface are also important and deserving of careful attention.

Each time you draw a positive shape on your page, you are simultaneously shaping the negative areas of your drawing. This means that positive and negative shapes have an immediate and reciprocal influence on one another. Therefore, any approach that neglects the negative shapes of a drawing will flaw the wholeness of a work and its expression. It will also limit your ability to take advantage of the total visual potential in both your subject, and its translation onto a sheet of drawing paper. In view of all this, we are inclined to say that decisions about how best to break up the surface of your picture plane into positive and negative shapes are among the most creative of the drawing process.

Accentuating the Positive or the Negative

Summarizing what we have established thus far in Chapter 2, we know that our drawing surface is flat and that all parts of our image, regardless of how convincingly they are modeled as volumes, are most essentially shapes. Thus, we may conclude that the substance of a drawing is crucially linked to the quality of its positive and negative shapes.

Further, each of the shapes you make in a drawing exist apart from the forms and spaces they portray. So, a positive shape that represents something we recognize from the natural world is not inherently more important than a negative shape that stands for an uninhabited plane or space. The way shapes *do* derive their level of importance in a drawing is from the specific artistic treatment they receive.

Let us look at a second banana flower by Georgia O'Keeffe (Fig. 2–4). Here, the major emphasis is on the positive image of the flower, but the surrounding negative areas are not merely residual. They act as a buffer zone to contain the gestural energy of the positive shape. And note that the tension between the positive and negative areas extends to the edges of the paper, making them insistent wherever you scan the drawing. Further, at several junctures the positive shape is open, admitting the surrounding negative area and suggesting a union between the two.

*The term background as used here is not to be confused with its spatial application in Chapter 1, where it was grouped with the terms foreground and middleground.

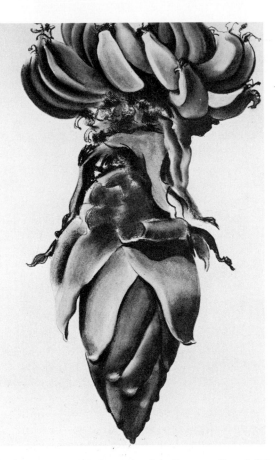

FIGURE 2–4
GEORGIA O'KEEFFE
Banana Plant, No. 4
Charcoal on paper, 21½ × 14⅜
inches
Collection, Carl E. Hiller

In the pastel drawing by George Segal (Fig. 2–5), it is the negative shape that presses for our attention. Thus, Segal heightens viewer fascination by providing what is least expected: a negative, "empty" shape occupying the central portion of the drawing, which is typically reserved for positive shapes.

FIGURE 2–5
GEORGE SEGAL
1965–4
Conte on Newsprint, 18 × 24
inches
Courtesy, Sidney Janis Gallery, New York

FIGURE 2–6
Constantin Brancusi
View of the Artist's Studio, 1918
Gouache and pencil, 13 × 16¼
inches
Collection of The Museum of Modern Art, New York, the Joan and Lester Avnet Collection

Exercise 2A

As we have indicated in this chapter, many of us are so accustomed to looking at positive forms that negative spaces often go unnoticed. And yet, by virtue of their unpredictability, the negative spaces of a subject can have greater visual and expressive potential than their positive counterparts (Fig. 2–6). By isolating them for interpretation as flat shapes, this exercise will heighten your awareness of the "hidden" resources of negative spaces.

Select some objects that have distinct negative spaces. Ladders, chairs, stools, tires, and the like make ideal subjects for this kind of drawing. Jumble and overlap these items so as to maximize the number and variety of negative spaces. If you turn some of these objects upside down you will find it generally easier to ignore their real world function and concentrate instead on their shape potential. Negative spaces may also be accentuated by keeping the room light low while turning a strong spotlight on the setup.

Next, find a viewpoint that offers the best assortment of negative spaces and translate them into darkly toned shapes on your drawing paper. Avoid using an outline to describe these shapes; instead, select media that come in a block form (such as lecturer's chalk, compressed charcoal, or a graphite stick) and draw the negative shapes by applying broad, vigorous strokes.

Exercise 2B

This project will teach you to grasp at once the visual wholeness of positive and negative shapes. Indeed, while doing this exercise you will find the outer limits and enclosed spaces of things more palpable to you, an experience which will rival that of a potter's when raising the walls of a clay vessel at the wheel.

Select two pieces of chalk or crayon of different colors. Set up a still life that consists of a good number of medium-sized objects. No special lighting is required.

Find a point on one of the objects in the still life. Holding pieces of chalk or crayon in both hands, begin drawing the object starting at that selected point. With your hands going in opposite directions, trace around the shape of the object until the lines rejoin. Now move to an adjacent object or space, keeping the colors in the same hands. Draw this second shape in the same way. In so doing, you will be redrawing, but with a different color, the boundary shared by the two shapes.

Try to draw the shape as honestly as possible, and do not worry if the redrawn line does not conform exactly to the original. Continue this process until all the objects and spaces of your subject are represented in your drawing.

Ambiguous Space

At the beginning of this chapter we indicated that many modern artists have deemphasized (or rejected entirely) the illusion of three-dimensional space, wishing instead to accentuate the two-dimensional character of pictorial art (Figs. 2–1 and 2–2). This does not mean to imply, however, that these artists abandoned spatial interplay in their work, but rather that they wished to achieve the sensation of space while maintaining for the viewer a firm awareness of the flat picture plane.

One of the most enduring ways for modern artists to accomplish this seeming contradiction of space and flatness in pictorial art is by creating what is often referred to as *ambiguous space*. Ambiguous space may be described as a visual phenomenon wherein the spatial relationships between positive and negative shapes are rendered perceptually unstable or uncertain. To clarify this description we turn now to a discussion of three kinds of ambiguous space: interspace, positive–negative reversal, and figure–ground shift.

INTERSPACE

The term *interspace* is sometimes considered synonymous with negative space, but in the work of many modern artists it is more appropriately defined as a subtle combination of negative shape and the illusion of positive form. To reinforce this concept, let us look at a watercolor and pencil landscape by Paul Cezanne (Fig. 2–7).

Can you detect in this work that each of the negative interstices appears to be a slightly rounded plane (think of a contact lens) through which the hints of space and atmosphere are seen?

To understand how Cezanne achieved this effect, allow your eyes to follow the contours that mutually describe tree forms and negative areas. Note that these contours vary in their sharpness and light and dark tonalities. This fluctuation in edge conveys the impression of negative planes that are alternately raised or lowered in relation to the cylindrical tree forms (the sharper darks may be seen as shadows cast on the more positive tree forms by the shallow warp of the negative shape).

FIGURE 2–7
PAUL CEZANNE (1839–1906)
Le Grande Arbre
Pencil and watercolor, 12 × 18⅛ inches
The Metropolitan Museum of Art, bequest of Theodore Rousseau, 1974, jointly owned with the Fogg Art Museum, Harvard University

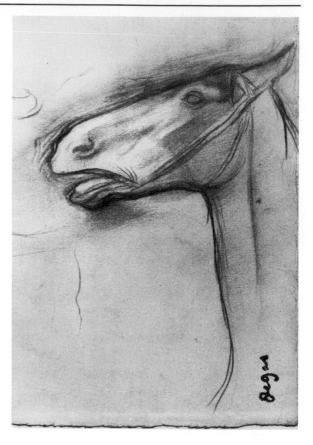

FIGURE 2–8
EDGAR DEGAS (1834–1917)
Head of a Horse
Pencil on paper, 6⁹⁄₁₆ × 4¾ inches
The Metropolitan Museum of Art, gift of A.E. Gallatin, 1923

So, Cezanne provides enough visual clues in his treatment of the negative areas to give them the barest suggestion of volume. Although they do not compete with the more concrete tree parts, they are, nonetheless, more full than "empty" negative spaces are often deemed to be.

In other words, we have a *tactile* response to the areas of interspace in the Cezanne; that is, our visual reading of the negative shapes is influenced by how, in our mind's eye, those slightly curved surfaces would feel to the touch (think of buckled puzzle pieces). And, by calling attention to the negative areas as *shapes*, Cezanne also reaffirmed the expanse of the flat picture plane.

Thus the term interspace implies that instead of being merely flat and "passive," negative shapes may in fact be given a suggestion of volume and thereby assume a more "active" role in the spatial illusion of a two-dimensional work of art. Note in this regard, the drawing by Degas (Fig. 2–8) in which the negative area appears to swell and push against the horse's chin and down its neck, as if it were a "cushion," to effectively bolster the quivering presence of the head.

POSITIVE–NEGATIVE REVERSAL

Ambiguous spatial relationships may also be achieved through *positive–negative reversals*, or when shapes in a drawing alternate between positive and negative identities. These alternations make the artifice of illusion more apparent and thereby acknowledge the presence of the work's actual two-dimensional surface. A good example of positive–negative reversal can be found in Figure 2–9, where at first glance the white shapes may appear to be positive "islands" floating forward against a dark ground. But stare at the central black zone for a moment and the reverse begins to happen: the black, formerly negative shape emerges as a positive "presence," and the white shapes seem to drop back like the sides of a box. What we may conclude from this is that either the black or the white shapes in Figure 2–9 may be understood as positive or negative according to viewer perception.

FIGURE 2–9
DONALD SULTAN
Menorca, August 17, 1978
Ink and graphite on paper, 12⅛ ×
12⅛ inches #3196
*Solomon R. Guggenheim Museum, New York. Gift,
Norman Dubrow, photographer David Heald*

This phenomenon may also be used to great effect in drawings which feature some level of representation. Look, for instance, at how the two dark shapes at the top of Figure 2–10 may be read as either positive cloud-like images on a gray ground, or as negative cavities representing eyes on a face. The reversal of the righthand shape is especially apparent; it seems to change its positive–negative identities continually. This is because one end of this shape coincides with the edge of the format, which heightens our variable reading of it as either an area drawn on the paper surface or the illusion of a shape cut out from that surface.

FIGURE 2–10
SIGMAR POLKE
Physiognomy with Car, 1966
Ball-point pen and gouache, 11⅝ ×
8¼ inches
*Collection, The Museum of Modern Art, New York.
Gift of the Cosmopolitan Arts Foundation*

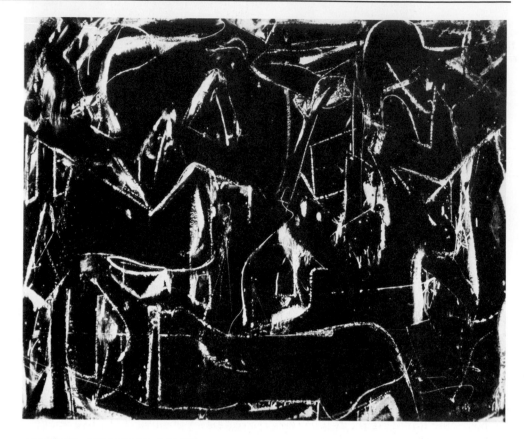

FIGURE 2–11
WILLEM DE KOONING
Dark Pond, 1947
Oil on composition board, 46½ ×
55½ inches
From the collection of the Frederick Weisman Company

FIGURE–GROUND SHIFT

The two previous topics have indicated ways in which individual shapes in a drawing may have two different identities. This may happen either simultaneously (as in the case of interspace) or alternately (as in the case of positive–negative reversals). A third type of spatial ambiguity aggressively combines aspects of both interspace and positive–negative reversals. It is commonly known as *figure–ground shift*.

Figure–ground shift occurs when all or most of the shapes in an image are given a suggestion of volume, and when virtually all the shapes appear to be constantly shifting, or slipping in and out of positive (figure) and negative (ground) identities.

In large part, figure–ground shift is the result of concentrating on the edges of shapes in a pictorial work of art. Varying the tone, thickness, and speed of edges can impart a positive, or figurative, weight to all the shapes in an image. And by making different portions of edges dip and rise, these variations also create an intricate webbing of overlaps which reinforces the physical existence of the flat picture plane. Consider, for example, the work entitled "Dark Pond" by Willem de Kooning (Fig. 2–11), where each of the shapes interlock, with edges that twist back and then forward, to create complicated spatial puzzles that the viewer cannot rationalize or solve.

Exercise 2C *This project builds on exercise 2B where you drew with two hands. That activity should have enabled you to "feel" how positive forms and negative spaces are integrated to create the overall impression you have of your subject.*

Armed with this experience, do a more finished drawing of a still life, where selected positive and negative areas clearly interlock to form the entirety of your two-dimensional image. You may also want to experiment with the concept of interspace by manipulating the contours of certain negative shapes, as in Figure 2–12 where, for example, the white shape in the upper righthand corner appears to have enough volume and weight to exert considerable downward pressure.

FIGURE 2–12
Student drawing incorporating
ambiguous space

3

Shape, Proportion, and Layout

In drawing from nature you will be concerned with questions of proportion on several different levels. Perhaps foremost in your mind will be the problem of drawing your *subject* in proportion, by which we mean that you will want to observe and record correctly the relative sizes among the parts of your subject and the relationship of the parts to the whole. This problem will be the focus for the first half of Chapter 3.

The second half of this chapter is devoted to the question of the proportional relationships *within the work of art itself*. In the most general terms, this entails how you choose to divide the two-dimensional surface of your drawing. Because these decisions are personal, they will have a great impact upon the expressive value of your drawing. Luckily, the same strategies for objectively observing proportion in your subject may be extended to aid you in the more subjective activity of determining the proportional relationships of your drawing as a whole.

Drawing in Proportion

Any subject you draw will have proportional relationships. If the subject is a familiar one, such as a human figure, it is likely you will be able to tell when it is incorrectly drawn. In such cases you may be able to correct the drawing using an educated guess, but in the vast majority of situations you will not have had sufficient familiarity with your subject to allow you to make intuitive judgments about its proportions.

Because artists since the Renaissance have been primarily concerned with depicting the *appearances* of their subjects, they have invented ways of using the picture plane to aid them in accurately measuring proportion. This chapter will provide you with a number of devices, some traditional and others new, that will enable you to better judge the proportions of things as you see them.

Shape and Proportion

Take a moment and look at some common object before you. Notice the main shapes that comprise the object and their proportions, or relative sizes to one another. Now change your position and you will find that those shapes have

FIGURE 3–1
LEONARDO DA VINCI
*Study of Human Proportions
According to Vitruvius*, 1485–1490
Pen and ink
Courtesy Art Resource

changed right along with you. Clearly then, each time you alter your position in relation to any object other than a sphere, you will be presented with a new set of shapes and proportions. And in only a few views of a subject will the proportions of its shapes as seen correspond to that subject's *actual*, measurable proportions.

To better understand this, compare the drawing by Leonardo da Vinci (Fig. 3–1) with a painting by Mantegna (Fig. 3–2a). In the da Vinci, the figure is positioned so that its relative height and width may be easily judged. However, in the work by Mantegna, the relative dimensions of the shape of the figure do

FIGURE 3–2a
ANDREA MANTEGNA
Dead Christ
Art Resource

FIGURE 3–2b

not match with those of the subject's real dimensions, since the vertical dimension of the shape is only slightly longer than its horizontal measurement. This may be seen quickly when the human attributes of the figure are masked out, as in Figure 3–2b.

Shape and Foreshortening

When an object is situated so that its longest dimension is parallel to the picture plane, as in the da Vinci drawing, the object is seen in its unforeshortened view. When the longest dimension of the object is at an angle to the picture plane, the object is said to be foreshortened. In the Mantegna, the longest dimension of the body is almost perpendicular (at a right angle) to the picture plane, making it an example of extreme foreshortening.

Da Vinci's figure, comfortably circumscribed by circle and square, is not in conflict with the two-dimensional space of the page. In this case the representation of the figure does not demand that we become involved with pictorial space. Mantegna, on the other hand, pushes this demand almost to its limit. The peculiar shape of the figure lets us know that we are seeing a body extended into space. And at the same time that we are made to acknowledge this deep fictive space, we may also become aware of the compression of the figure into a flat shape on the picture plane.

Herein lies the paradox of shape. It is in itself flat. Yet when we try to reconcile the peculiarities of its proportions with those of the object it represents, it becomes a powerful indicator of that object's spatial disposition in relation to us.

So, when an image of an object is projected onto the picture plane, it becomes a shape. This shape has measurable proportions within itself. And as a unit of area on the picture plane, it may be compared in size to other shapes and to the shape of the whole page. Therefore, whenever you have difficulty seeing an object's proportions relative to itself, or to its surroundings, it is helpful to ignore its three-dimensional character and concentrate instead on studying its shape.

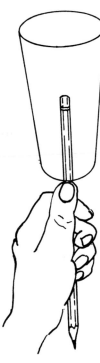

FIGURE 3–3

Measuring with Your Pencil

Measuring with your pencil will assist you in seeing the proportions of a particular shape. To measure with your pencil, look at the shape of the object you wish to draw, and decide which are the longest and the shortest of its dimensions, or axes. You will then proceed to determine how many times the smaller dimension of the shape goes into its larger dimension by following the steps demonstrated in Figure 3–3.

This procedure may be used to compare any measurements in your drawing. The accuracy of the procedure depends upon maintaining the pencil at a constant distance from your eyes (full arm's length is advised) and upon keeping the pencil parallel to your imaginary picture plane.*

*See ''The Picture Plane'' in Chapter 1.

Using the Viewfinder to See Proportion

A viewfinder may be simply described as a framed opening through which you may view a selected portion of the visual field in front of you. More than likely you have already had the experience of looking into the viewfinder of a camera in order to anticipate how your subject will look in the photograph.

When you are making a drawing a viewfinder is helpful in selecting the exact subject you wish to draw because the shape of the viewfinder corresponds to the shape, or format, of your drawing paper. In discussing a drawing, therefore, the word *format* is used to describe the total shape and size of the drawing surface.

You can make a viewfinder by cutting a window in a piece of lightweight cardboard. The proportions of this opening should correspond to the format of your paper. As an example, if the dimensions of your paper are eighteen inches by twenty–four inches, the ratio of the sides of the viewfinder window will be three to four, and the opening that you cut in your cardboard will be three inches by four inches (Fig. 3–4).

You will probably find the viewfinder an invaluable aid when it comes to observing proportion, largely because it will enable you to instantly recognize the shapes inherent to your subject. This is because the (usually rectangular) opening of the viewfinder itself will impress you as a strong shape, encouraging you to readily perceive the objects seen framed within the opening as smaller shape divisions of the whole.

When using a viewfinder, imagine that its format edges match exactly the edges of your drawing paper. Then draw the shape of your subject so that it fills the page in the same way the image fills the viewfinder. It is helpful to pay special attention to the negative shapes lying between the subject's outer edge and the boundaries of the viewfinder because you may find it easier to judge the proportion of these abstract shapes than the shapes of nameable objects.

For the sake of greater accuracy, some students prefer to use a gridded viewfinder. This can be made by punching holes into the margins of the viewfinder at equal intervals and running thread from one side to the other, forming a grid. If you place the holes at one inch intervals in a three-inch/by/four-inch

FIGURE 3–4

FIGURE 3–5a

FIGURE 3–5b

opening, you will divide the opening into twelve one-inch squares (Fig. 3–5a). To use this viewfinder effectively you should also divide your eighteen-by twenty-four inch-paper into twelve squares (each six inches square). What appears in each square of the viewfinder can be transferred to the corresponding square on your drawing.

A simpler alternative is to divide your viewfinder into only four rectangles. This will keep you aware of how your composition is centered without requiring that you painstakingly copy exactly what you see in the grid (Fig. 3–5b).

Spatial Configurations

Thus far in this chapter we have been discussing how seeing objects as flat shapes can aid you in drawing things in correct proportion. However, this process may also be applied to help you see proportional relationships between

various points in the spatial field before you. By this we mean that selected points on objects and surfaces distributed through a space when connected, will make up a distinctive shape.

The best analogy to this activity is the practice of looking at and naming constellations. Constellations of stars are actually three-dimensional configurations. In other words, the stars making up a constellation are located at various distances from the earth, and the difference between these distances may be measured in thousands of light years. But we are generally unaware of the vast depth discrepancy between stellar positions in the deep space of the universe, and consequently we perceive the apparent groupings of stars as flat shapes. So when we see the shape of a big dipper or a scorpion in the night sky, we are actually seeing the *shape aspect** of a configuration of points in very deep space.

Exercise 3A *The following exercise will help you see and measure proportions between points in a spatial field. It asks you to design and then draw your own constellation using a series of objects arranged in space. In addition to your drawing materials, you will need a ball of heavy string and a viewfinder.*

Using a continuous length of string, link up a dozen or so widely spaced points in a room, attaching the string to furniture, doorknobs, window-lock, and so forth. As you proceed to connect points in space, survey the configuration you are making from various vantage points; try to arrange the string so that it appears from some angles to enclose one or more shapes.

Now, choose several viewpoints from which the string armature takes on a strong identity. Make studies of the proportions and the spatial position of the shapes from each viewpoint. Do a finished drawing of the setup (including the string) from the vantage point that has the most dynamic configuration. Use the viewfinder to aid you in adjusting your proportions, paying special attention to the angles of the string and how they depart from the verticals and horizontals of your viewfinder edge.

Angling and the Picture Plane

Our environment is full of horizontal and vertical lines. Linear elements from the environment that are vertical will almost always appear as verticals on your picture plane. But linear elements that are horizontal (such as window sills, baseboards, and so forth) will often appear as diagonals on your picture plane. In order to transfer the angle seen in the environment to the drawing surface, we use a technique called *angling*.

We have broken down the angling procedure into the following steps:

Step 1. Stand at about arm's length from your easel. If you are righthanded, position your easel so that you are looking at your subject past the left margin of your page.

Step 2. Face your subject. Now imagine that there is a pane of glass at about arm's length in front of you. Grasping the pencil between thumb and fingers, run the pencil up and down in order to get the feel of this imaginary plane.

Step 3. Single out some item in the room that has a vertical line (such as a doorjamb). Still keeping your pencil pressed against the "glass," align it with the vertical line of the doorjamb. Now single out a line that is not vertical, such as one formed by the juncture of the ceiling and the wall. Pivot your pencil on the imaginary pane so that it is lined up with that diagonal (or horizontal). Practice aligning your pencil with various linear elements in your environment *taking care not to point through (or into) the imaginary pane of glass.*

*By "shape aspect" we mean the shape of something seen from any one vantage point.

Step 4. Station yourself at the easel. Choose one of the lines you have just practiced angling. Now swing your arm to your paper, keeping the angle of the pencil constant. Lay the pencil against the paper and draw a line parallel to it.

Step 5. Check the angle by repeating the process until the angle comes out the same each time.

ANGLING BETWEEN SPATIAL POINTS

The method just described for angling linear elements in your subject may also be used to measure the degree of angle formed by any two points in your visual field.

First, select two easily distinguished points in the space before you (such as, the corner of a table and the center of a clock). Next, angle these two points with your pencil (taking care not to point through the picture plane) and transfer that angle on to your drawing.

TRIANGULATION

Angling between a set of three points on the picture plane can be an invaluable aid in correctly positioning your overall image on the page. To triangulate, you will angle first between two points and then angle from these two points in order to locate the third.

The procedure for triangulation is outlined in Fig. 3–6. When you have followed this procedure, and if you have angled accurately, you will have established three widely spaced points in your drawing. You may then proceed to find other points in your picture by angling from any two points already determined.

TIPS ON TRIANGULATION

1. Always look for the largest possible triangle of points within your subject matter. The closer the points come to filling up your format the more valuable the triangle will be in setting up your entire image.

2. Always try to find a roughly equilateral triangle. If your triangle is made of obtuse and very acute angles, any error in your angling will throw off your proportions. If all legs of the triangle are about the same length, a slight miscalculation of angle will not make much difference.

3. If your pencil is not long enough to angle between the two desired points, you have two options: (a) Find something longer to angle with, such as a ruler or yardstick; (b) Hold the pencil closer to your eyes.

4. If you have great difficulty in picking up the technique of angling, try using the edge of a broad ruler or plastic triangle in lieu of a pencil. The plane of the ruler or triangle will remind you where your picture plane is so that you will have less of a tendency to point through it.

Advice on the Use of Proportioning Techniques

All the devices introduced in this chapter require that you make conscious use of shape and the picture plane to arrive at correct proportions.

In many circumstances the viewfinder will be the first proportioning device to which you will turn. Not only can it help you to select that part of your subject that you wish to draw, but its use will enable you to quickly lay out the

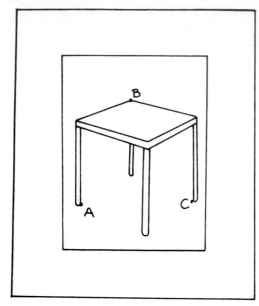

a. Look at the subject through a viewfinder and select three points that roughly comprise an equilateral triangle.

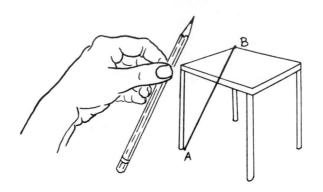

b. With your pencil angle between A and B. Record this angle and mark the points.

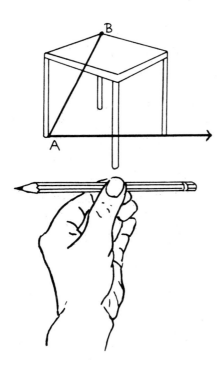

c. Now record the angle that goes from A through C. Extend the line from A beyond where you think C is located.

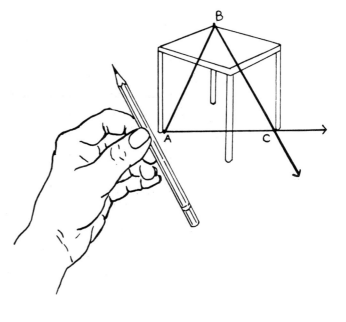

d. Record the angle from B through C. Where this line intersects the previous one is the location of point C.

FIGURE 3–6

overall proportions of your subject on your page. With the information you gather from observing the way in which the shapes of objects fill up the opening of your viewfinder, you will be able to sketch in the skeletal structure of your drawing before concerning yourself with any fixed measurement.

Your second recourse should be triangulation, the method used to fix the larger relationships between spatial points. It is a speedy and accurate way to proportion the overall image of your drawing. For more localized measurements, you may use the techniques of angling and measuring with your pencil.

Measuring with your pencil on the picture plane will give you a sense of the proportions of any individual shape you see and may also be used to determine the relative dimensions of separate shapes.

Although an overdependence on these mechanical devices could result in drawings that look stilted, the procedures described are beneficial beyond their immediate use for plotting proportions more accurately. First of all, they sensitize you to the presence of the picture plane. Secondly, these techniques will, through repeated use, become internalized, so that eventually you will begin to see shape relationships without actually having to go through the motions of angling, measuring, and so forth.

And anytime in the future when you are perplexed because a subject is unusual or overwhelming, you may be helped by recourse to one or more of these proportioning devices.

Laying Out Your Drawing

The basic arrangement of the parts of an image within a two-dimensional format is referred to as the *layout* of a drawing. However, before you lay out the basic blueprint of your drawing it is crucial that you spend some time considering the expressive potential of your subject.

EXPLORING THE VISUAL POTENTIAL OF YOUR SUBJECT

Because almost any subject you choose to draw will yield a variety of shapes when regarded from different points of view, it is generally advisable to explore your subject's visual potential before you begin to lay out your drawing. Spend some time moving around your subject, sizing it up from various vantage points and generally experiencing how different orientations provide different visual aspects of the same source material.

Avoid the all too common practice of taking the same seat or easel each time you enter the classroom and then remaining there as if anchored. On the face of it, this practice may seem harmless enough, but it amounts to allowing chance to determine what you will draw.

So, as a beginner, you must consciously take the initiative to find a meaningful approach to your subject matter. And remember that the drawing process really begins as you look at your subject to see and weigh the aesthetic possibilities it offers. This process of personal exploration is vital because you will gain a sense of control over what may be a complex situation; your ambitions for your drawing will be more clearly formulated; and you will feel that whatever point of view you ultimately take is unique and special, and furthermore, is one you have chosen for its expressive potential.

PROPORTION AND LAYOUT

Until now we have been discussing proportion in terms of correctly observing and recording the size relationships within your subject. However, proportion will also become an issue when you as an artist must decide how best to subdivide the surface area of your drawing.

Artists usually lay out, or sketch in, the major shape divisions of their drawing before working on any one area. But even before you put down the first mark, you are faced with the overall proportional relationship of your drawing surface, namely the ratio of its length to its width. In standard drawing pads the ratio of length to width is often three to four. But you do not have to accept the ratio dictated by the manufacturers of your pad. If you wish a particular drawing to have a square format (or a circular, triangular, or cruciform format, for that matter) you may either cut and piece your paper to the desired

shape, or even more simply, draw the new format border within the paper you have at hand.

Before you begin to draw you should also decide how to turn your pad so that it is best suited for drawing your subject. Because the standard pad is usually bound along one of its smaller sides, many students automatically set the pad with the bound side uppermost, so that the paper will not flop over. When the pad is in this position, with its longer dimension vertical, the student is using a *vertical format*. Turn the pad ninety degrees, and you have a *horizontal format*. (If you customarily stand your pad at a bench or easel and wish to leave your paper in the pad while using a horizontal format, you may use clips to keep the paper from falling forward.)

SCALING THE IMAGE TO THE FORMAT

A major consideration of layout and proportion is how large you should draw a subject in relation to your page.

Some students have the problem of drawing a subject so large that it will not fit comfortably on their paper. But a far more common problem, especially amongst beginners, is that of drawing a subject so small that it resembles an island floating in the middle of the page. Aside from looking timid, such drawings suffer from a lack of illusionistic depth, since the drawn image in this case will read as a single figure in an unspecified ground. And the overall surfaces of these drawings remain visually inactive as there is little or no tension between the drawn image and the edges of the format.

The process of adjusting the size of what you draw to the size of your page is called "scaling the image to the format." If you have difficulty scaling your image to your format consider using the proportioning devices we introduced earlier in this chapter.

When using triangulation as an aid in scaling your image to the format, choose three points from your subject which form an approximate equilateral triangle, and then proceed to transfer them to your paper as described in the section on triangulation. To fill your format, locate these points as close to the edges of your format as possible.

By adjusting the distance at which you hold your viewfinder (anywhere from a couple of inches from your face to full arm's length) you can view a subject at various sizes in relation to the format. If the viewfinder is held very close, the subject may appear to dwindle in relation to the space around it; at half arm's length, it may appear to push insistently against the edges of the format and at full arm's length you may observe only details of the object. The experience of changing the distance at which your viewfinder is held is akin to manipulating a zoom lens on a camera.

USING THE VIEWFINDER TO INFLUENCE LAYOUT

Scaling the image so as to most expressively utilize your format is just one of the major considerations related to the larger issue of the layout of your drawing. Another major consideration is the placement of the various parts of your subject in relation to the edges of your format. Just as the viewfinder is perhaps the single most helpful proportioning device for scaling your image to your format, so too will its use make you almost instantly aware of the range of possibilities for the placement of the image on the page.

Before you begin to draw, try studying your subject for a few moments through the viewfinder, not only holding it at different distances from your eyes, but also shifting the viewfinder vertically and laterally so that you can see different areas of your subject in relation to a format. Note that when you focus in on details, some of the objects may not be seen in their entirety. This will

FIGURE 3–7

tend to make those objects less recognizable, and therefore more easily perceived as abstract shapes.

Figure 3–7 shows different views of a subject as they might be discovered by experimentation with a viewfinder.

Tips on Selecting a Vantage Point

Generally, a subject seen in its foreshortened aspect will appear to engage space more actively than an unforeshortened view. To demonstrate this, let us compare a drawing of a bicycle by Alan Dworkowitz (Fig. 3–8) with a catalog illustration of the same subject (Fig. 3–9).

Both drawings may be considered realistic in that they depict the subject in a fair amount of clear and precise detail. There are, however, some very fundamental differences between the two drawings. The catalog illustration presents the bicycle in an unforeshortened view so that the potential consumer may see at a glance the various components and accessories this model has to offer. Correspondingly, the illustration avoids a unique vantage point because any part of the presentation which called attention to itself would detract from the primary intent of the drawing: to sell bicycles.

On the other hand, the intent of Dworkowitz's drawing is not to saturate us with facts but rather to captivate us *visually*. Depicted from a much less expected vantage point, the foreshortened frame of the bicycle enters the illusory space of the drawing in a very aggressive way. With the handlebars and front wheel turned out to the righthand margin of the page, we may sense an invitation to mount the bicycle, straighten the wheels, and go off touring countrysides.

FIGURE 3–8
ALAN DWORKOWITZ
Bicycle II, 1977
Graphite, 20 × 18 inches
Courtesy Louis Meisel Gallery

FIGURE 3–9
Bicycle advertisement
Courtesy of Kuwahara USA and Everything Bicycles, Compton, California

FIGURE 3–10
Student drawing of a bicycle

Tips on Laying Out Your Image

In Figures 3–8 and 3–9 we saw very different treatments of a bicycle in space. A further comparison will show how differently these two images have been laid out on the page.

In both drawings the bicycle is featured as a single isolated figure. But in the catalog illustration the entire bicycle is depicted and there is no boundary between the picture space of the illustration and the printed part of the page. For the purposes of the illustrator, the ground has no character in its own right; it does not imply space, nor does it have any limits that define it as a shape.

In contrast, the drawing by Dworkowitz is made visually exciting by its layout. How the image is laid out is as important as its depicted spatial disposition and precise detail. The fact that the image is cut off so that we see only the front half of the bicycle directs our attention to the space beyond. The empty ground here is dramatically contained; like an empty stage it anticipates action.

You can see, therefore, that while you are examining the subject from various angles, you should at the same time be thinking about how you are going to lay out that subject on your paper. Even when you are concerned primarily with the spatial aspect of your subject, the expressive potential of your page as a flat surface with a particular shape must be reckoned with. The flat piece of paper is all the two-dimensional space allotted to you for your statement; therefore, you should make the greatest possible use of it. If you respond fully to the presence of the drawing's entire surface, all the areas, positive and negative, will have meaning, as in the student drawing, Figure 3–10.

Exercise 3B *As this chapter suggests, such seemingly mechanical decisions about where to sit, which way to hold your pad, and the format you will use are actually the underpinnings of your drawing's expression. This project has been designed to guide you through these early stages of making a drawing, helping you to personally understand their sequence and their importance.*

FIGURE 3–11
Student drawing: page of layout
studies

Choose a subject that is visually diverse and also allows you to view it from a sufficient number of angles. Next, with viewfinder in hand move around your subject, carefully considering its visual potential from different vantage points. Narrow down your options and make a set of studies.

Begin your studies by loosely (gesturally) describing your subject. Take into account the scale of the entire image in relation to its format and how the flat surface of your drawing is being laid out, or subdivided, into positive and negative zones. You may want to blow up selected portions of your subject for individual study, altering the formats as appropriate (Fig. 3–11).

Last, choose one of your studies for development into a final drawing (eighteen by twenty-four inches or larger).

4

The Interaction
of Drawing
and Design

Previous chapters established the concept of the flat picture plane. This chapter enlarges upon that discussion and in the process confirms that the responses to two-dimensional organization are integral to the practice of expressive drawing, representational or otherwise.

Drawing and Design: A Natural Union

Design, on some level, plays a part in our everyday existence. But much of the order in our lives is taken for granted, from the simple matter of organizing daily routines, to managing the more complex forces of, let us say, career and homelife into a state of equilibrium.

Indeed, design is such a natural part of our consciousness that when we witness something that is superbly organized—as, for instance, the consummate execution of a double play in baseball—we recognize immediately how wonderfully all the parts had to fit together for that to happen. We are thrilled, and it literally feels good to witness something so well realized, perhaps because the order in our own lives seldom reaches that pitch of resolution.

In drawing, as in all the arts, design is just as natural and ever-present. In fact, you cannot draw *without* designing. Science revealed decades ago that visual perception itself is an automatic process of selecting and making patterns. This means that when we look at things our eyes and mind begin immediately organizing visual differences and similarities so that we might create order out of potential chaos.

So, when you draw to represent your subject, you are simultaneously recording sensations of perceived order. By this we don't mean to imply that you will necessarily create well-designed drawings from the outset of your drawing practice, but only that there is no mystery connected with the the qualities of design; they are simply a part of common experience.

Principles of Design

When transferred to the art-making process, these qualities of order are generally referred to as the principles of design. They are given names such as *unity* and *variety, contrast, emphasis, balance, movement, repetition* and *rhythm,* and *economy.* The principles of design are used by artists to organize the so-called *visual elements* (lines, tones, shapes, textures, and color) into a unified drawing.

Distinguishing these design phenomena by name may give the impression that they can be set apart from one another and given fixed definition. On the contrary, they are frequently inseparable and seemingly unlimited in their interactions. Thus, the descriptions below must, of necessity, be neither final nor precise. Our summaries are offered only as a set of guidelines to reinforce what you will quite naturally discover on your own.

UNITY AND VARIETY

Imagine, if you will, a country with a population so diverse that it suffers from internal dissension. The leadership of this country, recognizing that such discord makes a nation vulnerable, looks for ways to encourage unity, or a state of oneness, so that the nation's people may stand consolidated against external aggression.

The process of drawing is in many ways the same. Your blank sheet of drawing paper, before you put a mark on it, is a totality. Make a mark and you have interrupted its unity of surface—and thereby created tension. Adding more marks increases the potential of variety, or difference, while also causing areas of potential agreement, or similarity, to emerge. Your goal when drawing will be to find ways to harmonize the conflict of varied forces by building on those areas of agreement, so that a sense of unity may be restored.

Thus, we may say that the major polarities in a work of art are unity and variety. Unity underlies a work's impact as a complete event; variety is the agent that enlivens a work and sustains interest. In this regard, look at Figures 4–1 and 4–2. Both are complete visual statements, and yet each in its own way has sufficient variety to leaven the experience. The variations in "Short Schedule" (Fig. 4–1) consist essentially of subtle modifications among the nail groupings; in the Kitaj (Fig 4–2), the multiple images more distinctly differ in their tonal and textural combinations.

FIGURE 4–1
JAMES ROSENQUIST
Short Schedule, 1972
Pencil, charcoal, pastel, 30 × 40 inches (D37)
Courtesy Leo Castelli Gallery

FIGURE 4–2
R.B. Kitaj
*Untitled: Cover of the Times Literary
Supplement*, c. 1963–64
Pencil and pasted paper, 15 × 10¾
inches
*Collection, The Museum of Modern Art, New York.
John B. Turner Fund.*

CONTRAST

When aspects of variety in a drawing become more emphatic, contrast is the result. Contrast may refer to pronounced differences in, for example, scale, lights and darks, shape, handling of media, and activity (busy versus quiet).

In the drawing by Lee Bontecou (Fig. 4–3), look at the startling tonal contrasts, and also how rounded masses are poised against larger stretches of flat, unbroken shape. As often happens when contrasts are this extreme, the areas in conflict animate each other. They form a relationship based on an attraction of opposites that intensifies their respective differences and helps to bind the drawing together.

FIGURE 4–3
Lee Bontecou
Untitled, 1967
Pencil, ink on paper, 20 × 26
inches (D100)
Courtesy Leo Castelli Gallery

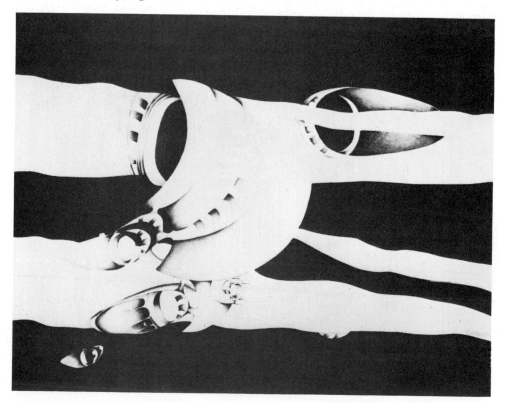

EMPHASIS

Looking further at Figure 4–3, you will notice that a definite center of interest has been established in the area of the black ellipse above and to the left of center. This portion of the drawing attracts attention because it represents the largest volume not held in check by an overlapping shape. Note as well the secondary centers of activity to the right and below that echo this dominant elliptical shape.

Levels of emphasis in a drawing are achieved through aesthetic handling (giving certain areas more contrast or a prominent texture, for example); or through the unusual placement, or scale of selected lines, tones or shapes. Without emphasis, a viewer would lack visual clues as to the artist's expressive priorities. Emphasis assists viewer perception by calling attention to significant parts of a drawing. And by placing the elements in dominant and subordinate roles, emphasis lends a hierarchical structure to a drawing and thereby advances unity.

BALANCE

Balance refers to a sense of equilibrium among all parts of a drawing.

Typically, drawings are organized on the basis of either symmetrical or asymmetrical balance. The term *symmetrical balance* applies to an image that is divided into virtually mirror-like halves. Perfect symmetry imparts a formal bearing and is therefore usually reserved for works that are emblematic in character (Fig. 4–4). However, many artists who wish to reap the unity that symmetry provides, but avoid the ceremonious quality often attached to perfect symmetry, will employ instead what is sometimes referred to as "near," or *approximate symmetry* (Fig. 4–5).

Ordinarily, though, working drawings will exhibit a diversity of image characteristics, that is, different shapes, tones, textures, sizes, directions, and so forth, unevenly distributed across the picture plane. When this happens you will want to use *asymmetrical balance* to bring these contrasting forces into a state of equilibrium. This will entail adjusting the "visual weights" of what you draw (visual weight refers to how much an area attracts the eye). For example, you won't want to cluster large, complex events on one side of your page without

FIGURE 4–4
MYRON STOUT
Delphi I, 1969–72
Graphite on paper, 4⅞ × 5⅛ inches
Courtesy: Oil and Steel Gallery, photographer Charles Unt

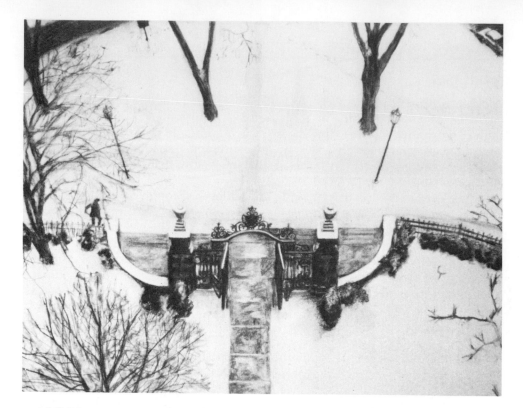

FIGURE 4–5
Dana Salisbury
Grecourt Gates, 1981
Charcoal, 19 × 25 inches
Courtesy the artist

establishing areas on the other side that, although dissimilar in their visual impact, serve as a counter-balance. In Figure 4–6, for instance, the bold, slightly bowed form moving off the right side of the drawing is in a state of asymmetrical balance with the large, overlapped images and dark, textural markings on the left.

MOVEMENT

When selected lines, tones and shapes are given emphasis in a drawing they will often imply direction. These separate directions should be organized into a pattern of movement to fluidly guide the viewer's eye across the entire two-dimensional space of a drawing.

FIGURE 4–6
Roy DeForest
Untitled, 1974
Pastel and crayon on paper, 22 × 30 inches
Courtesy: Allan Frumkin Gallery, photo by Schopplein Studio

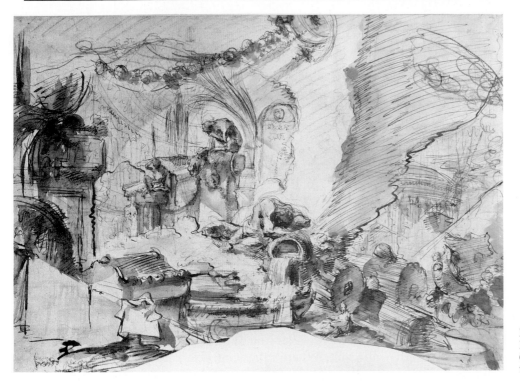

FIGURE 4–7
PIRANESI
Capriccio
The Pierpont Morgan Library, New York, 1966.11:9

Let us look at Figure 4–7. Although there is a central focal point in this drawing, the artist has not allowed our eyes to remain idle. We are swept around the surface by a series of curves and opposing diagonals, which are given momentum by changing line weights and clusters of shaded, smaller shapes.

REPETITION AND RHYTHM

Artists will often repeat similar shapes, lines, tones, textures, and movements to create organizational relationships in their drawings. Repeated elements do not have to reproduce each other exactly, nor must they always appear in an altogether obvious manner. In Figure 4–8, for example, the figure X on the horizon (representing a windmill) is echoed by a larger X in the foreground that is embedded in the landscape, as is made evident in Figure 4–9. This subtle use of pictorial repetition helps to unify both the two-dimensional and the illusory three-dimensional space of the drawing.

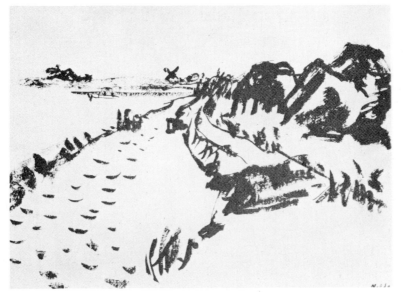

FIGURE 4–8
EMIL NOLDE (1867–1956)
Landscape with Windmill
Brush and black printer's ink on tan paper, 17½ × 23¼ inches (44 × 59 cm)
Private collection courtesy, Nolde-Stiftung Seebull; reprinted by permission of Holt, Rinehart and Winston

FIGURE 4–9

When a visual element, such as a line, shape, or unit of texture, is repeated often enough to make it a major unifying feature in a drawing, what is often referred to as a *motif* will have been created. In this regard, note the circular variations in Figure 4–10, which assume the various guises of flower pot, head, rocks, and clouds. And if a particular unit of a drawing is repeated extensively, a marked pattern will result. When a drawing is largely constituted of such a pattern, sufficient variation should occur to avoid visual boredom, as in Figure 4–11.

Rhythm is based on the measured repetition of features in a drawing. The more that related elements are stressed, and especially if the accents and visual pace (or tempo) are varied, the more pronounced the rhythm will be in a work of art. Look, for example, at Figure 4–12 where the similar movements of the depicted tree trunks, and the intervals of negative space between them, are both charged with an alternation of stronger and weaker accents.

Rhythm may also be used to invest an otherwise uniform pattern with a sense of pulse. In Rene Magritte's "The Thought Which Sees" (Fig. 4–13), the delicate tonal changes in the marks create a unified surface that optically vibrates. This work is also a prime example of how organizational properties in a drawing may extend meaning: the meter of the finely woven pattern of marks recalls the hypnotic rhythms of the depicted waves and rolling clouds.

FIGURE 4–10
ED VALENTINE
Sketch Page with Dead Tree, 1986
Oil crayon/pastel on paper, 26 × 46
inches EV86-10
Courtesy of Avenue B. Gallery, New York, NY

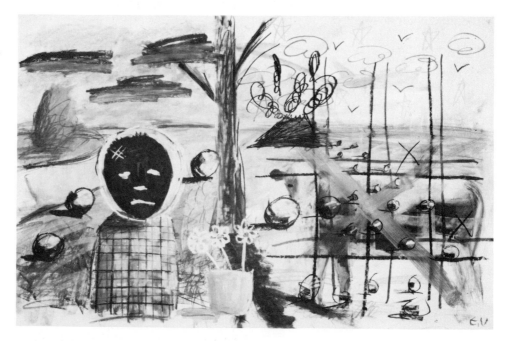

FIGURE 4–11
Student drawing with motif of leaf shapes

FIGURE 4–12
BILL RICHARDS
Fern Swamp, 1974
Graphite on paper, 17 × 21½ inches
Courtesy of Nancy Hoffman Gallery, New York

FIGURE 4–13
RENÉ MAGRITTE
The Thought Which Sees, 1965
Graphite, 15¾ × 11⅝ inches
*Collection, The Museum of Modern Art, New York.
Gift of Mr. and Mrs. Charles B. Benenson.*

FIGURE 4–14
MIMI GROSS
The Choice of Dainty Women, 1973
Crayon and Gouache, 14 × 21¾
inches
Courtesy the artist, photographer Bevan Davies

ECONOMY

From time to time, you may find a drawing you are working on is too complicated
and, as a result, appears disorganized. In that case, it will be important for you
to rework certain aspects of your drawing, strengthening latent areas of similarity
and eliminating nonessential areas of difference. By this means you will clarify
relationships so that a more simple arrangement is achieved, thus imparting to
your drawing an economy of expression. However, economy is not based on
limiting the number of things portrayed. It does depend upon each part con-
tributing to a larger system of order, as in Mimi Gross' drawing (Fig. 4–14)
where the abundant patterns are organized on the basis of larger tonal areas
and contrasted with the variously accented rhythm of the heads and strategically
placed banners.

Exercise 4A *Here are two simple exercises that will provide countless hours of challenging drawing in
your sketchbook.*

*__Drawing 1.__ Choose a subject because it clearly exhibits a particular design principle. For
example, a landscape may be perceived as having asymmetrical balance, and a machine may
be made of contrasting large and small parts. Carefully observe and draw your subject, paying
special attention to its particular design implications and how they may be extended, as in*

FIGURE 4–15
Student drawing of reed cane

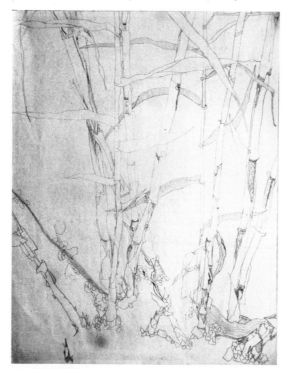

FIGURE 4–16
Student study of a fan

this study of reed cane (Fig. 4–15) where the repetition of stalks activates the entire field of the drawing.

Drawing 2. *Choose a common object as the source of a motif for your drawing. Repeat the object, or selected parts of it, across your paper. Make sure to overlap some of the images and to draw them in different visual guises, that is, change their scale, clarity, positive–negative status, and so forth. As the drawing proceeds, place more emphasis on certain areas to establish a center of interest and also to develop paths of movement to guide the eye through your drawing (Fig. 4–16).*

Gesture Drawing as a Means to Design

In Chapter 1, gesture drawing was presented as the primary way for artists to grasp the essential visual character of an object or a space. But a gesture drawing may also serve as the foundation, or "rough," for the more sustained development of a particular image.

At times, artists will divide a page into several formats to test, in a sort of gestural "shorthand," how a subject may best be laid out in preparation for a sustained work (Fig. 4–17).

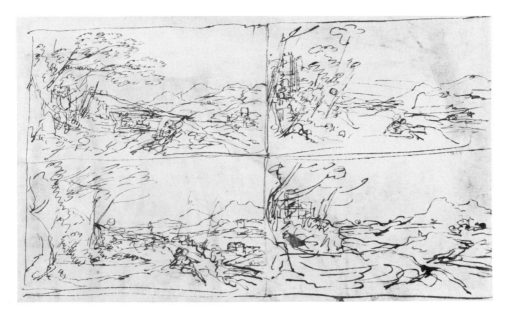

FIGURE 4–17
CLAUDE LORRAIN
Landscape Studies, 1630–35
Pen, 184 × 272 mm (verso of
Wooded View) S.10
Teylers Museum, Haarlem, Netherlands

FIGURE 4–18
ALBERTO GIACOMMETTI
Landscape
Pen on paper
*Collection, Louis Clayeux, Paris Copyright ARS
NY/ADAGP 1987*

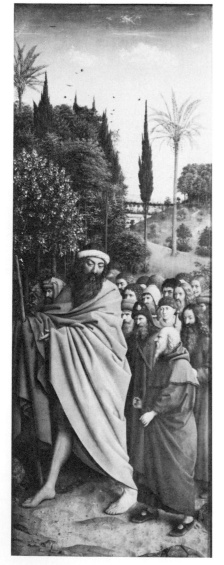

FIGURE 4–19
HUBERT and JAN VAN EYCK
The outer, right-hand panel from
"The Adoration of the Mystic
Lamb," *The Ghent Altarpiece*
Courtesy Art Resource

But just as frequently, marks from gestural explorations serve as the underpinning for a work in progress and so are not apparent to the eye in the finished product. The gestural spirit of search and discovery remains embedded, however, in the naturalness with which the subject has been represented.

A particularly illuminating example of this may be found in Figure 4–18. In this drawing, Giacometti, the twentieth-century Swiss artist, has penetrated below the surface detail of a section of a fifteenth-century painting by Jan and Hubert Van Eyck (Fig. 4–19) to expose the work's latent gestural energy and structural conviction.

The Giacometti is thrilling to look at not only because it is a beautiful drawing in its own right, but also because it functions as a sort of x-ray, interpreting for the onlooker what takes place inside another work of art. This latter point is especially significant for us, since it suggests that artists may use gesture drawing as a tool to diagnose the basic state of their *own* works in progress. Let us suppose, for example, that after a drawing is well under way you decide that parts of your image are lacking in structure, or that the overall design is in some way deficient. In response, you might very well make gestural studies on separate sheets of paper so as to analyze these shortcomings prior to resolving them in the actual work.

Giacometti's interpretive drawing has another far-reaching implication for the drawing student. You will notice that he deliberately made a format border to enclose the excerpt of the Ghent altarpiece he chose to draw. His awareness of the rectangular shape within which to conduct his search suggests that gestural activity may be intimately linked with the design conception of a drawing.

In fact, we may say that design in a drawing is often initiated when gestural responses to a subject are laid out and scaled to the limits of a format. Figure 4–20 echoes the Lorrain we saw earlier (Fig. 4–17) in the way it demonstrates how a set of gestural studies may function as the initial means of joining vigorous responses to a subject with elementary design trials. To enlarge upon this point, let us consider Barlach's study of a running man in Figure 4–21.

Barlach's gestural study has admirably taken into account the overall proportions and rudimentary structural properties of this running figure. But what interests us most here is the way in which the figure's extension into space coincides with the paper's edges. This is significant because, while Barlach took visual possession of the man's image, he simultaneously took physical possession of the two-dimensional area of his drawing surface.

This simultaneity of action is typical of gesture drawing when it is most insightfully practiced. The rapid movements of the artist's eye and arm generalize the expressive attitudes and the organization of parts that is characteristic

FIGURE 4–20
ROBERT WILSON
The Golden Windows, 1981
Graphite on paper, 36½ × 60
inches (RW 556)
*Courtesy, Paula Cooper Gallery, photographer D.
James Dee*

FIGURE 4–21
ERNST BARLACH
Running Man, 1918
Charcoal on white drawing paper,
22.8 × 30 cm
*Courtesy, Ernst Barlach Haus, Stiftung H.F.
Reemtsma, Photo: Thormann*

FIGURE 4–22
RICHARD SERRA
Zonder Titel
Rijksmuseum Kroller-Muller

of a subject. At the same time, the artist is intuitively aware of the visual inter-actions between the placement and directional energies of the thing drawn and the actual size and shape of the chosen format. A second powerful example of this may be found in the gestural study by sculptor Richard Serra (Fig. 4–22), where a quadrilateral form has been dramatically represented on an unusually large sheet of paper.

Beginners often start with single objects to get the feel of gesture drawing and its design implications. But the gestural approach is equally appropriate for subjects comprised of multiple objects, such as still lifes, interiors (Fig. 4–23) and landscapes (Fig. 4–24). Drawing multiple objects challenges the artist to empathize with the unique gestural expression of each part of a subject. And, as individual gestures are realized, the artist must be alert to correspondences that emerge between areas, since they will suggest larger gestural patterns, which may in turn point to options for organizing the drawing overall.

In this regard, look at John Bennett's drawing, "The Farm," (Fig. 4–25). Each area has its own kind of gestural short-hand, producing a work that is fresh and altogether unstudied in expression. But, as an outgrowth of its spontaneity, the trailing lines from each major division of the page create a zigzagging pattern that very purposely binds together the spatial illusion and surface design of this drawing.

In comparison, it is interesting to see how the drawing by Gaspar Van Wittel (Fig. 4–26) retains a similar gestural freshness. In this drawing, the slashing marks and abruptly brushed areas of wash summarize the major spatial planes. At the same time, they describe the edges of a mountain range, cuts in the landscape, and the underside of a mass of vegetation that advances toward the picture plane. But, much as with Bennett's drawing, these same marks are

FIGURE 4–23
EDGAR DEGAS
Study for Interior
Pencil
Bibliothèque Nationale, Paris

FIGURE 4–24
FRANK AUERBACH
Study for Mornington Crescent, 1967
Pencil, 9⅞ × 11¾ inches
Private collection, NY

FIGURE 4–25
JOHN BENNETT
The Farm, 1981
Pencil, 9 × 6 inches
Courtesy Denise Cadé Gallery

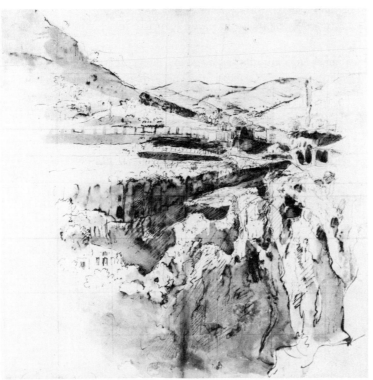

FIGURE 4–26
GASPAR VAN WITTEL
View of Tivoli, 1700–10
Pen and brown ink
Courtesy, Courtauld Institute Galleries, London

also the agents of an inventive design strategy in which positive and negative zones are melded into a cohesive unit.

To clarify this last point, compare Figure 4–26 to Figure 4–27. Note that Van Wittel divided his page into three major areas, and also see how he grouped

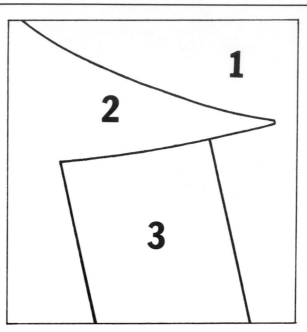

FIGURE 4–27

the dominant dark masses into a tilted, rectangular shape that rests on the bottom edge of the drawing, poised, it would seem, to move into spectator space.

Exercise 4B *These two projects will urge you toward a more gestural conception in your work.*

Drawing 1. Imagine a simple spatial configuration, such as a loop or an intersection. Taking a broad medium, such as lecturer's chalk or a brush charged with ink or acrylic, boldly draw that imagined spatial figure in such a way as to take possession of your entire format (see Fig. 4–22).

Drawing 2. Drawing from an observed subject, gesturally record its major axes and spatial movements. Be sure to draw the image large enough so that your gestural marks are also responsive to the two-dimensional area of your paper.

Finish your drawing, developing its design implications but without losing the spontaneous character of your initial gesture drawing (Fig. 4–28).

FIGURE 4–28
Student drawing: sustained gesture

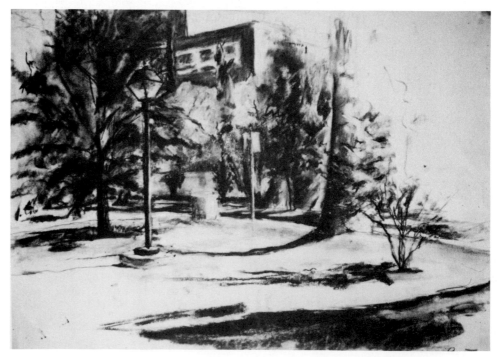

5

Linear Perspective

Because linear perspective has the aura of a technical subject, many students think it will be difficult to understand. But, while perspectival systems involving complex mechanical procedures have been developed for people who do technical drafting (such as architects, designers and engineers), the basic concepts behind linear perspective are few and simple, and therefore easily within the grasp of the non-technically minded person.

Point of View

Perspective drawing, in its broadest sense, refers to the representation of things as they are arranged in space and as they are seen from a *single point of view*. Therefore, what is central to the issue of drawing in perspective (whether we are employing linear or aerial perspective*), is the concept of the artist's bodily position in relation to the things represented.

When looking at a drawing or painting, we tend to identify with the implied point of view. That is, we instinctively know whether the artist was looking up, down, or straight ahead at the subject. In the drawing by Henry Schnakenberg (Fig. 5–1), for instance, there is no doubt about the artist's viewpoint. In consequence, our own inferred position is consistent and clear, perched as we are above this forest floor covered with leaves and needles.

Because a fixed viewpoint in a picture helps establish a convincing illusion of space, it is generally recommended that aspiring artists have at their command the means for determining a fixed viewpoint in their work. However, it is important to recognize that an artist's choice to develop a consistent viewpoint in a particular work will depend upon the demands of subject matter and expression. In this regard, let us compare two works.

The multiple points of view in Edwin Dickinson's "The Fossil Hunters" (Fig. 5–2) serve to disorient the viewer and reinforce the work's phantasmagorical quality. On the other hand, the untitled drawing by Vincent Desiderio (Fig. 5–3) elicits a strong response from the viewer due to its unconventional, yet thoroughly consistent point of view.

*See Chapter 1 for a discussion of aerial perspective.

FIGURE 5–1
HENRY SCHNAKENBERG
Forest Carpet, 1924
Watercolor, 11¾ × 15¾ inches,
acquisition #31.463

Gift of Gertrude Vanderbilt Whitney. Collection of
Whitney Museum of American Art, New York

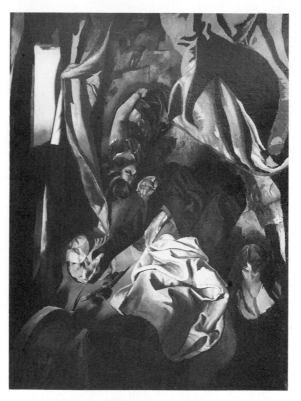

FIGURE 5–2
EDWIN DICKINSON
The Fossil Hunters, 1926–28
Oil on canvas, 96½ × 73¾ inches,
acquisition #58.29

Collection of Whitney Museum of American Art,
New York. Purchase. Acquisition #58.29.

FIGURE 5–3
VINCENT DESIDERIO
Untitled (one of a series of four
drawings dedicated to Salvador
Allende), 1985
Charcoal on paper, 50 inches
(diameter)

Courtesy of the Everson Museum of Art

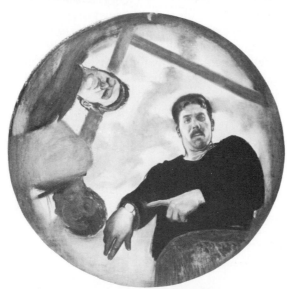

THE CONE OF VISION

To better understand the three-dimensional character of things you see, it might be helpful to think of your field of vision as a conical volume. The apex of this cone of vision is located at your eyes, and the cone will extend as far as you can see. For this reason, there is no fixed or actual base to this cone, but when you imagine a picture plane (window on nature) intersecting this cone, its base lies within that plane (Fig. 5–4a).

Let us take a moment to investigate the cone of vision. If you were to lift your eyes from this book and look out across the room, or better yet, out a window, you would note that your eyes can take in the entire image of something large when it is a fair distance away. For instance, you would be able to see the full image of a medium-sized building at a single glance if it were across the street from you. However, something much smaller and yet far closer, such as this book held broadside against your nose, could more than fill up your cone of vision. This little experiment should make you more conscious of the fact that what we think of as a field of vision is actually a conical volume.

If you tilt your head back in order to look up, the cone of vision will be angled away from the ground. The picture plane, which contains the base of the cone of vision, will also be at an angle, as illustrated (Fig. 5–4b), but still in the same relationship to the eye.

FIXED POSITION

Artists not trained to draw in perspective will often combine what they *see* with what they *know* in such a way as to produce contradictory information. As an example let us compare the free-hand drawing a beginning student might make of a square-topped table (Fig. 5–5a) with the drawing the student would make if the image were traced on glass (Fig. 5–5b).

The student knows that the table has a square top and four vertical legs. But the top of the table may be perceived as a square only when it is parallel to the picture plane (as when seen from directly above), and from this vantage point it is impossible to see any of the table legs. So, the student made the

FIGURE 5–5

(a) (b)

compromise of drawing what was known (that the table top was square) with what could actually be seen from that vantage point (three out of four table legs). In effect, Figure 5–5a attempts to show two entirely different views of the table.

The drawing in Figure 5–5b, on the other hand, shows what the table would look like from a single point of view. Notice that you still have no difficulty recognizing that the tabletop is square although it is not drawn that way. The irregular shape that represents the tabletop is, in fact, what we expect to see when a square is at that particular angle to the eyes. Furthermore, it is consistent with the position of the table legs.

A picture in which all elements are drawn so as to be consistent with a single point of view conveys a sense of fixed position. *Fixed position* may be defined as the exact location of the viewer's eyes in relation to the subject. In order to achieve a consistent point of view in your drawing, it is important to maintain a fixed bodily position in relation to your subject. In other words, do not move closer or farther to the left or the right, do not stoop down or stand on tiptoe, to obtain another view of what you are drawing.

THE CONCEPT OF EYE-LEVEL

Eye-level may be defined as the height at which your eyes are located in relation to a ground plane. So often taken for granted, an awareness of eye-level is essential to the understanding of fixed position.

In respect to a three-dimensional space, the eye-level should be thought of as the horizontal plane in which your eyes are located. To get a better idea of this concept, it might be helpful to hold up a piece of thin cardboard horizontally to your eyes so that you can see only the edge of it. Since you can see neither the top nor the bottom of the cardboard, we can describe the cardboard in this position as a diminished horizontal plane.

If you are standing on level ground, the diminished horizontal plane will be parallel to the ground plane. But because of your vantage point, the ground plane will *appear* to tilt up to meet the diminished horizontal plane. The apparent intersection of these two planes forms what we will call the *horizon line*.

Eye-level is described as high or low by virtue of its distance from the ground plane. We think of normal eye-level as that of an average person when standing up—say about five and a half feet above the ground plane. Many representational drawings make use of this conventional eye-level, but any time a drawing is executed from a vantage point radically different from the normal one, we are aware of its implied eye-level as being unusually high or low. In the Michael Heizer (Fig. 5–6) we identify with the bodily position of the aerial photographer because our experience tells us that only from an extremely high vantage point are we able to see so much of the ground plane.

When looking at works of art, however, we are generally more concerned with the implied eye-level in relation to the subject than we are with the artist's actual eye-level at time of execution. In the Joel Janowitz drawing (Fig. 5–7) the artist's actual eye-level is unknown, but we have no reason to believe that it departs radically from the height of a standing person. What we do notice, is that we seem to be looking almost straight up at the subject. So in this case we would describe the eye-level of the drawing as low because of its relation to the subject. Notice that in both this drawing and in the Heizer, the eye-level is so extreme that the horizon lines do not even appear within their formats.

Establishing the eye-level in a drawing means simply to acknowledge that the things portrayed have been seen by looking up at them (they are above eye-level, or seen from what is commonly referred to as "worm's eye" view), or looking down at them (they are below eye-level, or seen from what is commonly referred to as "bird's eye" view). Sometimes artists will draw a horizontal line across their paper to indicate their eye-level. Placement of this line is discre-

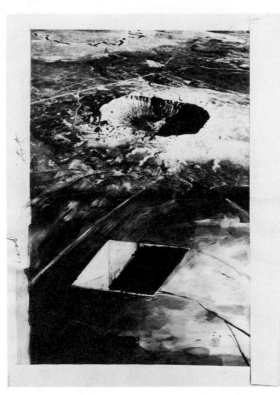

FIGURE 5–6
MICHAEL HEIZER
Untitled, 1969
Photograph, pencil and watercolor
on paper, 39 × 30 inches
*Gift of Norman Dubrow, collection of Whitney
Museum of American Art, New York, Acquisition
#80.26.1*

FIGURE 5–7
JOEL JANOWITZ
The Painter, 1974
Charcoal, 28 × 38¾ inches
Courtesy the artist

tionary; what does matter, however, is that once the eye-level is determined in
a drawing, all descriptions of objects should be consistent with that viewpoint.

*A consistent viewpoint in a drawing helps establish a convincing illusion of space; it also
immediately communicates to the viewer an important aspect of the way you perceived your
subject.*

 For this exercise draw a still-life that consists of small objects, or even a single object,

Exercise 5A

FIGURE 5–8
Student drawings of a still-life at 3
different eye-levels

*from various eye-levels. Figures 5–8 a, b and c show a simple arrangement of objects from
different points of view.*

Convergence and Fixed Position

One of the concepts central to the study of linear perspective is that parallel
lines in nature appear to converge (come together) as they recede. This phe-
nomenon is such an integral part of common experience it has even been the
basis of a popular cartoon (Fig. 5–9). If you followed the angling exercise in
Chapter 3, you probably verified this for yourself. And if you were very obser-
vant or already possessed some knowledge of linear perspective, you noticed
that this convergence occurs at eye-level.

FIGURE 5–9
WEBER
"Look, men, shouldn't this be the
other way around?"
Cartoon
*Reprinted by permission of Esquire. © 1966 by
Esquire Associates.*

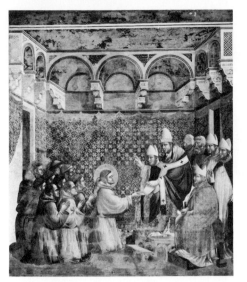

FIGURE 5–10a (left)
Gɪᴏᴛᴛᴏ
Innocenzo III approva la regola
Courtesy Alinari-Scala/Art Resource

FIGURE 5–10b (right)

Prior to the invention of the system of linear perspective, artists had recognized that receding parallels translate into diagonals on a picture's surface. The rules governing the use of these diagonals were very general. As you may see in the Giotto fresco (Fig. 5–10a), there is an understanding that sets of parallel lines should converge. But the idea is not extended to include all sets of parallel lines. Notice, however, that all the parallel lines in this painting, if extended, will converge on a vertical axis (Fig. 5–10b).

Now, compare the Giotto fresco with the one painted by Masaccio in 1425, shortly after the development of linear perspective (Fig. 5–11). We see a marked difference between the new system used here and the less complete system used by Giotto. Notice in Masaccio's fresco that all the diagonals in the architecture can be extended to meet at a single point located at the base of the cross. This point indicates the viewer's fixed position as centered laterally on the composition and at an unusually low eye-level.

FIGURE 5–11
Mᴀsᴀᴄᴄɪᴏ
Trinity with the Virgin and St. John
Courtesy Alinari-Scala

FIGURE 5–12
Film still from Peter Lorre's *Stranger on the Third Floor,* shot with Peter Lorre and John McGuire on a staircase
Courtesy Museum of Modern Art/Film Stills Archive

Our own culture has come to expect pictures to have a fixed point of view. The prevalence of photography in our society reinforces this expectation. (The forerunner of the photographic camera is in fact the *camera obscura*, an instrument that aided the artist in recreating a perspective view of a subject by funneling its image through a small aperture, thus simulating a single point of view.)

Artists in general, but especially filmmakers, often use perspective to make the viewer more aware of a specific viewpoint, with the intent of heightening the suspense of a scene. Look at the movie still in Figure 5–12. Although you may be disoriented by the tilted camera angle and the dramatic shadows, you can follow the converging lines so as to obtain a strong indication of the camera's position (just inside the lower left-hand corner of the frame). As a viewer, you naturally identify with the camera's "eye," and as a result you feel that you are a half-hidden witness to the scene. It is this sense of being a voyeur to terrifying or sordid events that the makers of psychological melodrama wish to exploit.

Having made these general observations about the artistic uses of two concepts central to linear perspective—fixed position and the convergence of parallel lines—we will now explain the whole system in greater depth.

THE DIMINUTION OF OBJECTS

The convergence of parallel lines on the picture plane is directly related to the phenomenon of more distant objects appearing smaller.

This phenomenon can be explained by examining how two things of identical size, but at different distances from the spectator, relate to the spectator's cone of vision.

Let us suppose you are standing in a position where you can see two elephants in profile. One is perhaps thirty feet away from you and the other only ten feet. The closer elephant will be located near the apex of your cone of vision. In our illustration Figure 5–13a, the trunk is barely included within the farthermost right ray of vision. There is a space of about one-third of its body length left between the tail and the left ray of vision. Therefore in Figure 5–13b, the shape of the elephant fills three-quarters of the binocular shape that makes up the field of vision. Let us say that the second elephant is the same size as the first. As it is farther from the apex of the cone of vision, the length of its

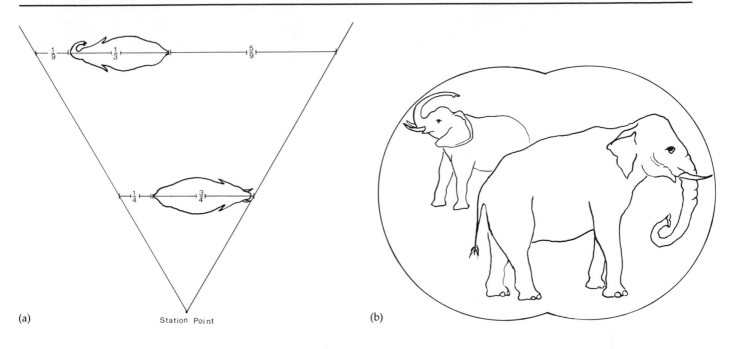

(a) Station Point (b)

body takes up a far smaller proportion of the cone. The image will, therefore, take up correspondingly less area in the field of vision.

FIGURE 5–13

CONVERGENCE OF PARALLEL LINES

The principle of the diminution of objects can be used to explain the apparent convergence of parallel lines as they recede from the spectator's station point. We will use the familiar image of the railroad track running off into the distance to demonstrate the idea of convergence. (Note that when dealing with the system of linear perspective, the fixed position you occupy in relation to your subject is referred to as the *station point*, which is abbreviated to SP in our illustrations.)

In Figure 5–14a, you are standing on a railroad track, midway between the two rails. The track a few feet ahead of you fills up the lower part of your field of vision. As the track recedes it takes up proportionately less space in both your cone of vision and your field of vision (Fig. 5–14b).

FIGURE 5–14

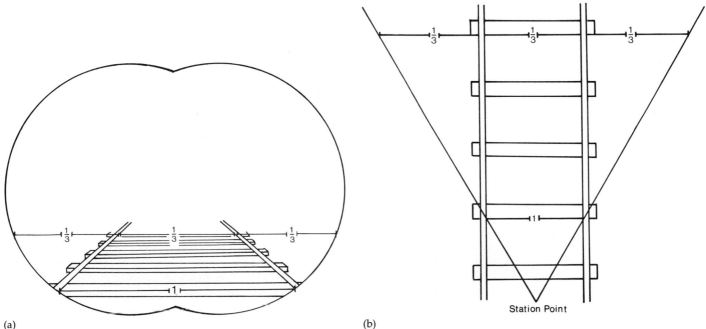

(a) (b) Station Point

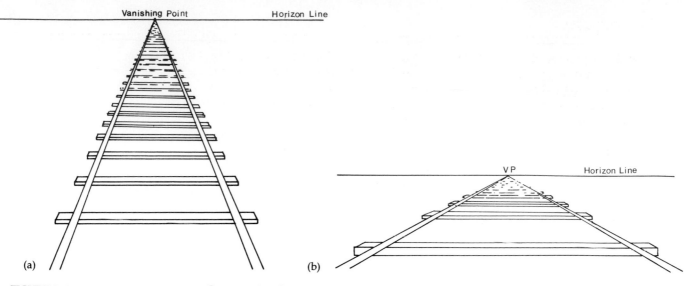

(a)

(b)

FIGURE 5–15

One-Point Perspective

The example of the railroad track is a classic demonstration of *one-point perspective*. The "one-point" referred to is the vanishing point.

THE VANISHING POINT

The illustrations in Figure 5–14 depict only the near sections of the railroad track. If you were to stand at the center of a straight stretch of railroad track you could let your eyes follow the rails until they appear to finally converge. This point of convergence is called the *vanishing point*. Presuming that the ground we are standing on is flat, the vanishing point will be located on the horizon line.

EYE LEVEL AND THE RATE OF CONVERGENCE

If one had a view of the track from the top of an engine, one would see the tracks converging at a slow rate toward a high vanishing point (Fig. 5–15a). If, however, one had the misfortune to be tied to the railroad track, one would see the tracks converging sharply to a low vanishing point (Fig. 5–15b).

DIMINUTION OF UNITS ON A RECEDING PLANE

In studying the preceding illustrations you probably noticed that the spaces between the railroad ties became progressively smaller as the tracks converged. Refer to the illustration in Figure 5–16 and follow the procedure used to arrive at the proper spacing of the ties.

FIGURE 5–16

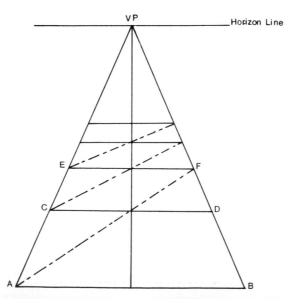

1. Draw the first tie at the bottom of your page. Carry a line from the center of the first tie up to the vanishing point. This line will bisect the angle formed by the two tracks. Draw the second tie at an appropriate distance from the first. (If you were drawing from nature, you could arrive at this appropriate distance through angling or measuring with your pencil.)

2. Draw a diagonal line from point A through the point at which the line bisecting the angle of the tracks intersects with tie CD. Where this diagonal line intersects the track on your right put another horizontal for EF.

3. Successive ties can be located by repeating the procedure.

THE RECTANGULAR VOLUME: INTERIOR VIEW

The preceding demonstration showed how to draw a railroad track from a vantage point above the center of the track. In this case there was one set of parallel lines that appeared to converge at one point on our eye-level. Now we will add a second set of parallel lines above the eye-level (Fig. 5–17). A line of telephone poles running parallel to each track would carry cables that also vanish at the same point as the railroad tracks. (Note that in spacing the telephone poles we use a procedure similar to that outlined in Figure 5–16. In this case the first operational line is extended from the midpoint of the first telephone pole to the vanishing point. This line will divide the height of each pole in half.)

If we were to enter a long rectangular room from a doorway located at the center of one of its shorter walls (Fig. 5–18), we would see a space similar to that of the railroad track flanked by telephone poles. The perspective of the

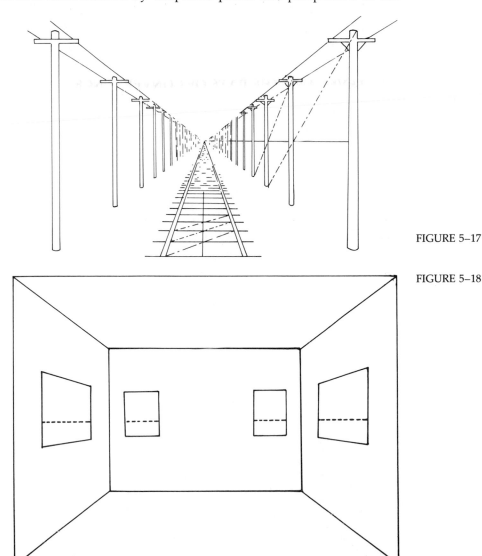

FIGURE 5–17

FIGURE 5–18

room is, of course, more subtle since the vanishing point is obscured by the end wall. But note that in the illustration the receding lines of the floor, wall, and ceiling, if continued, converge at one vanishing point located at eye-level. The horizon line in this case may be observed through the windows.

Note also that all horizontal lines on the wall facing the viewer, and any other horizontal line parallel to the picture plane, appear as horizontal. Any horizontal line located at the eye-level appears as a horizontal, regardless of its angle to the picture plane. All vertical lines retain their vertical aspect.

Exercise 5B *To apply what you've learned about one-point perspective find a long rectangular room or corridor. Station yourself at the center of one end. Notice that all the receding horizontal lines on the walls, ceiling, and floor converge at the same point.*

Draw the corridor using your skills at angling to find the vanishing point (Fig. 5–19). To achieve proportion, use a combination of triangulation and measuring with your pencil as discussed in Chapter 3.

Figure 5–20 shows another subject seen in one-point perspective. In this case the low eye-level makes the massive architectural elements more dramatic.

FIGURE 5–19
Student drawing of a corridor in one-point perspective

FIGURE 5–20
Student drawing in one-point perspective from low eye level

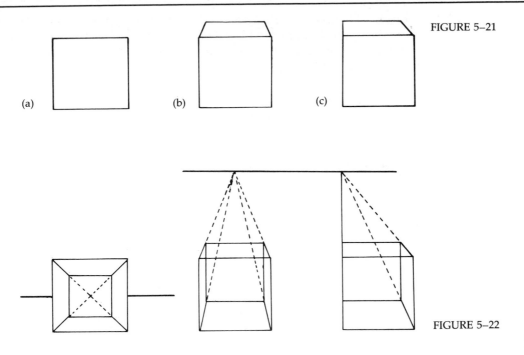

FIGURE 5–21

FIGURE 5–22

THE RECTANGULAR VOLUME: EXTERIOR VIEW

Now that you have an understanding of the interior of a rectangular volume viewed from one end, the next step is to look at the volume from the outside.

If the rectangular volume or box is held at eye-level so that its front face is parallel to your picture plane, it will appear as a flat rectangle (see Fig. 5–21a). This view does not give any information as to the three-dimensional nature of the box. If, however, the box is lowered slightly so that we see its top as well as its front, it will appear as it does in Figure 5–21b. Right away we have an indication not only of the box's three-dimensional nature, but also of our own eye-level in relationship to it.

If you shift the box so that it is not quite centered on your line of vision, but not so far that you can see a third face (see Fig. 5–21c), you will still be able to draw it in one-point perspective.

Study Figure 5–22 to understand how the concealed faces of these boxes would be drawn if they were transparent.

Find a rectangular volume of some sort. A box or block of wood will do. It may be a cube but it need not be.

Place it so that one face is roughly parallel to the picture plane. Draw the box at different relations to your eye-level. To determine the vanishing point, angle the converging lines.

Exercise 5C

Two-Point Perspective

THE RECTANGULAR VOLUME IN TWO-POINT PERSPECTIVE

When a rectangular volume is positioned so that none of its faces is parallel to the picture plane, you will no longer be able to draw it using one vanishing point.

Figure 5–23 shows three cubes positioned so that their vertical faces are at a forty-five degree angle to the picture plane. Notice that in this schematic drawing the cubes are stacked so that they all share the same two vanishing points.

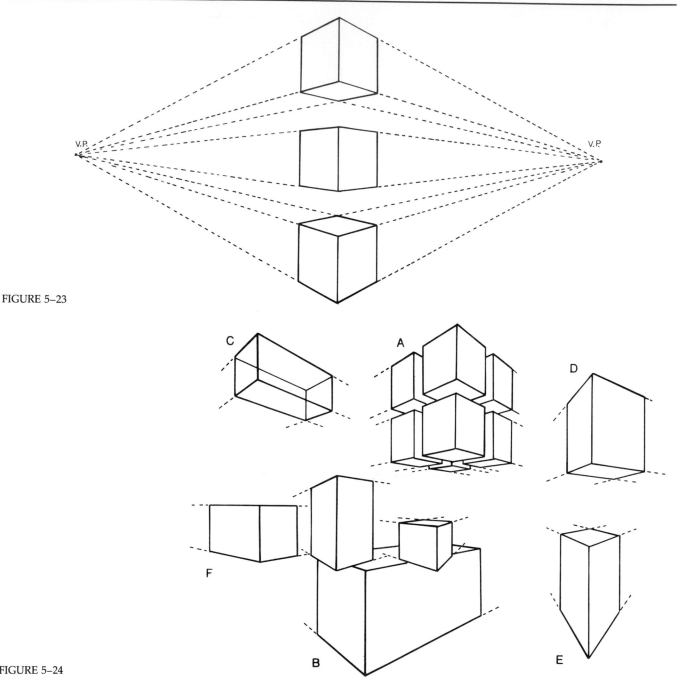

FIGURE 5–23

FIGURE 5–24

In most drawing encounters with box-like forms, you will make use of two-point perspective. But although all items in a given situation may require treatment in two-point perspective, they will not necessarily share vanishing points. Figure 5–24 shows a variety of boxes drawn in two-point perspective. As they are all positioned with their base planes on or parallel to the ground plane, the vanishing points will be located on the horizon line.

Notice that the cluster of boxes labeled A shares common vanishing points whereas cluster B does not. Box C is drawn as if transparent. Box D is positioned so that we see a great deal more of one face than the other two. In such a case the vanishing point for the greater face will be located farther away. (The placement of vanishing points is based on judgment. Sometimes you may find it necessary to locate either or both points outside the format of a drawing. What you want to avoid, however, is the distortion that occurs from placing the vanishing points too close together, as in box E.) The top of box F is located at eye-level and is, therefore, not visible.

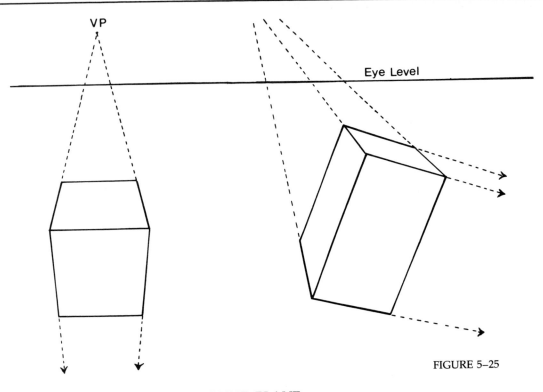

FIGURE 5–25

THE BOX TILTED AWAY FROM THE GROUND PLANE

So far we have been dealing with boxes that *sit on, or float parallel to*, the ground plane. The faces of these boxes are all either horizontal or vertical, and so all the vanishing points are located at eye-level. However, if the box is *tilted* in relation to the ground plane, it will no longer have any horizontal or vertical planes, and none of the vanishing points will be located at eye-level. Normally a box positioned in this way will be drawn using two-point perspective (see Figure 5–25). Later in this chapter a case will be made for drawing some tilted boxes in three-point perspective.

The Circle in Perspective

Circles in perspective are drawn as ellipses. When it is necessary to find the center of the circle in perspective, the ellipse is drawn within a square in perspective. Figure 5–26 shows how this is done.

 Figure 5–26a is an unforeshortened view of the circle within a square; its center is found at the intersection of the diagonals connecting the corners of the square.

 If the square containing the circle were tipped away from the picture plane, it would appear as an ellipse (Fig. 5–26b).We have added a dotted horizontal line to divide this figure in half. This has been done to show that the front half of the circle appears fuller than the rear half. Note also that the undotted horizontal line through the center of the circle does not correspond with the fullest horizontal measurement of the ellipse. This is indicated by the dotted line.

FIGURE 5–26

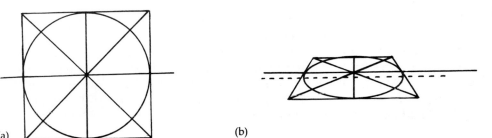

(a) (b)

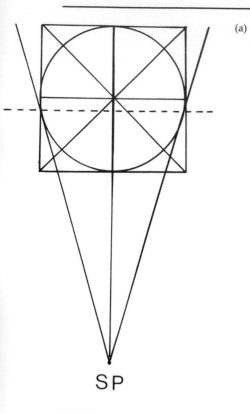

(a)

(b) (c)

SP

FIGURE 5–27

Figure 5–27 demonstrates what is happening to the circle in relation to the cone of vision. In Figure 5–27a the center line of vision goes through the center of the circle. The rays of sight from the station point (SP) are tangential to the circle. A horizontal line connecting these two tangential points locates the fullest dimension of the circle that the eye will perceive. This line falls well below the horizontal through the center of the circle.

This fullest visible dimension of the circle seen in perspective (indicated by a dotted line) will become the major axis of the ellipse when the circle is drawn on the picture plane (Fig. 5–27b). To locate the major axis of the ellipse, draw a rectangle around it and then draw diagonals connecting the corners of the rectangle. The major axis of the ellipse will be drawn horizontally through the point where the diagonals intersect (Fig. 5–27c).

The minor axis of the ellipse coincides in this case with the vertical line going to the central vanishing point. *The minor axis of the ellipse will always be drawn perpendicular to the major axis.*

This method of drawing the ellipses will pertain to any situation in which the major axis of the ellipse is horizontal and parallel to the picture plane.

Whenever the major axis of an ellipse is horizontal, the ellipse may be drawn within a square in one-point perspective. This is because the circle, unlike any other shape, appears the same when rotated within its plane.

Other Geometric Volumes and Near-Geometric Volumes

You can apply your knowledge of drawing boxes and circles in perspective to drawing other basic geometric forms, such as cylinders, cones, pyramids, and spheres (Fig. 5–28). Many manufactured objects can be drawn with greater understanding if you try to relate them to the geometric forms they most closely resemble. Flower pots, drinking glasses, and lampshades are basically conical; most furniture is box-like; tree trunks and bottles are cylindrical; and many vegetable forms, such as fruits, flowers, bushes, and trees, are spherical.

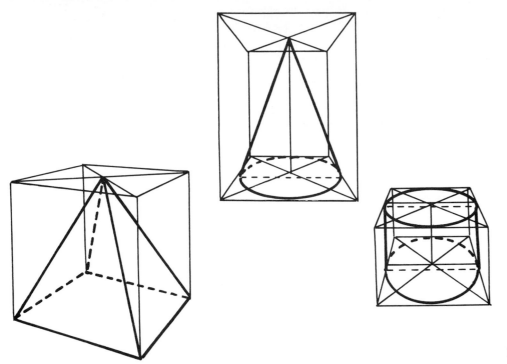

FIGURE 5–28

The Advantages and Shortcomings
of Linear Perspective

Throughout this chapter we have stressed combining the use of proportional devices with a knowledge of linear perspective whenever you draw from a subject that suggests perspectival treatment. On the other hand, it is entirely possible to draw a form such as a building correctly, even without a theoretical knowledge of perspective, so long as you triangulate in order to find the angle and length of every single line.

But, obviously this would be a very tedious and time-consuming process, especially when a knowledge of linear perspective will equip you to anticipate the angles of a good many of the lines and thus shorten your drawing time. Furthermore, this knowledge will enable you to quickly assess mistakes in a drawing and help you to determine which lines stand in need of correction. Therefore, many artists who have no interest in perspective as an end in itself feel that linear perspective has an important role to play in support of careful seeing.

At times, however, the information you gain through measuring and angling will be at odds with your knowledge of perspective. When this happens you will probably want to check the measurements in your drawing to get them in agreement with your expectations. A beginner, given the choice of trusting either what is seen or the system of perspective, will usually opt to trust the system; the system is, after all, rational. This is a healthy response and in most cases will yield the desired result. But in some cases a subjective hunch, fortified by careful angling, will turn out to be correct.

This is because in certain situations traditional one- or two-point perspective does not help to create an image that most closely resembles what is seen in the visual field. Although it will always yield an image consistent with its own logic, the sterile look typical of some perspective drawings is due to the fact that the system is based in part upon some false assumptions.

The first of these assumptions is that our vision is monocular (one-eyed), when in fact it is stereoscopic (two-eyed) and therefore includes two separate cones of vision. Normal visual perception of an object therefore consists of two

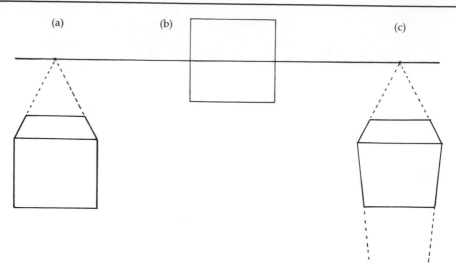

FIGURE 5–29

slightly different views of that object incorporated into a single image. This phenomenon of stereoscopic vision is especially apparent when you regard something very close, since in this case the discrepancy is greater between the two images of the object.

The second false assumption upon which the systems of one- and two-point perspective operate is that the picture plane is literally a vertical plane. But as we pointed out earlier in this chapter, the picture plane is not necessarily vertical; rather, it occupies a position perpendicular to your line of vision (Fig. 5–4b).

The box in Figure 5–29a is drawn in traditional one-point perspective, assuming that the front plane of the box is parallel to the picture plane. However, since the box is located below eye-level, our gaze must be directed downward in order to see it. This means that the picture plane is tilted slightly off the vertical. In theory, then, the use of one-point perspective can only be justified when drawing an object or space that is truly centered on our line of vision, as in Figure 5–29b. As a consequence, the corrected perspective for Figure 5–29a would be as that seen in Figure 5–29c.

In most circumstances the inclination of the picture plane is so slight that the convergence of the vertical sides of a box is imperceptible. If, however, the box were extremely large, or you were very close to it, you would notice the second vanishing point. Compare Figure 5–30 with Figure 5–29c. Note that the converging verticals in Figure 5–30 not only give you an indication of your high eye-level in relation to the subject, but also contribute to a sense of intimacy by implying that you are very close to it.

FIGURE 5–30
Student drawing of a chair tilted
away from a vertical axis

Three-Point Perspective

When you are situated so that you see two vertical faces of a very large (or very close) box-like form, you may wish to draw it in three-point perspective. This means that when you stand at street-level looking up at the corner of a skyscraper, you will see vanishing points not only for the horizontal lines, but also for the vertical ones. In the drawing by Diane Olivier (Fig. 5–31) notice that the sides of the buildings converge at a point beyond the top of the page.

FIGURE 5–31
DIANE C. OLIVIER
Sansome and Battery
Charcoal on paper, 84 × 66 inches
Collection of artist, courtesy, Dorothy Weiss Gallery, San Francisco, CA, photographer Robert Haavie

FIGURE 5–32

THREE-POINT PERSPECTIVE AND THE TILTED BOX

When a box is tilted away from the ground plane, a case can be made for drawing it in three-point perspective. The necessity for this treatment is especially clear when you tilt an oblong box toward or away from your picture plane as in Figure 5–32.

Exercise 5D These projects will enable you to apply the rules of three-point perspective.

Drawing 1. *Find an oblong box or block of wood. Prop it up so that it is leaning toward you. Draw the box taking care to angle all the sides carefully.*

Drawing 2. *Put a large cardboard box on the floor. Situate your easel as close to it as you can, yet retain a view in which you can see two side faces and a top face (or interior) of the box. Do the vertical sides of the box appear to converge at a point below the floor? Draw the box using a combination of angling and your knowledge of perspective.*

Any rectangular object, such as a chair (Fig. 5–30), may substitute for a box in this exercise.

Drawing 3. *Situating yourself cater-cornered to a very tall building, draw it in three-point perspective.*

6

Form in Space

Have you ever had the experience of looking at an object and suddenly feeling that it possessed an extraordinary power? It may have been an intricately organized flower that you investigated carefully for the first time, a worn coiled rope glistening with tar and resins that you unexpectedly glimpsed along the railroad tracks, or a well-rusted, unidentifiable machine part that you picked off a vacant lot as a child and kept for years before throwing it out in a fit of spring cleaning.

The word "presence" is used to describe this mysterious power that is sometimes inferred from the forms of objects. Objects are said to command our attention in this way when they seem to be charged with hidden meanings or functions which, like some secret code, we cannot penetrate. This can hold true even for things we have seen and used and taken for granted, such as objects of common utility. Seen in a different context or from an unusual viewpoint, an otherwise ordinary object may suddenly assume a totally new identity.

From time to time, many people will experience this rather romantic and usually fleeting impression that objects have a transcendental meaning. This is especially true of artists who are accustomed to finding significance in form and who return to these experiences as models for the quality of presence that they wish to achieve in their own works.

Most artists, in fact, become so sensitized to visual experience, that they regularly discern unnameable powers in forms they encounter. For them the powers sensed in an object can be translated into expressive potential when they draw. But first they must complement these sensations with a more deliberate search for the prominent form characteristics of the object in question. For example, in his drawing of a screw (Fig. 6–1), Claes Oldenburg identifies spiraling movement and linear direction as those characteristics essential to the form. He exaggerates these properties by transferring to the shaft the movement that properly belongs to the threads themselves, thus greatly increasing the object's spatial gesture. Moreover, the monumental scale that he gives this most commonplace of small objects, invests the image with all the fearsome torque of a tornado.

The Oldenburg drawing succeeds in evoking presence because it takes distinctive characteristics of "screwness"—spiraling movement, tensile strength,

and linear direction—and gives them unanticipated emphasis. But in order to achieve this without resorting to caricature, the artist had to have a clear concept of the actual physical form of the screw.

The Visual and the Tactile

We use two perceptual systems to acquaint ourselves with the three-dimensional condition of an object: vision and the sense of touch. Psychologists tell us that these two senses work in tandem and that knowing what one sees is to a great extent dependent on being able to verify it by the sense of touch.

Although drawing is a visual medium, those drawings that strike the deepest chord within us usually recall a memory of tactile sensations. In the portrait by Edwin Dickinson (Fig. 6–2), the illusion of the elderly woman's soft flesh

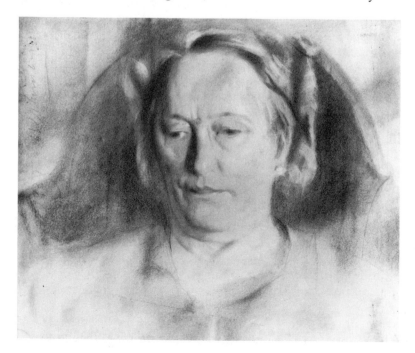

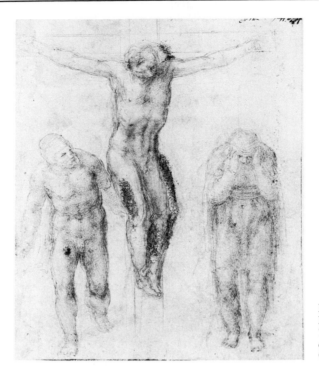

FIGURE 6–3
MICHELANGELO
The Crucifixion
Copyright to the photograph Ashmolean Museum, Oxford

and thinning hair evokes an almost physical response in the viewer. In the Michelangelo drawing, on the other hand (Fig. 6–3), the tactile stimulus is located in the concentric searching lines. The viewer empathizes with the artist's repeated attempts to recreate on the surface of the paper how it would feel to physically embrace each of these forms.

Form and Gestalt

All three-dimensional objects possess mass, volume and form.

For the purpose of the artist, *mass* may be defined as the weight or density of an object. In most cases weight and density are experienced through tactile, as opposed to visual, means. The term *volume* expresses the sheer size of an object and by extension the quantity of three-dimensional space it occupies.

Form refers to the three-dimensional configuration of an object. Form sets the specific spatial limits of an object and also encompasses the notion of its structure or organization. Of the three properties, mass, volume and form, it is the latter that interests artists the most.

Form is most easily grasped by visual means, and yet we can receive only a limited amount of information about an object's form from any single point of view. To get a more complete picture of a whole form, we must obtain several views of it and synthesize them in our mind's eye. The more complex and unfamiliar a form is, the more difficult this process will be. Figure 6–4 shows how Leonardo da Vinci gradually rotated an arm to assist his understanding of its musculature.

The term *gestalt* is used to describe a *total* concept of a form. Some objects have a strong gestalt, that is, when seen from a single point of view their entire three-dimensional character is readily comprehended, as is the case with simple structures, such as the basic geometric solids (the sphere, cone, cylinder, pyramid and cube). The instant gestalt recognition of these forms is due in part to our familiarity with them. But they are also each defined by a set number of surfaces that are at predictable relations to each other.

You might take a moment to try obtaining a gestalt (or total picture) of something with which you have daily contact—say a coffee mug. Pick it up and

FIGURE 6–4
LEONARDO DA VINCI
Muscles of the right arm, shoulder and chest
Courtesy of Windsor Castle, Royal Library, © Her
Majesty Queen Elizabeth II

get to know its various surfaces. Can you remember the motions you go through when washing it? How much coffee does it hold compared to other mugs that you use? After you have asked these questions, set the mug down and look away from it. You should be able to retain a concept of its three-dimensional form in your mind's eye, and even be able to recreate different views of it. This exercise will greatly increase your ability to imagine forms in the round and draw them convincingly.

Approaches to General Form Analysis and Depiction

You have probably at some point had the desire to draw a highly complex form. Confronted with an object whose surface was characterized by a wealth of detail or numerous subtle turns, you may have felt at a loss about where to begin. But essential to a strong representation of any form is a feeling for its overall spatial structure. To assist you in depicting the overall structure of forms, we will now present several simplified approaches to form analysis. While it may benefit you at the start to try these approaches separately, you will eventually wish to use them in combination in order to produce richer and more resonant drawings.

GENERALIZING THE SHAPE AND STRUCTURE OF COMPLEX FORMS

When setting out to draw a complex object you should simplify your initial approach to its form. Such an approach might entail that you rely solely upon what you see in order to generalize the form; or you might try to understand the form through a combination of observation and using your imagination to

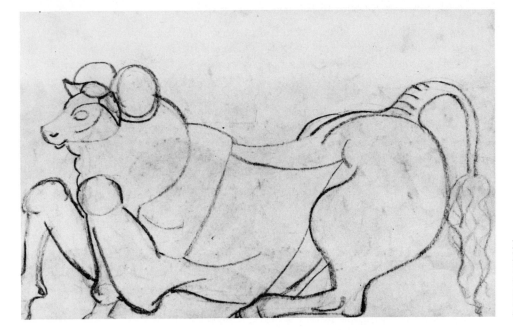

FIGURE 6–5
Reuben Nakian
Bull Crouching, 1921
Crayon, 10 × 15 inches
Gift of Gertrude Vanderbilt Whitney, collection of Whitney Museum of American Art, New York, acquisition # 31.562

visualize that part of its essential structure which you cannot actually see. Specific methods for summarizing the form of complicated objects are listed below.

Form summary is a technique that is used to describe a more complex or articulated (jointed) form in simpler terms. When summarizing such a form you need not feel restricted to using box-like volumes. In his drawing of a bull crouching, Reuben Nakian plays taut rounded forms against each other to achieve an effect that is as virile as it is decorative (Fig. 6–5).

Shape summary is another means to generalize form. Shape summary does not entail an exact delineation of the outer contour of a shape. Rather, when making a shape summary, one first sizes up the major areas of a three-dimensional form and then records them in terms of flat shape. The Theo van Doesburg drawing of a cow (Fig. 6–6) is a good example of shape summary. Notice that the head is seen in terms of a series of rectangular shapes, the neck and shoulder as a triangle, and the haunch as an inverted triangle.

FIGURE 6–6
Theo van Doesburg
Study for the Composition (The Cow), 1917
Pencil, 4⅛ × 5¾ inches
Collection, The Museum of Modern Art, New York, gift of Nelly van Doesburg

GESTURE AS A MEANS OF EXPLORING FORM

In previous chapters we have discussed gesture drawing as a way to represent the general pattern of things as they are arranged in space (Chapter 1) and also as a primary means for organizing a drawing's surface design (Chapter 4). Extended to the practice of depicting form, gesture drawing can be useful not only for revealing those aspects of a form which can be seen, but also for suggesting something of the form's internal forces and stresses.

Gesture drawing necessarily involves a good measure of empathy on the part of the artist for the subject; that is, the artist must feel out with marks, tones, or lines the essential structure and energies of what is being drawn. To this end Rodin, without looking at his page, let the gesture of his pencil line recreate the spirit of a dance (Fig. 6–7).

The subject in the Matisse (Fig. 6–8) is more static in nature. Here the outer contour of the figure seems to have been arrived at through a series of trials which have left a radiating energy about its form. But much of the gestural force of the drawing is a result of the feeling for internal stresses expressed by the sharply contrasting lights and darks in the weight-bearing leg. This plus the effect of the other leg dragging through the shadows helps us to identify with the physical gesture of the model.

Artists frequently use gestural marks to diagnose and express the relative position and scale of an object in space. These marks are generally called *diagrammatic marks*, because they are often so direct and graphic, as in Figure 6–9. Or look at the drawing by Wolf Kahn and see how his stroking, gestural marks "feel out" his tactile impressions of a cow (Fig. 6–10). And note how the contrast

FIGURE 6–7 (left)
AUGUSTE RODIN
Untitled Drawing
Pencil and watercolor on paper
Rodin Museum, gift of Jules E. Mastbaum

FIGURE 6–8 (right)
HENRI MATISSE
Standing Nude 1901–1903
Brush and ink, 10⅜ × 8 inches
Collection of the Museum of Modern Art, New York, gift of Edward Steichen

FIGURE 6–9
JODY PINTO
Skin Tent for a Backbone
Watercolor, gouache, graphite, and
crayon on paper, 30 × 39¾ inches
Collection of Whitney Museum of American Art,
New York, gift of Norman Dubrow

FIGURE 6–10
WOLF KAHN
Prize Cow, 1955
Pencil on paper, 9 × 12 inches
(wk 1419)
Courtesy Grace Borgenicht Gallery

between the well-defined marks portraying the handle-like tail and the sketchier
ones indicating her head gives us a strong sensation of the way the cow is
oriented in space. This differentiation in clarity of marks is an example, if you
will, of aerial perspective used to show varying distance within a single object.

FIGURE 6–11
Student studies of a piano

Gesture drawing is generally done rapidly and is thus admirably suited to a moving subject, as in Figure 6–7. But the intense energy and level of identification required for gesture drawing also makes it a most important means for making quick studies of inanimate objects. So prior to undertaking a drawing of longer duration, an artist will frequently do a series of gesture drawings in order to invest the more prolonged drawing of a stationary subject with greater energy (Fig. 6–11).

But even when drawing for a long period of time, a feeling for the subject's gesture may be sustained. The Mondrian drawing (Fig. 6–12) is just such an

FIGURE 6–12
PIET MONDRIAN
Chrysanthemum, 1906
Pencil, 14¼ × 9⅝ inches
*Collection, The Museum of Modern Art, New York,
gift of Mr. and Mrs. Armand P. Bartos*

example of how a subject of considerable complexity may be accurately drawn without sacrificing the gestural energy of its overall form. In this drawing, seemingly countless petals come curling aggressively out from the center of the flower towards the viewer. But notice that although each petal is individually modeled and thus holds its own space, their unruly conglomerate adds up to a clearly felt spherical mass. Such a powerful illusion of a writhing mass would not have been possible unless the artist had from the very start a clear idea of the overall form of the flower head. Thus, by combining an initial analysis of the general form with careful observation of the spatial activity of the individual petals, he gave to the insubstantial flower an immense spatial presence.

LINE AND SPATIAL STRUCTURE

You will find that line is an invaluable tool for analyzing the spatial aspects of form. What makes line so effective in showing the turn of surface on a three-dimensional form is, strangely enough, its unidirectional character. By definition line travels from point to point. To illustrate this, look at the drawing by Agnes Denes (Fig. 6–13) where the delicate diagrammatic lines connect carefully plotted points to direct the eye around the form in a measured way.

OUTLINE VERSUS CONTOUR LINE

Before we proceed to discuss the potential of line to depict form it is necessary to differentiate between outline and contour line.

Outline may be defined as a boundary that separates a form from its surroundings. Usually regarded as the most primitive of all artistic techniques, outline works best when it is reserved for depicting literal flat shapes, such as the illustrations of road signs in a driver's manual. The tendency for outline to direct the viewer's attention to the two-dimensional spread of the area it encloses confounds any power it might have to depict three-dimensional form. Additionally, the uniform thickness, tone and speed of an outline does not distinguish between those parts of a form that are close to the picture plane and those farther

FIGURE 6–13
AGNES DENES
Map Project—The Snail, 1976
Lithograph, printed in color, 24$\frac{1}{16}$
× 30$\frac{1}{16}$ inches
Collection of The Museum of Art, New York, John B. Turner Fund

FIGURE 6–14

from it. Thus the outlined image of a man walking his dog (Fig. 6–14) looks as flat as the images of road signs.

Another long-held objection to outline is that in recording the outer edge of an object, one unavoidably draws attention to that part of the object farthest from the eye. Because of the dynamics of figure–ground play, this line tends to push forward, allowing the interior of the shape to fall back. Thus a circle drawn to represent a sphere will look more like an empty hoop, especially if it is drawn with a line of consistent thickness.

An alternative to outline is the *contour* line which may also be used to describe the outer edge of an object. But, unlike the outline which functions as a neutral boundary between the object and its surroundings, the contour line gives the impression of being located just within this border. So, contour line more properly belongs to the form of an object, as we may see in the Picasso portrait of Derain (Fig. 6–15). When you look at the outer contour, you will see that the artist is alluding to this edge as the last visible part of the form before it slips away from sight.

It is its varying thickness, and often tone and speed that gives contour line its capacity to suggest three-dimensional form. To demonstrate this, we have traced the Picasso drawing with a drafting pen so as to render the image with a line of uniform thickness. The result (Fig. 6–16) appears flat when compared to the original in which no line retains the same thickness for long.

Contour line can also be applied within the outer borders of a depicted form. In the Picasso drawing this use of contour is especially evident in the delineation of the folds in the sitter's jacket sleeve. An even more structural use of contour may be observed in the way the nose is drawn. Here, contour is used to indicate a break in planes.

A further example of the modeling effect of contour may be found in the drawing by Jean Ipoustegy (Fig. 6–17). Here line is used with great economy; a single line, indicating the weighted outer contour of the belly, travels up into the form to reveal the structure of the rib cage. A dark smudge representing the shadow cast by a protruding hipbone feeds into a line that tapers as it travels away from the picture plane over the form of the body, disappearing finally where the curve of the breast melts into the underarm.

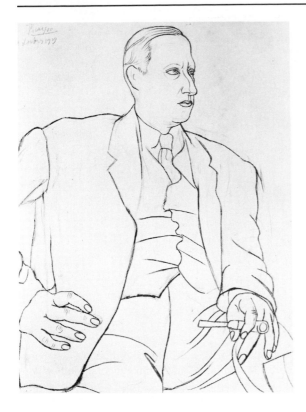

FIGURE 6–15 (top left)
PABLO PICASSO
Portrait of Derain, 1919
Courtesy of Art Resource

FIGURE 6–16 (top right)

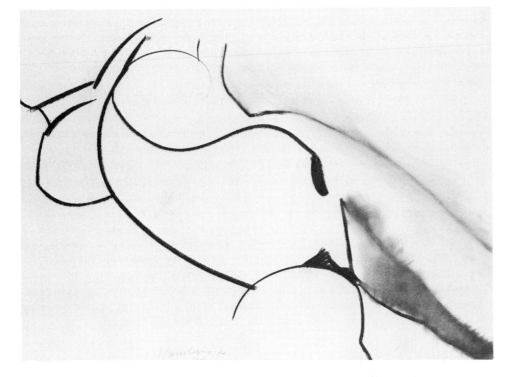

FIGURE 6–17
JEAN IPOUSTEGUY
White, 1970
Charcoal on paper mounted on
board, 21½ × 29½ inches #3026
*Solomon R. Guggenheim Museum, New York,
Photographer Carmelo Guadagno*

Blind contour* *is one of the best ways to get acquainted with how line may be used to express* ***Exercise 6A***
the structure of forms in space.

*Blind contour drawing is also discussed in Chapter 1.

FIGURE 6–18
Student drawing: blind contour
study of hands

Drawing 1. *Using pencil, ballpoint, or technical pen, do a series of blind contour drawings of your hand in different positions. Remember that blind contour drawing entails letting your eye creep slowly around the contours of a form without looking at your paper. Be sure to indicate major plane breaks within the form of your hand (Fig. 6–18).*

Drawing 2. *Arrange some objects that have a lot of curves into a simple still life. Vegetables such as cabbage or cauliflower, kitchen gadgets, and overstuffed furniture all make good subjects. Do a blind contour drawing of these objects, but this time change the thickness and value of the line more emphatically, exaggerating to some extent the principles of atmospheric perspective. In other words, where a form moves aggressively toward you increase the speed and pressure with which you draw to thicken, darken, and add clarity to your line. But as edges begin to drop from sight, slow down and let up on the pressure so your line becomes thinner and less distinct.*

Suggested media include fountain pen or brush with ink, a sharpened conte crayon or graphite stick, or a carpenter's pencil.

Drawing 3. *Blind contour is a tactic used by artists to heighten their awareness about how the form of what they draw "feels" to the eye. With that in mind, use the insights you've gained from your second blind contour study to make a more precise contour line representation of your still life, this time looking at your paper (refer to Fig. 6–16).*

MASS GESTURE

We use the term *mass gesture* to describe a complex of gestural marks that expresses the density and weight of a form. Artists have several ways of communicating that forms have weight and spatial presence. Among them is the laying in of marks, one on top of the other, until a sense of impenetrable mass is achieved, as in the drawing of a clay form (Fig. 6–19). In the Mazur drawing (Fig. 6–20), dark gestural marks imply the bulk of a human head.

Exercise 6B *Prepare yourself for this exercise in mass gesture by imagining what it would be like to tunnel under a mountain, or even to penetrate to the earth's center.*

Drawing from objects that are simple and compact in form (such as boulders, root vegetables, tree stumps, or stacks of books), concentrate on the sheer quantity and density of their matter. As you draw each object, begin by scribbling some tight, hard, knot-like marks to represent its core, or most active part. Ask yourself, if you had x-ray vision where would your eyes have to pass through the most matter in order to come out on the other side? Without lifting your charcoal from the paper, build out from the core with random scribbling, gradually lightening your pressure on the charcoal until you have reached the outer surfaces of the form (Fig. 6–21).

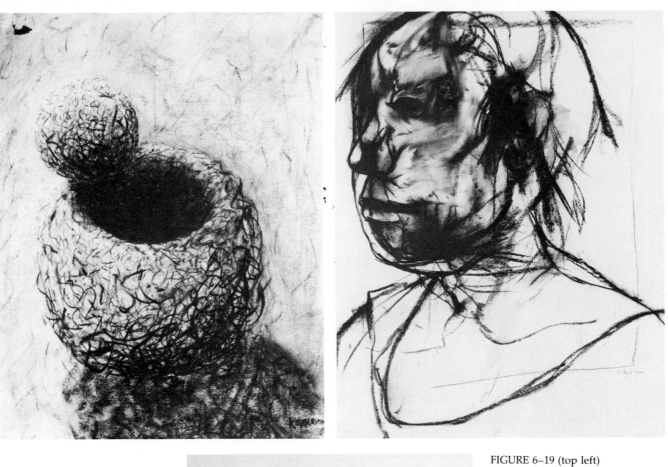

FIGURE 6–19 (top left)
Student drawing: mass gesture

FIGURE 6–20 (top right)
MICHAEL MAZUR
Untitled (Head), 1965
Charcoal on paper, 25 × 19 inches
*New York University Art Collection, Grey Art
Gallery and Study Center, gift of Paul Schapf, 1969,
photographer Charles Uht*

FIGURE 6–21

CROSS CONTOUR

Cross contours are lines that appear to go around a depicted object's surface, thereby indicating the turn of its form. You have already seen cross-contour lines in the drawing by Agnes Denes (Fig. 6–13).

Some forms have cross-contour lines inherent to their structure, such as the wicker bee-hives in Figure 6–22. In the Rockwell Kent drawing (Fig. 6–23), the natural contour lines existing in the ribbed surface of the lifeboat are visible in the small illuminated triangle on the right. On the other side of the boat, these lines are lost in shadow, but the artist indicates the shadow with lines that curve around the boat's surface in the way that the natural cross-contour lines do.

Cross-contour line need not be as precise or literal as in the above mentioned illustrations. In the drawing by Ernst Barlach (Fig. 6–24), the cylindrical masses of the woman's body are forcefully shown by the gestural lines sweeping

FIGURE 6–22
Workshop of Pieter Brueghel the Elder (Flemish, 1528–1569)
The Bee Keepers
Pen and brown ink, 204 × 315 mm, 1978.2.31

By permission of the Fine Arts Museum of San Francisco, Achenbach Foundation for Graphic Arts, Achenbach Foundation of Graphic Arts purchase and William H. Noble Bequest Fund

FIGURE 6–23
ROCKWELL KENT (1882–1971)
The Kathleen, 1924
Ink on paper, 6½ × 7½ inches, acquisition #31.548

Gift of Gertrude Vanderbilt Whitney, collection of Whitney Museum of American Art, New York, Acquisition #31.548

FIGURE 6–24
ERNST BARLACH
Woman Killing a Horse, 1910–11
Charcoal on paper, 10⅝ × 15¼
inches, #1172 × 189
Solomon R. Guggenheim Museum, New York.
Photographer Robert E. Mates

FIGURE 6–25
DALE CHIHULY
Untitled, 1983
Graphite and W.C. on paper, 22 ×
30 inches
Courtesy of the Charles Cowles Gallery, New York

across her form. These lines impart to her image an illusion of solidity and power that makes credible the idea that she is more than a match for the much larger horse.

In his drawing of vessels, Figure 6–25, the glass artist Dale Chihuly develops a strong sense of form with no recourse at all to outer contour. The heavily dimpled surface of the top study is amply indicated by a loose and varied collection of cross-contour lines and marks. In the two spherical forms at the bottom of the page, the lines weave about in a more continuous fashion, giving the impression of massive but transparent receptacles.

Cross-contour marks and lines reinforce the apparent solidity of depicted forms. To make yourself more adept at executing cross contour, follow the steps of this exercise.

Exercise 6C

Drawing 1. *Find a subject with naturally occurring cross-contour lines. Objects such as bird cages or open-weave baskets make ideal subjects because their relative "transparency" allows you to trace their cross-contour lines around to the far side of their forms.*

113

Observe how the cross-contour lines reveal the structure of your object. Avoiding the outer edges of your subject, draw lines that record the relative angles or sweeping curves of its cross contours. Be selective, especially if your subject is very detailed. In other words, draw only those lines that best give a sense of the form.

Drawing 2. *Find an object with both swelling and indented surfaces. If possible, draw roughly parallel lines around its form. (Think of them as the latitude lines on a globe.)*

Represent your subject with a loose system of cross-contour marks, referring to the parallel lines on the form in order to better understand the major turns of direction of the form's surface. If your approach to this drawing is very gestural, use marks that appear to wrap around the entire form, as in the Dale Chihuly drawing (Fig. 6–25).

PLANAR ANALYSIS

To investigate and give spatial definition to curvaceous forms, artists will sometimes turn to planar analysis. Planar analysis entails a structural description of a form, in which its complex curves are generalized into major planar, or spatial, zones.

Planar analysis is especially helpful when the surface of the form is comprised of numerous undulations, or if the outer contour of the form gives no clue to the surface irregularities within its shape. A pillow, for instance, may have a geometric shape from some aspects, but this shape will not communicate the plump curves of its form. In the drawing of a cushion, Figure 6–26, the sense of volume has been communicated by planar treatment.

In Figure 6–27 the complex curves of a form's surface have been broken into facets. Each facet has been given a "hatched" line pattern that indicates the inflection of its plane and imparts to a rather soft and wobbly form a strong sense of spatial definition and solidity. (The term *hatched line* refers to an area of massed strokes that are parallel or roughly parallel to each other.)

In Figure 6–28 planar analysis is used to make the spatial gesture of articulated forms more apparent. And in turn, the choreographing of these blocked-in figures dramatizes the depth of the stage-like space.

FIGURE 6–26
Student drawing: planar analysis of a pillow

FIGURE 6–27
Student drawing: planar analysis
with hatched line

FIGURE 6–28
LUCA CAMBIASO
The Arrest of Christ, 1570–1575
Pen, ink, and wash
*Courtesy, the Frederick and Lucy S. Herman
Foundation*

Planar analysis is an excellent way to uncover the large, more simple structure that underlies complex looking forms. As a practical introduction to planar analysis, we have designed this exercise.

Choose a soft or semisoft form to draw. A sofa cushion, a slightly dented felt hat, or a

Exercise 6D

FIGURE 6–29
Student drawing: planar analysis of
paper bags

*half-stuffed canvas or leather bag should provide sufficient challenge. A paper bag, as in
Figure 6–29 makes a good subject because it has an abundance of clearly defined planes.*

*Look at the curved surfaces of your subject. Can you consolidate them into a series of
abutting planes? To help, look for any slight crease, raised or indented, which might be
interpreted as a planar division. A small lamp or flashlight may help you see these subtle
divisions. If possible, outline them by drawing directly on the surface of the object. Continue
tracing these planar divisions until the entire form appears to be made up of small facets.*

*Do a drawing of your object, copying the planar structure that you have imposed upon
it. To indicate the changing inflections of the surface, you may wish to add a hatched line
pattern to the individual planes, as in Figure 6–27.*

Surface Structure of Natural Forms

In examining a natural form, you may want to consider whether its surface
character is a result of the play of internal or external forces. The surfaces of
living things are generally determined by internal forces and structures, whereas
the surfaces of inanimate objects are generally determined by external forces,
such as gravity or erosion.

Concavities in forms are often a result of erosion. In the landscape by
Ruskin (Fig. 6–30), one sees a huge concave scar in the mountainside, evidence
of the grinding passage of a departed glacier. Within a much shorter temporal
span we may witness the concave shapes caused by the action of wind on sand
dunes, or the pressure of wind upon a sail.

Forms that are a result of natural growth rarely possess any true concavities.
If you carefully scrutinize any apparently concave surface on a living form,
chances are you will discover that it is actually comprised of several convex
areas. This is demonstrated well in the Segantini (Fig. 6–31) where there are
many points at which the outer contour of the form becomes concave. Yet in
all cases these apparent concavities are explained by the coming together of two
or more convex forms.

Convex forms give the impression of dynamic internal forces. Most natural
forms possess an internal structure that thrusts against the surface at particular
points. Bones protrude against the skin at the joints, contracted muscles bulge
at specific places, peas swell in their pods, and so forth. The presence of internal
force-points is elegantly shown in Ingres' drawing of a male nude (Fig. 6–32).

FIGURE 6–30
JOHN RUSKIN
Study of Part of Turner's Pass of Faido
© Copyright reserved to the Ashmolean Museum,
Oxford

FIGURE 6–31
GIOVANNI SEGANTINI (1858–1899)
Male Torso
Black Chalk, 312 × 204 mm
*Courtesy of The Harvard University Art Museums
(Fogg Art Museum), bequest Grenville L. Winthrop*

FIGURE 6–32
JOHN AUGUSTE DOMINIQUE INGRES
Three Studies of a male nude
Lead pencil on paper, 7¾ × 14⅜
inches
*The Metropolitan Museum of Art, Rogers Fund,
1919*

Whenever you draw a form that has compound curves, you should stop and analyze the forces that make them concave or convex. And remember that concave forms are generally caused by external forces, and that organic forms, or those caused by growth from within, are generally convex. (This holds true as well when you make sculpture. Convex surfaces seem to belong naturally to their volume, whereas concave forms suggest the hand or tool of the sculptor.)

TOPOGRAPHICAL MARKS

Topographical marks are any marks used to indicate the turn of a depicted object's surface. Cross contour lines and the hatched lines that artists frequently use to show the inflection of planes are both topographical marks.

Topographical marks may be seen in the Kollwitz (Fig. 6–33) where short parallel strokes follow the surface curvature of the heads. This work is of special interest because the smaller sketch, in which the marks describe the general form of the head, appears to be preparatory to the larger one, in which the topography of specific facial forms as well as the texture of the hair are indicated.

A looser and more spontaneous application of topographical marks may be seen in the drawing by Marsden Hartley (Fig. 6–34). The speedy marks in this drawing clearly suggest the presence and turn of rounded surfaces, but seem reluctant to pin them down, an effect well befitting a portrayal of human work rhythms.

Topographical marks may also be highly controlled, as in the drawing by Victor Newsome (Fig. 6–35). This drawing actually uses several different systems of marks to indicate the form of the head. The general form is built out from the picture plane by a set of concentric oval shapes. These function similarly to the contour lines showing relative altitude on a topographical map. A second set of lines crosscuts and circles the head, like the latitude lines on a globe. A third set includes the ribbed bands that wrap around the head turban-style, and the fine lines running in general over the terrain of the skull which indicate the play of light and shadow.

TEXTURE

Another topographical feature that you might wish to consider when dealing with the surface of an object is *texture*.

FIGURE 6–33
KATHE KOLLWITZ
Two Studies of a Woman's Head, c. 1903
Black chalk on tan paper, 19 × 24¾ inches
The Minneapolis Institute of Arts, donated by David M. Daniels

FIGURE 6–34
MARSDEN HARTLEY (1877–1943)
Sawing Wood, c. 1908
Pencil on paper, 12 × 8⅞ inches

Gift of Mr. and Mrs. Walter Fillin, collection of Whitney Museum of American Art, Acquisition #77.39

FIGURE 6–35
VICTOR NEWSOME (b.1935)
Untitled, 1982
Pencil, ink, and tempera, 22⅞ × 23½ inches, 58.2 × 59.7 cm., PCA 831024

Private Collection, courtesy Marlborough Fine Art (London) Ltd.

The texture of an object is sometimes directly related to its overall structure or organization, as in the convolutions of the human brain, or the spiny corrugated texture of a cactus. The texture of foliage, so skillfully rendered by Thomas Ender (Fig. 6–36), is a further example of texture that is inseparable from form.

At other times texture is a mere surface effect that bears no direct relation to the internal structure of the form; fur on an animal, the clothes on a human

FIGURE 6–36
THOMAS ENDER
Woman and Children in Front of a Tree
Pencil, 9 × 7¼ inches
Courtesy, the Frederick and Lucy S. Herman Foundation

body, or the shiny chrome on a car fender, are all examples of texture that is "skin deep."

But even a superficial texture will sometimes provide you a valuable clue about the particular turn of a form, as can be seen by looking again at Figure 6–33, in which the chalk strokes that indicate the coarse texture of the hair also model the volume of the head.

PATTERN

Surface pattern helps a viewer grasp the curvature or shifting angles of a surface.

In the Grant Wood drawing (Fig. 6–37), note the pattern on both flat and rounded surfaces. On the angled flat surface of the dividing wall, the wallpaper pattern is drawn in perspective. The lattice pattern found on both the tablecloth and a farm woman's dress is an example of the way patterns can illusionistically wrap around a curved form, adding to its impression of solidity.

FIGURE 6–37
GRANT WOOD (1892–1942)
Dinner for Threshers (right section), 1933
Pencil, 17¾ × 26¾ inches
Collection of Whitney Musem of American Art, photographer Geoffrey Clements

7

Form in Light

The vivid impressions of form we receive through certain light effects have preoccupied Western artists for a long time. Consider the following observations recorded by Leonardo da Vinci in his *Trattato della Pittura*: "Very great charm of shadow and light is to be found in the faces of those who sit in doors of dark houses. The eye of the spectator sees that part of the face which is in shadow lost in the darkness of the house, and that part of the face which is lit draws its brilliancy from the splendor of the sky. From this intensification of light and shade the face gains greatly in relief . . . and beauty."

This admiration for light's descriptive and transformative powers persists unabated today. In the drawing by Claudio Bravo (Fig. 7–1), a dramatic use of light and shadow has changed an unremarkable subject into a thing of great

FIGURE 7–1
CLAUDIO BRAVO (b. 1936)
Feet, 1983
Charcoal and pencil on paper, 15 × 15 inches (NON 29.564), signed and dated lower right
Private collection, courtesy Marlborough Gallery

121

loveliness. We are transfixed by the sheer voluptuousness of the form, and also by the quality of light in which it is bathed.

The Directional Nature of Light

In the Bravo drawing we have a strong impression that the light, diffused as it may be, is nevertheless coming from one dominant direction. If we attempt to pinpoint the source of the light within three-dimensional space, we would say that it is located in front, above, and to the left of the subject. We make this calculation by observing the position of the lights and darks on the form and also by observing the angle of the shadow cast by the feet upon the floor.

We may locate the light source in Figure 7–2 with just as much certainty. Since the lefthand walls and portions of roofs in this drawing are illuminated, and the shadows are cast in front of the buildings, we can assume that the light source is fairly high and located off to the left and in back of the subject. (By observing the length of the cast shadows we may even conjecture that the subject is portrayed at midmorning or midafternoon.)

Now, look at this drawing overall and you will see that a definite pattern of light and dark emerges. Most of the planar surfaces that face left, most of the ground plane, and all surfaces parallel to the ground plane (such as the tops of the broken walls) are illuminated. All surfaces roughly parallel to the picture plane and those portions of the walls which are under eaves, are in shade.

As a last example, note the direction of light in the drawing by Wayne Thiebaud (Fig. 7–3). In this case the fairly high light source is located directly to the right of the subject. That it is neither in front nor in back of the subject may be determined by observing the horizontal direction of the cast shadows.

Value Shapes

Value refers to black, white, and the gradations of gray tone between them. Figures 7–2 and 7–3 may be described as drawings that emphasize value over line. But notice that in both of these drawings the subject's lights and darks have been represented by using value shapes: that is, each shape in the drawing

FIGURE 7–2
Valentijn Klotz
View of Grave, 1675
Pen and brown and gray ink and
blue watercolor washes
Courtesy, Courtauld Institute Galleries, London

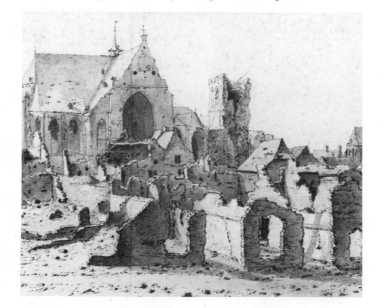

FIGURE 7–3
WAYNE THIEBAUD
Pies, 1961
India ink on paper, 19 × 24⅞
inches
*Rose Art Museum, Brandeis University, Waltham,
Massachusetts, gift of the Friends of the Rose Art
Museum Acquisitions Society*

has been assigned a particular tone that is coordinated with the values of other shapes in the drawing.

Take special note of how the subject in Figure 7–3 has been restricted to shapes of black and white, making it a two-tone drawing. Two-tone drawings are not limited to black and white, however; they may be made by pairing any two values from black, through the intermediate grays, to white.

As we have seen, the use of value shapes is admirably suited to creating an illusion of light striking flat surfaces. But rounded surfaces may also be implied in a drawing if the value shapes correspond to the way areas of light and dark follow the curve of the form.* In the drawing *Isabelle* (Fig. 7–4), value has been massed into semiamorphous shapes that convey an impression of form in a shimmering haze of light.

FIGURE 7–4
MARVIN CHERNEY
Isabelle, 1962
Oil on paper, 14⅝ × 12⅝ inches
*Gift of Samuel Shore, collection of Whitney Museum
of American Art, acquisition #62.35*

*The use of *chiaroscuro* to create the illusion of tones blended on a rounded form is discussed later in this chapter.

(a) (b)

FIGURE 7–5

Exercise 7A This exercise in value shapes will assist you in expressing a convincing sense of form and light with a minimum of means. Appropriate media include charcoal, brush and ink, black and white gouache or acrylic, and collaged papers.

Before proceeding, remember that when using value to distinguish between two planes that are located at different angles to a light source, you should be careful to carry the tone all the way to the edge of the shape. Notice that in Figure 7–5a, in which the boundaries between planes are indicated by lines surrounded by white margins, the illusion of abutting planes is not so clear as in Figure 7–5b.

Drawing 1. This drawing will be done using two tones. In a somewhat darkened room, arrange some brown cardboard cartons so they are illuminated by one strong spotlight. Under this kind of lighting the shadowed sides of the cartons, their cast shadows, and darkened surroundings (or "background") will probably all be converted into a single, uniform dark tonality. The illuminated tops, sides, and ground plane will figure as the light value.

Draw two squares in the margin of your paper. Fill one with the dark tone you see in your subject, the other with the light tone. If white is to be the lightest value and you are using gouache or acrylic, paint the one square white; otherwise leave it the tone of your paper.

Using the squares as your tonal key, draw the subject as areas of light or dark. Since a system of value shapes is the emphasis of this exercise, it is not necessary to make a preparatory line drawing. Remember that connecting planes identified as all dark or all light should be consolidated into one shape (for an example, refer to Fig. 7–3).

Drawing 2. This time you will use three values. Depict the cartons (or other angular objects) by making a collage of torn paper, in tones of black, white, and middle gray (Fig. 7–6).

FIGURE 7–6
Student collage using three values

FIGURE 7–7
Student drawing using five values

Drawing 3. *On a sheet separate from your drawing paper, make a row of five contiguous tones, from light through middle gray to dark. Note that tones two and four will be an average of the middle gray and, respectively, the lightest and darkest values in the end squares.*

Utilizing all five tones, depict a set of common objects against a ground plane of one constant value (Fig. 7–7).

Local Value and the Value Scale

Two factors regulate the amount of light that is reflected off a surface. The first is the degree of illumination the surface receives. This is determined by the angle of the surface in relation to the light source: surfaces perpendicular to the rays of light will appear the brightest; those parallel to the rays will be of middle-brightness; and those turned away from the light source will be the darkest.

The second factor is the inherent color of an object's surface. The surface of an object that is dark in color, such as a desk with a deep walnut finish, will reflect less light than one that is equally illuminated but of a paler color, such as a powder blue telephone. So, a basic attribute of any color is its relative lightness or darkness. Artists who work with traditional "black and white" drawing media analyze the lightness or darkness, or color tone, of objects and record them as value.

Often, artists will squint at their subjects, concentrating on how the eye, much like the lens mechanism of a camera, admits the relative lights and darks of the colored surfaces they want to draw. This strategy allows them to more readily ignore the colors and identify the *inherent* tonality of each object's surface. This inherent tone, free of any variations that result from lighting effects or surface texture, is commonly referred to as the *local value* of an object.

Local values may be broadly translated into shape areas, as in Figure 7–8. In this early drawing by Picasso, the dark tone of the seminarians' robes contrasts sharply with the paleness of their faces and likewise with the delicate tones of the ground plane and surrounding walls. The middle gray of the trees has a calming and softening effect on this otherwise stark portrayal.

FIGURE 7–8
PABLO PICASSO (Spanish, 1881–
1973)
Priests at a Seminary
Pen, ink, watercolor
*Private collection, photograph courtesy of the
Museum of Art, Rhode Island School of Design*

Picasso's decision to virtually limit his tonal palette to the local value of each individual area in Figure 7–8 heightens the work's expressive impact. Frequently, though, artists wish to consider not only the local value of their subject but also the major variations of surface tone that are caused by incidences of light. In this circumstance, the local value can function as a tonal center, or constant, to which artists may relate the variable lights and darks they interpret from an object. To clarify this point look at Figure 7–9 where the rectangular shafts of light are each divided into three carefully measured tones to register respectively the local values of the wall, molding, and blackboard.

Armed with an awareness of local value, you will gradually become more sensitive to the intimate alliance between the essential lightness or darkness of an object and the value variations that appear on its surface. As a consequence, any tendency to represent all light as white and all shadows as black will be moderated by personal observation. In actuality, such extremes of light and dark on a single form are rare under normal lighting conditions. More often you will notice that only objects with a local value of dark gray will approach black in the shadows, and the highlight on such a form will seldom exceed middle gray. Similarly, the local value of an egg simply does not permit a coal black shadow.

FIGURE 7–9
NORMAN LUNDIN
San Antonio Anatomy Lesson, 1982
Pastel and charcoal, 28 × 44 inches
Courtesy of Space, Los Angeles, California

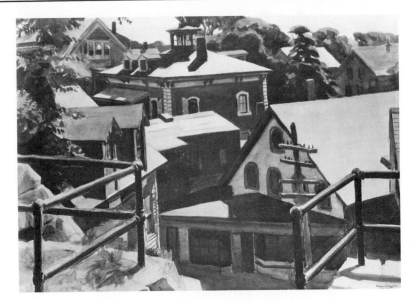

FIGURE 7–10
EDWARD HOPPER
Houses in Gloucester
Watercolor, 13½ × 19½ inches
(APG 10044 d)
Collection of Mr. and Mrs. James A. Fisher,
Pittsburgh, Pennsylvania

Directional Light and Local Value

In his drawing *Gloucester Houses* (Fig. 7–10), Edward Hopper indicates both a directed source of light and a range of local values. Although any sense of a tonal center in most of the roofs is obliterated by the powerful light of the sun, local values are clearly evident in the shaded portions of the houses. Compare this drawing to Figure 7–2 in which all the buildings and the ground plane are treated as if they were of identical local value.

When you combine an interest in directed light with the use of local value it is best, whenever possible, to control the source of illumination. Strong lighting, such as that provided by direct sunlight or the use of a spotlight alone, will produce a sharp contrast between lights and darks and thus make it difficult for you to see local value (see Fig. 7–11a). An even light, such as you would find in a room well-lit by fluorescent tubes, will reveal local value very well, but since such light is nondirectional it will not show the form of an object to advantage. The ideal lighting condition for observing both the local value and the form of an object is one in which the light is directional, but not harshly so, such as might be found by a window that does not admit direct sunlight, (Fig. 7–11b).

To give the illusion of both directional light and local value, you will need to have a command over a range of tones. To acquaint yourself with the tonal spectrum of which your media is capable, we suggest that you make a scale of

FIGURE 7–11a (bottom left)

FIGURE 7–11b (bottom right)

nine separate values. The value scale in Figure 7–12 is particularly useful because the dot of middle gray in the center of each square demonstrates the relative nature of value. The same midgray that appears as a dark spot in the midst of light-toned squares appears as a pale spot within the context of the darker values.

In making a scale of this kind, we suggest that you start by lightly outlining nine adjoining squares with a circle in the middle of each one. Place the darkest and the lightest tones that you can achieve with your media on opposite ends of the scale, taking care to leave the circles blank. Then proceed to fill the middle square and the circles with a middle gray. Finally, fill in the remaining squares so that there is an equal jump in tone between them. Remember to blend each individual tone thoroughly, leaving no white margin or black dividing line between the squares.

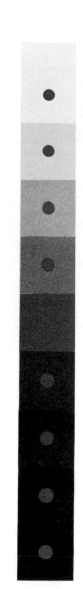

Exercise 7B

Representing a directed source of light in a drawing will lend a sense of authenticity to the objects you portray. Care in relating the variable tones on an object to a tonal center will give your interpretation of those objects a convincing sense of unity and wholeness and also add optical richness to your drawing overall. This project helps you apply both of these concepts in drawings of relatively simple, common objects.

Collect some boxes or other angular objects of different local values. You may even wish to paint these boxes black, gray, and white using a cheap brand of house paint. Experiment with both the intensity and the direction of your lighting so that both the local values and the forms of the boxes are seen to advantage. It is also advisable to view these objects against a medium gray background so as to provide you with a constant reference point when gauging values in your subject.

In a row of squares along one margin of your paper, indicate the local value of each object in your subject, going from left to right. Now, depict the planes of each object as a value shape, making sure that the tones you put down are within a range of lightness or darkness appropriate to the tonal center, or local value, of that object.

You may want to establish the boundaries of your very lightest shapes first, that is, those you wish to have remain the white of your paper. Give the rest of the page a light gray tone and then proceed to fill in your very darkest and middle gray shapes. After these have been drawn, move on to the remaining intermediate tones.

As an alternative, you may wish to draw a set of buildings under different lighting conditions in order to experience the effect light can have on your perception of local value (Fig. 7–13). Or do a self-portrait in value shapes with the aim of expressing the local value of your skin and hair when illuminated by a direct light source (Fig. 7–14).

Optical Grays

Certain dry media, such as pastel or charcoal, and wet media, such as ink wash, watercolor, gouache, and acrylic, are commonly used to make flat *actual* gray tones. Media more suited to a linear approach, such as pen and ink, pencil, felt-tip marker and silverpoint, may be used to create *optical* gray tones. Optical grays are commonly the result of hatched or "cross-hatched" lines which the eye involuntarily blends to produce a tone. You will recall from Chapter 6 that the term "hatched lines" refers to an area of massed strokes that are parallel or roughly parallel to each other. *Cross-hatching* is a technique that results when sets of these lines intersect one another.

Optical grays may be utilized to achieve the same ends as blended or actual grays. In the drawing by Gaspard Dughet (Fig. 7–15), hatched parallel lines indicate the relative tones of trees and sky. Notice that the hatched lines do not change direction in an attempt to show the topography of the form. Instead, their role is restricted to the depiction of light and dark. In spite of their mechanical look, hatched lines of this sort are well suited to drawing natural subjects. And, in contrast to areas of subtly blended tone, the rapid laying in of hatched lines appears to allow a form to breathe.

FIGURE 7–12

FIGURE 7–13 (top left)
Student drawings of houses under different lighting conditions

FIGURE 7–14 (top right)
Student self-portrait using shapes of tone to express local value

FIGURE 7–15
GASPARD DUGHET (1615–1675)
Landscape
Red chalk, 27.4 × 41.3 cm (68-1)
Courtesy of The Art Museum, Princeton University, gift of Margaret Mower for the Elsa Durand Mower Collection

FIGURE 7–16
HENRY MOORE
Women Winding Wool, 1949
Watercolor, crayon, and brush, 13¾
× 25 inches
Collection of The Museum of Modern Art, New York, gift of Mr. and Mrs. John A. Pope in honor of Paul J. Sachs

A robust and gestural use of cross-hatched lines to construct shadows may be seen in Figure 7–16. Notice how the varying densities of hatched lines help establish the spatial position of the forms and their gradual emergence from the shadows. This approach to value is an additive one; in other words, the artist began with some selective scribbling and continued to add marks here and there until the form was sufficiently developed.

An additive approach is particularly evident in Figure 7–17 which showcases an unorthodox technique for achieving optical grays. In this stamp-pad ink drawing by Chuck Close, fingerprints of different intensities have been carefully daubed onto a grid.

FIGURE 7–17
CHUCK CLOSE
Phil/Fingerprint II, 1978
Stamp-pad ink and pencil on paper, 29¾ × 22¼ inches
Purchase, with funds from Peggy and Richard Danzigger, collection of Whitney Museum of American Art, Acquisition #78.55

Drawing with hatched and scribbled lines is an excellent way to record your spontaneous impressions of things observed. For this reason, scribbled tone drawing is an especially useful sketchbook practice, so you will probably have ample recourse to it in the future.

For this exercise we suggest using a felt-tip marker, since it is ideal for fast renditions of objects. Start by making a value scale of nine optical grays (Fig. 7–18). This will help you gain sufficient control with your felt-tip marker to begin making drawings of actual objects.

Next, find an object that possesses a fairly complex system of concavities and convexities and place it where it will receive illumination from basically one direction. Draw the major shadows with your marker, using either a carefully hatched or scribbled line. Continue adding marks until the form starts to appear. Areas of darkest shadow will ultimately receive the most attention. Fig. 7–19 is an example of carefully controlled scribbled line used to build optical grays.

Exercise 7C

FIGURE 7–19
Student drawing using scribbled line to achieve optical grays

FIGURE 7–18

Chiaroscuro

Chiaroscuro is an Italian term that basically translates to mean light and dark. In the pictorial arts chiaroscuro refers more specifically to a gradual transition of values used to achieve the illusion of how light and shadow interact on actual, three-dimensional forms.

However, only certain kinds of light will adequately reveal the curvature of a rounded form. A very harsh light, for instance, will tend to flatten areas of light and dark into value shapes, as the earliest masters of chiaroscuro knew. Leonardo cautioned against drawing under any lighting conditions that cast strong shadows. In his *Trattato della Pittura* he outlines specific recommendations for illuminating the head of a young woman so that it can be drawn with all its delicacy and charm: the model should be seated in a courtyard with high walls that are painted black, and direct sunlight should be excluded from the space by a roof fashioned of muslin. Whether or not Leonardo ever followed his own set of guidelines, the drawing in Figure 7–20 is certainly evidence of his fascination with the ability of light to model form.

Impractical as Leonardo's advice may be, the general point it makes is sound: a very strong light source must be avoided when the intention is to concentrate on the three-dimensionality of a subject. But, so too, must the situation be avoided in which the subject is illuminated entirely by *ambient light*.

Ambient light is the opposite of a unidirectional light source since it appears to come from all directions. The familiar white-walled institutional room, lit with banks of fluorescent tubing, is drenched with ambient light. Although in some circumstances daylight may also be defined as an all enveloping ambient light, the daylight that comes into a studio with north facing windows is traditionally favored by people who draw. This is because it is sufficiently directional to reveal form, yet not strong enough to cast harsh shadows.

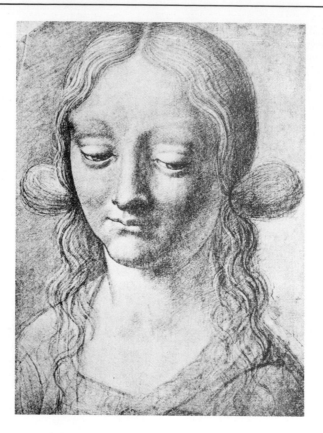

FIGURE 7–20
Leonardo da Vinci
Portrait of a Woman
New York Public Library picture collection

Let us imagine that you are situated in a studio with north light and that the back of your left shoulder is pointed toward the window. The light source is, therefore, behind you, above you, and to the left. In front of you is a light gray sphere softly illumined by light coming in the window and reflected from the light gray tabletop.

The gradations of light that you would see on the sphere may be separated for convenience sake into five separate zones, with the addition of the sphere's cast shadow. These zones, illustrated in Figure 7–21, are as follows:

1. The *highlight,* or brightest area of illumination. The highlight appears on that part of the surface most perpendicular to the light source. If the surface is a

FIGURE 7–21

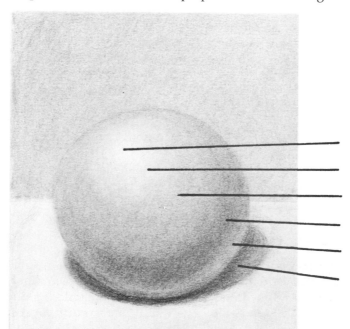

Highlight
Quarter tone
Half tone
Base tone
Reflected light
Cast shadow

highly reflective material, such as glass, the shape of the light source will be
mirrored onto the form's surface at the point of the highlight. If the surface
of the sphere is very matte (dull, or light absorbing, as is velvet) you may
see no highlight at all. In our illustration the surface of the form may be
assumed to be semimatte.

FIGURE 7–22
MARTHA ALF
Still Life #6, 1967
Charcoal on bond paper, 8½ ×
24½ inches
Collection, the artist

2. The *quartertone* or next brightest area. On the semimatte object the highlight
 is blended well into the quartertone.

3. The *halftone*, which is located on that part of the surface that is parallel to the
 rays of light.

4. The *basetone*, or that part of the surface that is turned away from the rays of
 light and is, therefore, the darkest tone.

5. *Reflected light*, or the light bounced off a nearby surface. This light is relatively
 weak and will be observed on the shadowed side of the form just inside its
 outer contour.

6. The *cast shadow*, which is thrown by the form onto an adjacent or nearby
 surface in a direction away from the light source. Although there are rules
 of linear perspective governing the use of cast shadows, you would do best
 to rely upon your own visual judgment to record the shapes of these shadows.

A similar organization of tones may be found in curved forms other than
true spheres, as can be seen in the still life drawing by Martha Alf (Fig. 7–22).

*Paint a ball a flat, medium light gray, and put it on a surface of the same color. Set up to
draw so that the light source is a little behind you and off to one side.*

Exercise 7D

*Using compressed charcoal or black conte crayon, do a chiaroscuro drawing of the
ball taking care to include all five areas of tone and the cast shadow. Use a piece of wadded
newsprint or a store bought paper stump to blend the areas of tone, thus achieving smooth
transitions between them.*

*Avoid exaggerating the size and brightness of the highlight and reflected light. You will
need to blend the edges of these areas into the surrounding tones; if you do not, they will
have the illusion of pushing forward from the volume's surface.*

CHIAROSCURO AND TOPOGRAPHICAL MARKS

Of all the techniques used to render form, the one traditionally favored combines
the observation of the way that light falls upon a form with a judicious use of
topographical marks.* This technique requires that the lines or marks used to
create optical grays should also follow the turn of the form's surface. A fairly

*See "Topographical Marks" in Chapter 6.

FIGURE 7–23
Leonardo da Vinci
Leda and the Swan
Courtesy, Boymans Museum

gestural example of this can be seen in Figure 7–23, in which Leonardo used cross-contour to feel out the forms at the same time that he is observing (or imagining!) the play of light on their surfaces.

By analyzing the topography of a form simultaneously with recording the accidental play of light upon its surface, one can achieve a more convincing and more sculptural effect than would result from the use of either optical grays created by hatched line, or by the use of topographical lines alone. This technique, after all, combines the knowledge of form that can be gained through the tactile senses with knowledge that is gained through our observation of light and shadow. And when employed in a highly controlled way, this technique is unsurpassed for its capacity to model forms of the greatest complexity and subtlety, as we have seen in Figure 7–1.

CHIAROSCURO AND LOCAL VALUE

From the High Renaissance to the early nineteenth century, chiaroscuro was considered virtually indispensable to the art of drawing. A premium was placed upon the modeling of form in the sculptural sense, as may be seen in Michelangelo's drawing of the Libyan Sybil (Fig. 7–24).

During this extended period, local value in drawing was not generally deemed important, although many artists used local color to great compositional effect in their paintings. In the nineteenth century, however, the Renaissance tradition of the picture plane as a window onto infinite space was replaced with a new concern for the flat working surface used by the pictorial artist. As a result of this concentration on the flatness of the picture plane, shape became a more primary means of expression than the traditional illusion of sculptural form. And with an emphasis on shape arose an increased preoccupation with local value.

By the end of the nineteenth century artists had become adept at using local value shapes to arrive at striking compositions. Furthermore, they found that by manipulating the figure–ground relationship of local values, they could achieve a graphic illusion of space, as we have seen in the Picasso drawing (Fig. 7–8).

Artists will frequently elect to concentrate on either the chiaroscuro modeling of a subject or its local value. This may be demonstrated by comparing the Degas study of drapery (Fig. 7–25) with the drawing of a Spanish dancer by

FIGURE 7–24
MICHELANGELO (1475–1564)
Studies for the *Libyan Sybil*
Red chalk, 11⅜ × 8⅜ inches
*The Metropolitan Museum of Art, purchase, 1924,
Joseph Pulitzer Bequest*

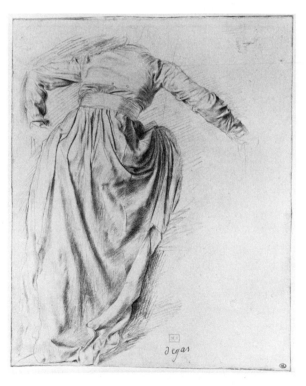

FIGURE 7–25
EDGAR DEGAS
Draped Figure, *Study for Semiramis*
Pencil, 30.9 × 23.5 cm
Courtesy the Louvre, Paris

Henri (Fig. 7–26). The drapery study lacks a sense of local value; whether the cloth portrayed is of the palest rose or the deepest purple we do not know. But since Degas' concern was to develop the intricacies of this draped garment in a sculptural manner, the tone of the actual color is of no account. In the *Spanish Dancer*, however, Henri found the play of relative local values essential to the portrayal of his colorful subject. We get a strong sense of boldly rouged lips and cheeks, dark hair, and fabric gaily splashed in floral motif. But note that there is very little sense of chiaroscuro in this drawing.

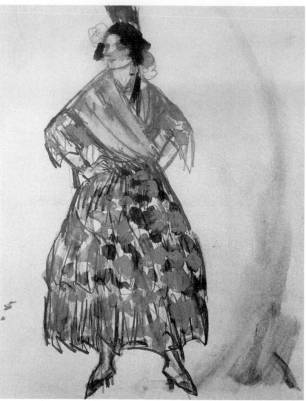

FIGURE 7–26
ROBERT HENRI (1865–1929)
Spanish Dancer
Watercolor, pencil, 10½ × 8 inches
Phoenix Art Museum, gift of Edward Jacobson

That artists have often chosen to concentrate on either a chiaroscuro modeling of form or local value does not rule out that the two can be successfully combined in one drawing, as we may see in Figure 7–27. To represent the play of light and shadow on his subject, Pearlstein employs the systematic changes of value identifiable with chiaroscuro technique. But instead of blending the tones he records them as a sequence of value shapes that are carefully contoured to the form. The profusion of these lighting effects are always, however, kept within the boundaries of a tonal "home-base," or local value. And when joined with a spectrum of clear and relatively unmodulated local values, as in the patterned rug, the almost clinical sensibility that emerges can be disquieting.

When combining chiaroscuro with local value, you must be careful not to

FIGURE 7–27
PHILLIP PEARLSTEIN
Male and Female Mirrored, 1985
Conté crayon/paper, 32 × 40
inches
Courtesy of Hirschl & Adler Modern, New York

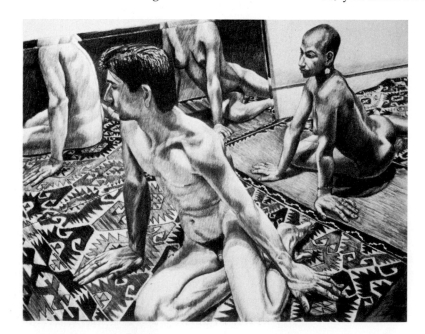

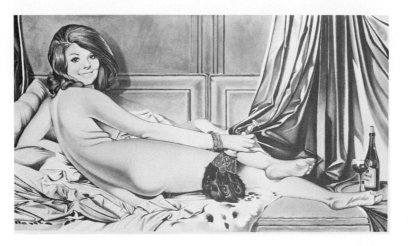

FIGURE 7–28
MEL RAMOS
Plenti Grand Odalisque, 1974
Watercolor, 14 × 20 inches
*Courtesy Collection Mr. and Mrs. Paul Sack,
San Francisco*

let the chiaroscuro get out of hand. The Mel Ramos drawing, (Fig. 7–28) is an example of how local value may be forfeited if every item possesses similarly a brilliant highlight, a light quartertone, and a dark shadow. The effect of using chiaroscuro without regard for local value is that all things will have a glossy appearance, an effect that is desirable in this case, given the banality of the subject matter.

A related issue concerns the belief that value richness in a drawing is always dependent upon the use of a full range of tones, including the high contrast of black and white. This is far from true since many fine drawings in the history of art are comprised of a limited series of closely related values that establish a dominant mood, or *tonal key*.

Tonal keys may be high (ranging from white to middle-gray); middle (which tends to occupy tones within the middle range of the value scale); and low (the dark half of the scale). A tonal key refers to the *overall* choices and effect of a coordinated group of values. So, it would not preclude, for example, the use of dark accents in an otherwise high-key drawing.

Establishing a tonal key can be a means to both unifying the value schema of a drawing and expressing a distinctive condition of light and mood, as may be seen in Figures 7–29 (a low tonal key) and 7–30 (a high tonal key). Interest-

FIGURE 7–29
MELL DANIEL
Untitled (The Forest), 1923
Crayon, pen and ink, 12 × 9 inches
*Collection the Museum of Modern Art, New York,
gift of Willem and Elaine de Kooning*

FIGURE 7–30
JOHN WILDE
Objecta Naturlica Divini, 1949
Silverpoint and ink on gessoed
paper
*Robert Hull Fleming Museum, University of
Vermont, gift of Henry Schnakenberg*

ingly, artists will sometimes transpose the actual values of their subject into
another key, making sure to adjust each tonal area proportionately.

In summation, you may employ chiaroscuro without sacrificing the tonal
identity of your subject so long as the range of tones used to model a form is
responsive to that form's local value. Figure 7–31 demonstrates how chiaroscuro
used within the confines of three different tonal keys—high, middle, and low
—can give the impression of forms of distinct local values.

FIGURE 7–31

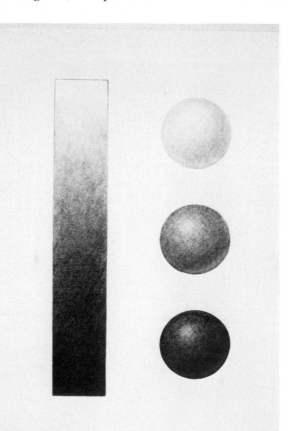

CHIAROSCURO AND TEXTURE

The texture of an object may be drawn using chiaroscuro technique if you consider the various protrusions and indentations of the surface as form in the miniature. One example is the exposed grain of weathered wood, which, when held at the correct angle to the light, will reveal itself as a pattern of shallow hills and valleys. An unusual application of this concept may be found in Figure 7–32 where an area of ocean has been conceived entirely in terms of chiaroscuro and texture.

As Figure 7–32 clearly shows, texture is best revealed by raking light, that is, a light that is directed from the side to throw textural details into visual relief. Therefore you will find that texture is most apparent in the areas of halftone where the rays of light are most parallel to the surface of a form. This may be seen in the Claudio Bravo drawing, Figure 7–33 in which the wrinkled and pitted surface of each lemon is most visible where the form starts to turn away from the light. In the more illuminated areas of the surface, where the angle of the rays is most direct, the texture will be saturated with light. In the darker areas of the form, texture will be lost in shadow.

FIGURE 7–32
Vija Celmins
Ocean Image, 1970
Graphic and acrylic spray, 14¼ × 18⅞ inches
Collection the Museum of Modern Art, New York, Mrs. Florene M. Schoenborn Fund

FIGURE 7–33
Claudio Bravo (b. 1936)
Lemons, 1982
Drawing on paper, 15¾ × 13⁵⁄₁₆ inches (NON 24.242)
Private Collection, Courtesy Marlborough Gallery

FIGURE 7–34
MARY ANN CURRIER
Onions and Tomato, 1984
Oil pastel on matboard, 26½ × 56
inches
Courtesy, Alexander F. Milliken Gallery

Texture includes the idea of the ultrasmooth as well as the very rough. When a surface is so smooth that it is shiny, the normal guidelines of chiaroscuro will not apply. In such cases the surface will reflect values from the surrounding environment, and frequently very light and very dark tones will appear next to each other. An example of this may be seen in the reflective surface of the pot in the Currier drawing (Fig. 7–34).

Texture need not receive the literal interpretation seen in the last three illustrations. Instead, it may be approximated by a more spontaneous system of marks, as in the Arneson self-portrait, Figure 7–35. Notice that the light and dark marks in this drawing are graded so as to show the general turn of the form.

FIGURE 7–35
ROBERT ARNESON
Eye of the Beholder, 1983
Acrylic, oil stick on paper, 38 × 53
inches
Courtesy Allan Frumkin Gallery, Photographer eeva-inkera

8

Subject Matter: Sources and Meanings

The preceding chapters of this book are designed to help you master the basics of drawing. In the midst of learning these fundamentals you may at times have wondered when you would be able to put your "basic training" aside and begin to make expressive drawings. But in truth, the drawings you have been making all along have been involved on some level with self-expression. Maybe you have even noticed that your drawings have consistently exhibited certain visual characteristics that are different from those of your classmates, even when a very specific assignment had to be carried out? These features that distinguish your drawings from those of your peers reflect your particular way of seeing and making visual order and, once recognized, will give you an inkling of your own artistic identity.

From this chapter forward our emphasis will be more fully upon expressive issues in drawing. We will examine how self-expression is rooted in *what* you draw and *how* you draw it and also how these two factors combine to affect the thoughts and emotions of a viewer. Or, in art terminology, we are speaking of what are often called the components of an artwork's expression, namely: subject matter, form, and content. As an introduction to what these terms mean, we provide the following definitions:

Subject matter refers to what artists select to represent in their artwork, such as a landscape, portrait, or imaginary event.

Form refers to the set of visual relationships that artists create to unify their responses to subject matter.

Content is the sum of meanings that are inferred from the subject matter and form of an artwork.

Subject matter, form, and content are indivisible in a work of art. However, in order to suggest more clearly their expressive possibilities, we discuss each of these components separately. We begin by exploring traditional subject-matter areas.

Traditional Subject-Matter Areas

There are four major areas of subject matter—the human figure, landscape, still life, and the interior—which may be considered "classic" since they have survived the test of time. That they are still viable today attests to the fact that they are both meaningful enough in themselves to have relevance to contemporary life and general enough to allow almost unlimited scope for personal expression.

Almost any subject you draw will in some way include the human figure, landscape, still life, or the interior. An awareness of the rich heritage of meaning attached to each of these subject-matter areas should help you consolidate your own emotional and intellectual reactions to any particular subject you choose to draw.

Although the four major subject-matter areas were sometimes accorded separate treatment in Classical (Greek and Roman) art, in the Middle Ages they were for the most part subsumed into narrative works, which were usually religious, but occasionally allegorical or historical. When these subjects were not essential to the story illustrated, they often appeared as incidental detail that nonetheless had allegorical content that reflected back on the larger meaning of the narrative.

Starting in the Renaissance, each of these formerly incidental areas began to reemerge as a subject in its own right. And, as new symbolic content gathered around them, the set of meanings these subject areas carried from narrative painting evolved over the centuries. What follows now is a brief, but not comprehensive, survey of thematic variations found under these four major subject matter areas.

THE HUMAN FIGURE

The figure as a subject in itself was the first to reemerge from the narrative art of the early Renaissance. This happened at a time when the philosophy of humanism was initially taking shape. The humanist movement upheld the inherent dignity of the individual with the assertion that one could be ethical and find fulfillment without help or guidance from supernatural powers. The rationalist basis of this philosophy is embodied in the drawings of idealized nudes by Leonardo, and to a lesser degree in the earlier drawings of Michelangelo. This secular bent of humanism made possible a view in which human beings stand heroically alone and responsible for their own destiny. Today the essential loneliness of the individual is a central theme around which many portrayals of the figure are constructed.

The male nudes by Sylvia Sleigh (Fig. 8–1) and Stephan Hale (Fig. 8–2) are contemporary variations on the notion of the ideal body. Although a genuine affection and admiration characterize the drawing by Sleigh, the prettifying of the young adult male seems to be a wry comment upon the traditional depictions of the female odalisque as object of the male gaze (see Mel Ramos, Fig. 7–28). No such personal involvement is evident in the drawing by Hale, but rather the means for idealizing, and even glamorizing the figure—the level gaze, the floodlighting that reveals the facial structure and musculature, the single prop, and the shallow space—are all appropriated from the field of fashion photography.

In contrast, the figures in the Pearlstein drawing (Fig. 8–3) are devoid of both idealized beauty and glamour, making them appear more naked than classically nude. Instead of stylizing the figures, this artist has more directly addressed the corporeality of the human body, a property that has been exaggerated by the way in which the figures fill the picture space.

In the Modern era, the idea of the lonely state of the individual found its extreme expression in the theme of alienation, of which the Georg Baselitz drawing is a contemporary example (Fig. 8–4). What is of particular interest here is the way in which the viewer is implicated in this topsy-turvy world. Common sense tells us that when we perceive the world upside down, it is our

FIGURE 8–1
SYLVIA SLEIGH
The Seasons, 1976
Pencil on paper, 36 × 60 inches
Courtesy, The Zaks Gallery

FIGURE 8–2
STEPHEN HALE
Untitled, 1985
Graphite on paper, 40 × 30 inches
*Private collection, NYC, courtesy Greathouse
Gallery*

own bodily position, and not the world's, that is inverted. But common sense is absent from this drawing, for the figure is losing its head; and that head, detached literally and figuratively from the hysterical body, invites us to question whether it is we, as individuals, or the world that is insane.

Portraiture, which may be considered a subcategory of figurative art, is often concerned with the rank or social position of the individual portrayed. In the Jan van Eyck painting (Fig. 8–5), the social rank and respectability of the Arnolfini household is alluded to by representing the couple in the context of the Sacrament of Holy Matrimony (the single candle signifies the all-seeing

FIGURE 8–3
PHILIP PEARLSTEIN
*Male and Female Model with Cast-Iron
Bench and Rocker*, 1982
Charcoal, 44 × 30 inches
Private Collection

FIGURE 8–4
GEORG BASELITZ
Edvards Kopf (Munch), 1983
Kohle, 61.2 × 43.2 cm., 1985. 136
Offentliche Kunstsammlung Basel

FIGURE 8–5
JAN VAN EYCK
*The Marriage of Giovanni Arnolfini
and Giovanna Cenami*

*The National Gallery, London, reproduced by
courtesy of the Trustees*

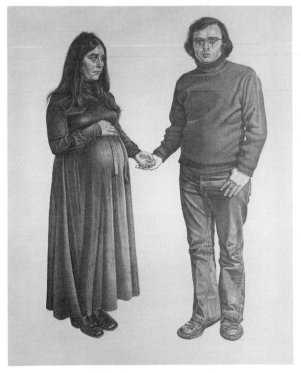

FIGURE 8–6
JAMES VALERIO
Mark and Barbara, 1972
Pencil on paper, 29 × 23⅛ inches,
#3123

*Solomon R. Guggenheim Museum, New York, gift,
Norman Dubrow, photographer Carmelo Guadagno*

Christ; the little dog signifies fidelity; and the cast off shoes signify the bridal chamber as holy ground*). In the Valerio drawing (Fig. 8–6), which is an updated version of this well-known image, the symbolic elements that conferred special status upon the Arnolfini couple are conspicuously absent. Additionally, the shabby gentility evident in their clothing and hairstyles leaves us in little doubt as to their social position.

*Janson, H. W. *History of Art*, Englewood Cliffs, N.J.: Prentice-Hall, 1967, p. 292.

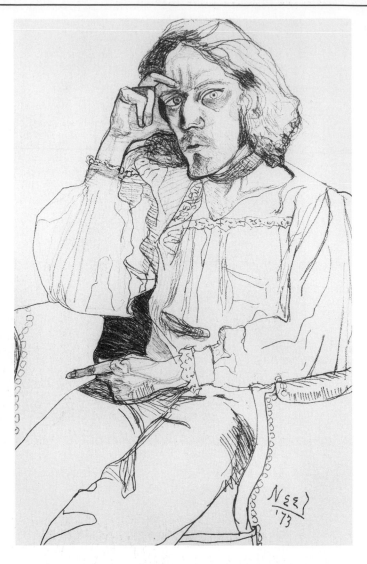

FIGURE 8–7
ALICE NEEL
Stephen Brown, 1973
Ink on paper, 44 × 30 inches
(approximate)
Courtesy, Robert Miller Gallery

Like Valerio, Alice Neel is concerned with depicting her subjects in the context of the "zeitgeist" or prevailing spirit of the times. Her drawing (Fig. 8–7) is an impassioned yet ironic portrayal of the conflict between her subject's image of himself and the way she sees him as a member of society at large. His angry and impatient glance and the furtive, admonishing gesture of his forefinger, seem to imply that he is some kind of revolutionary. But the artist has played up the dandyish aspect of his hippy's garb so that he ultimately recalls the politically retrograde seventeenth-century cavalier.

LANDSCAPE

Landscape as a separate subject came into its own in the Low Countries sometime in the sixteenth or seventeenth centuries. The early Dutch landscape artists often found work as cartographers, and assuredly there was a crossover in the two disciplines of mapmaking and landscape art at that time. Maps of countries were often decorated with topographic views of major cities, and maps of specific locations often included horizon lines (Fig. 8–8). So in the earliest phase, landscape had as an aim the portrait, so to speak, of a particular place or region.

This interest in the specific features of a place was often in relation to the use made of those features by the region's inhabitants, whether they were soldiers (as in Fig. 8–8), farmers, or townspeople. Later, this idea was enlarged and became an early romantic concept, that is, a feeling for the "genius" or resident spirit of a place.

FIGURE 8–8
C.V. Kittensteyn, after Pieter Saenredam
The Siege of Haarlem
Etching (nr. 9219G)
Muncipal Archives, Haarlem

FIGURE 8–9
John Constable
One of Seven Cloud Studies after Alexander Cozens No. 15, c. 1822-23
Pencil on white paper
Courtauld Institute Galleries, London

In romantic landscape, human existence is regarded as basically irrelevant, although today we may detect in such works the contrived human presence that results from an infusion of the subject with poetic spirit. All the same, the firsthand involvement that artists of this time had with nature, while trying to catch the spirit of its ever-changing aspect, often resulted in studies of surprising objectivity (Fig. 8–9).

In the work by John Virtue (Fig. 8–10), the ambition to capture the portrait of a place has been achieved by including several views of a particular locale,

FIGURE 8–10
JOHN VIRTUE
No. 32, 1985-86
Ink on paper on hard board
mounted on wood, 50 × 56 inches
Courtesy Lisson Gallery, London

in this case a hamlet in Lancashire, England. Arranged on a map-like grid, these intimate portraits may be presumed to be glimpses caught of a single group of buildings from a series of different vantage points. Taken as a whole, the group evokes a sense of familiarity with place that grows from the experience of daily country walks close to home.

We may consider the drawings by Bittleman (Fig. 8–11) and Lees (Fig. 8–

FIGURE 8–11
ARNOLD BITTLEMAN
View of the Green Mountains, 1977
Charcoal heightened with white
conté, 67½ × 60½ inches
Courtesy Alexander F. Milliken Gallery

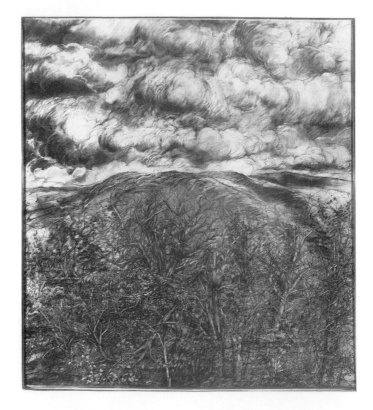

FIGURE 8–12
JOHN LEES
Bog, 1986
Ink, wc, pencil, and mixed media/
paper, 22½ × 37½ inches
Hirschl & Adler Modern, photographer Pelka/Noble

12) to be concerned primarily with a romantic view of nature, since human landmarks are absent from both works. In the sultry landscape that Bittleman creates, everything appears in closeup. The minutely textured hedges in the foreground forbid entry into the space, while the boiling clouds overhead seem to rush forward. Even the horizon is brought disturbingly close by a series of not-too-distant hills. It is a landscape intimate in its detail, yet one that threatens to ensnare with twigs and smother with demonic clouds.

The image in the Lees drawing, on the other hand, seems more remote. The impenetrable mass of nondescript bushes coalesces into a shape that hovers quietly in the middle of the page. Here is nature at its wildest, with forms that are inexplicable to human understanding.

The four studies by Carol Brown (Fig. 8–13) reflect her confidence in approaching the mystery of nature and the spirit of place. The sparsely vegetated landscape of the American Southwest, which is the subject of these studies, is certainly awe-inspiring and inhospitable terrain. Yet this artist, who works almost entirely out-of-doors, captures the essence of grandly scaled geological features within an intimate format. Concentrating on a feeling for the land as mass or form, the artist simplifies localized texture so that geological formations take on a flesh-like quality.

The romantic conception of nature as being in a constant state of flux finds its contemporary counterpart in Figure 8–14. Here, commuters careen over precipitous bay area streets under a network of cables transporting invisible electrical impulses. The buildings, like the stunted trees, seem temporary in this cityscape, where yearnings for place and permanence are secondary to the imperatives of rapid transit and telecommunication.

STILL LIFE

Still life became a subject in its own right in the Low Countries at about the same time as the reappearance of landscape. The still life genre, more than landscape or the figure, retained a strong allegorical content long after it was removed from the context of religious narrative. Detailed paintings or drawings

FIGURE 8–13
CAROL BROWN
Sand Spring Monument Valley, 3
Nov. 81, 4 PM; *Monument Valley
Sand Springs*, 18 October 81, 3:30
PM; *Sand Spring Monument Valley*,
3 Nov. 81, 2 PM; *Aspens-Betatakin*
17 October 1981
Colored pencil, 2 × 4 inches (each)
Courtesy Carol Brown

of flowers and insects (Fig. 8–15) were symbolic of the variety and also the impermanence of Creation. Vast piles of food—fruits, vegetables, dead poultry, game, fish, and raw flesh of all kinds—were evidence not only of the wealth and abundance of the bourgeois household, but also a cheerful recognition of the transience of all life. The moralistic theme of the temporality of all material

FIGURE 8–16
Herman Steenwijck
Vanitas, c. 1640
Panel, 14⅞ × 15 inches
Courtesy Musuem De Lakenhal, Leiden

things finds its culmination in the vanitas still life (Fig. 8–16). (The Latin word "vanitas" literally means emptiness, but in Medieval times it became associated with the folly of empty pride.)

The vanitas theme is one that has survived to this day in still life. In the drawing by William Wiley (Fig. 8–17) the objects in the left hand side are the memento mori so commonly found in Dutch vanitas paintings: the apple is a symbol of the mortal result of Original Sin; the dice and chess piece are symbolic of life as a game of chance; the steaming beaker suggests the futile search for the elixir of life; the jewels are symbols of earthly pride; and the knife, skull, and candle all belong to the iconography of human mortality. A framed mirror near the center of the drawing bears the fleeting inscription "What is not a bridge to something else?" a reference to the passing of all material things.

FIGURE 8–17
William Wiley
G.A.D., 1980
35½ × 53½ inches
Collection of Shelley and Ann Weinstein

FIGURE 8–18
ALEXANDER POPE, 1849-1924
Emblems of the Civil War, 1888
Oil on canvas, 137.6 × 129.8 cm.
(54³⁄₁₆ × 51⅛ inches)

The Brooklyn Museum, 66.5, Dick S. Ramsay Fund, Governing Committee of the Brooklyn Museum, and Anonymous Donors

Below it is a longstemmed pipe common to both Dutch and American still life. The pipe and tobacco box (tobacco is a New World plant) act as a bridge between the fatalistic iconography of the Old World and the iconography of death by (mis)adventure with the American frontier. The items on the right side of the drawing—the pistol, the key, the pewter cup, the quill, and the American battle standard—are objects common to the already nostalgic trompe l'oeil (fool the eye) painting of the nineteenth century (Fig. 8–18).

Larger than life portrayals of food and other consumable items locate the contemporary Pop art movement within the vanitas tradition. The Wesselman drawing (Fig. 8–19) concentrates on the packaged nature of frequently consumed goods. It even goes so far as to equate the glamour and convenience proclaimed for name brand foods with the glamour and convenience of jet travel (another packaged experience). The only natural foodstuffs in this drawing are the two lemons, whose acerbic juices hardly promise the immediate gratification enjoyed

FIGURE 8–19
TOM WESSELMAN
Drawing for Still-Life No. 35, 1963
Charcoal, 30 × 48 inches

Courtesy, Sidney Janis Gallery, New York, photographer Geoffrey Clements

FIGURE 8–20
JANET FISH
Three Restaurant Glasses, 1974
Pastel on paper, 30¼ × 16 inches
Acquisition Fund Purchase, collection Minnesota
Museum of Art, St. Paul, 75.43.08

by the Sunshine Girl on the bread wrapper. And the cigarettes, the cola, and the highly processed foods are presented as objects of questionable desire. They are not linked overtly to the issue of life and death as are the poultry, fish, game, and so forth, of Dutch still life, but they are nonetheless icons of death, first because of their own throwaway identities, and second because their consumption may prove more harmful than nourishing.

Glass drinking vessels, such as the overturned wine goblet in the Steenwijck painting or the ominous-looking liquor glass in the Wiley drawing, are common vanitas symbols. Among the characteristics that make them such a fitting symbol of temporality are: they can be drained of their contents; they are fragile; and they are transparent (as are ghosts), with surfaces that reflect an evanescent world in miniature.

Janet Fish exploits the theme of reflection in her depiction of glassware (Fig. 8–20). The shapes of the rather sturdy and commonplace restaurant glasses are subdivided into countless shimmering splinter-like pieces. Just as the forms of the glasses are lost in the myriad reflections, so too are the forms of the immediate environment distorted almost beyond recognition in the reflections on the glass surfaces. In the end, we get a picture of a world that is comprised of fugitive appearances.

THE INTERIOR

The domestic interior has long been associated with the contemplative life. In Medieval and Renaissance painting, meticulously rendered interiors appeared in such subjects as St. Jerome in his study, or in Annunciation scenes in which the Virgin is usually depicted with a book. In the Romantic era, poets and artists became increasingly preoccupied with exploring the workings of an imagination that could have free rein only in solitude. In literature, the novel delved into the private thoughts of fictitious characters who had the middle-class leisure to reflect on all the petty intrigues of domestic life. Thus, the rooms to which a person could go in order to ruminate, reminisce, or daydream took on special significance.

The drawing by Lucas Samaras (Fig. 8–21) is in the tradition of the room as metaphor for the private mind. This interior is devoid of any personal domestic effects, but it is populated by memories or daydreams of amorous trysts that have left their imprint upon the walls.

The drawings of empty interiors by Lundin (Fig. 8–22) and Garcia (Fig. 8–23) are far less confessional. Both may be regarded as images of the mind swept clean. The Lundin drawing shows a section of what appears to be a spacious empty studio. The softly polished floor and the slender shaft of weak sunlight that falls upon it, exude a meditative calm. In the Garcia drawing, the uncluttered kitchen contains several clues that attest to a life that is more austere than meditative. The only relief from the bare, brightly lit surfaces is the stark geometric pattern on the floor.

The high vantage point in the drawing by Birmelin (Fig. 8–24) gives us a sense of a room as a deep cave-like space steeped in melancholic darkness. The angles of the furniture and the arc inscribed on the floor counteract the quickly vanishing perspective lines so that the space appears to pivot around the two figures isolated in their weariness on the couch; and the protective darkness that seems about to envelop these figures suggests the slow winding down of daytime energies toward the ultimate refuge of sleep.

FIGURE 8–21
Lucas Samaras
Untitled, 8/18/87
Pastel on paper, 13 × 10 inches
Photograph courtesy of The Pace Gallery

FIGURE 8–22
NORMAN LUNDIN
Studio: Light on the Floor (small version), 1983
Pastel, 14 × 22 inches
Courtesy of Francine Seders Gallery, Seattle, Washington

FIGURE 8–23
ANTONIO GARCIA-LOPEZ
Cocina de Tomelloso (The Kitchen in Tomelloso), 1975-80
Pencil, 29⅛ × 24 inches (Photo #2429)
Private collection, courtesy Marlborough Gallery

The Hollis Sigler drawing, *Crawl Back to Safety* (Fig. 8–25) shows the interior as literally a place of refuge. The inner sanctum of the house or apartment is the bathroom, which in most homes is the only room with a lock on the door. Here a person can be safely alone; and in the revitalizing comfort of the warm bath which is being drawn, one can soak away the grime and tensions accumulated during the day. The discarded clothes on the floor and the neatly set out bathrobe and slippers promise a cozy retreat from the crazy world still visible through the window.

FIGURE 8–24
ROBERT BIRMELIN
Two Women on a Sofa, 1963
Watercolor, gouache and pencil,
24⅞ × 24½ inches

*Collection, The Museum of Modern Art, New York,
gift of Nancy and Arnold Smoller in memory of Esta
M. Josephs*

FIGURE 8–25
HOLLIS SIGLER
Crawl Back to Safety, 1982
Craypas on paper, 28½ × 34
inches
Courtesy Barbara Gladstone Gallery

Subject Matter as a Source of Meaning

That aspect of content that is derived from subject matter in a work of art is
generally referred to as *subject-meaning*. Subject-meaning is most often literary
in character; that is, it is meaning that is interpreted from the depiction of an
event, story, or allegory.

FIGURE 8–26
Honoré Daumier
The Murder in the Rue Transnonain,
1834
Lithograph
Bildarchiv der Österreichischen Nationalbibliothek

The content that is taken from pictorial subject matter may be loosely categorized as inhabiting either public or private spheres of meaning. Artists interested in tapping content from the public domain often do so with the intent of addressing universal truths. The Daumier, for instance (Fig. 8–26), boldly engages the issue of crimes against humanity, portraying as it does the brutal murders of a household of innocent workers by the French civil guard in 1834.

A more recent and reassuring example of topical content may be found in Red Groom's "Local 1971" (Fig. 8–27). In this satirical narrative, Grooms' characterizations are not only amusing; they also betray the curiosity we all have about the facts and foibles of humankind.

FIGURE 8–27
Red Grooms
Local 1971
Color litho from "No Gas"
portfolio, 22 × 28 inches
Courtesy of Marlborough Gallery, photographer Eric Pollitzer

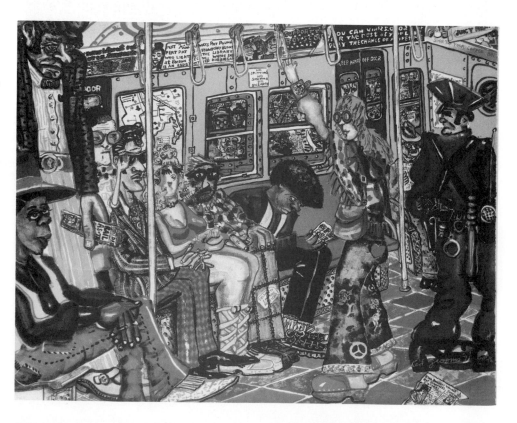

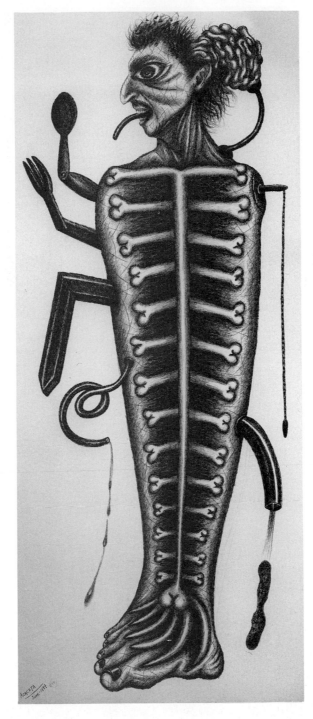

FIGURE 8–28
LUIZ CRUZ AZACETA
Self-Portrait: Mechanical Fish, 1984
Colored pencils, conte crayon on
paper, 103 × 44 inches (AFG
#4385)

*Courtesy: Allan Frumkin Gallery, photographer
eeva-inkeri*

Leaving the public side of life, let us now turn our attention to works with
more private, or personal, content.

The harrowing image in Figure 8–28 is a record of this artist's intense
personal vision. Yet, in its own eccentric way, it bespeaks of modern-day bar-
barism by inciting in us simultaneously the emotions of fear (of death and
dismemberment) and compassion (for a victim).

But content in a work of art does not have to depend upon spectacle, or
subject matter that makes an aggressive appeal to extreme states of emotion. In
the portrait by Mary Joan Waid (Fig. 8–29), for instance, meaning is insinuated
gradually. Presented with the most enigmatic of subjects, the gaze of another
human being, we might be moved to wonder about this woman's particular

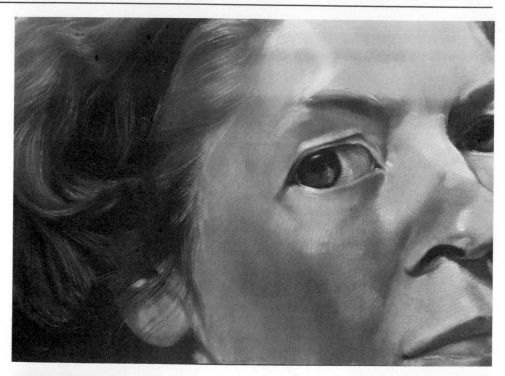

FIGURE 8–29
MARY JOAN WAID
Dream Series IX, 1984
Pastel, 29¾ × 41½ inches
Collection of the artist, photographer Sarah Wells

FIGURE 8–30
ELYN ZIMMERMAN
Untitled, 1980-81
Graphite on Mylar, 18 × 24 inches
Courtesy of the artist

story, or what thoughts lie behind her melancholy glance. Content may also be effectively derived from humble subjects that the artist found personally moving, as in Figure 8–30, which depicts the mundane but beautiful event of sunlight streaming into a room.

Thematic Variations

As a student working in the structured environment of the classroom, you may not always have free rein in your choice of subject matter. But even so, this should not put a damper on the expressive values of your work. One way to

FIGURE 8–31
PAUL WONNER
Study for *Still-Life with Cracker Jacks and Candy*, 1980
Synthetic polymer paint and pencil, 44¾ × 30 inches

Collection, The Museum of Modern Art, New York, gift of R.L.B. Tobin in honor of Lily vA. Auchincloss

inject more personal excitement into your drawing is to cast the subject in a new thematic light. For an example of how a potentially banal subject may be charged by a reality existing outside the realm of ordinary studio surroundings, let us look at the still life variations by Paul Wonner (Fig. 8–31) and Manny Farber (Fig. 8–32).

FIGURE 8–32
MANNY FARBER
Cracker Jack, 1973-74
Oil on paper, 23¼ × 21¼ inches
Collection of Shelia A. Sharpe

161

Art historical context provides the guiding impulse for the Wonner drawing. The deep space and suggestion of ever-changing light, plus the flowers, delicate vessels, and comestibles that melt in the mouth all harken back to early Dutch still life paintings. And lest we should be in any doubt about this allusion to an art historical precedent, the artist has included a representation of a Droste chocolate bar (a Dutch brand).

In the Farber, the presence of space, form, and light is minimized. Seen from directly above, the unforeshortened mat-like shape does not invite us into an illusionistic space, but rather stops us short. The only recourse the viewer has is to follow the clockwise movement around the periphery of the square, a movement that recalls the advance of markers on a gameboard. Taken further, this clockwise motion suggests a hidden storyline in which the cheery pieces of confectionery and the more ominous cork, eyedropper, and cigar play out their dramatic roles.

So in the end, we have two works with basically the same subject matter, but which stir up a very different set of associations. In the Wonner, we are taken up by the Dutch inspired theme of the temporality of all earthly delights; in the Farber, *we* are the subject of the work, acting as sleuths trying to decipher inexplicable clues within the narrative.

Exercise 8A *The illustrations in this chapter are meant to indicate the vast storehouse of expressive potential inherent to the four subject-matter categories: human figure, landscape, still life, and interior. It is important that you use this resource as a starting point for your own continuing personal research into subject-matter meanings. Look at monuments from art history on a daily basis, and with those works for which you feel an especial affinity, read about the social context in which they were created. An art historical perspective will help you grasp how classic subject matter has been utilized and adapted over the ages as a basis for countless cultural expressions.*

As a means to help you begin assembling personal insights into subject-matter themes, we have designed the following projects:

Drawing 1. Draw an interior that clearly reflects the way that space functions for you on a daily basis. Does its clutter suggest that you live at a frenetic pace? Or does its relative order imply, as in Figures 8–33 and 8–34, that you value this setting as a place for private study and meditation?

Another option would be to make an ordinary domestic interior extraordinary, as in Figure 8–35, where normally reassuring subjects have taken on overtones of the macabre.

FIGURE 8–33
Student drawing:
meditative interior

FIGURE 8–34
Student drawing:
meditative interior

FIGURE 8–35
Student drawing:
interior with macabre overtones

FIGURE 8–36
Student drawing:
autobiographical still life

Drawing 2. Draw a diaristic or autobiographical still life using objects that have collected quite naturally, for example, on the top of a desk, dresser, or television set (Fig. 8–36). As an alternative, depict an assortment of objects that symbolize for you aspects of our current cultural condition (see the vanitas drawings, Figs. 8–17 and 8–19).

Drawing 3. Draw firsthand a portrait of a landscape that for you embodies a sense of genius, or romantic spirit, free of the trappings and overtones of human existence. Create strong contrasts of marks and values to express the intense feelings this landscape elicits (as in Figs. 8–11 and 8–12).

Drawing 4. Drawing from a photograph or statue, exaggerate to some extent, aspects of the human image to express an extreme state of emotion, as in Figure 8–37, where stark tonal contrasts, simplified forms, and the boldness with which the figure fills the page, may stir up feelings of awe or melancholy.

FIGURE 8–37
Student drawing: figure
with psychological content

164

Alternatively, try using subjects or themes belonging to more than one of the major categories. Such is the case in Figure 8–38, which on the one hand may be considered a still life, since it is comprised of a skeleton and a draped piece of furniture. But the skeleton's gesture recalls the presence of a living figure, insinuating that the draped desk is more than a mere studio prop. In this context, it suggests something sinister, such as a shrouded tomb or a piece of furniture stored in a house after the death of its occupant. Or look at Figure 8–39, in which a figure and an interior combine to create an unmistakably haunting narrative.

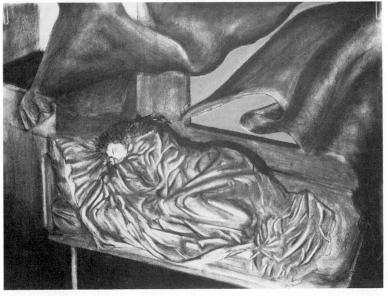

FIGURE 8–38
Student work: still life
with psychological content

FIGURE 8–39
Student drawing: interior with
psychological content

The Form
of Expression

In earlier chapters we introduced ways to organize the two-dimensional space of a drawing, from the initial layout to the development of a more complex set of design relationships. This chapter enlarges upon the topic of pictorial order by linking more fully the artist's orchestration of the visual elements to the creation of expressive *form* in a drawing. Also included is a set of strategies to help you troubleshoot problems of observation and design in your drawings.

The Two Definitions of the Term Form

As defined previously,* form may refer to the shape, structure, and volume of actual objects in our environment, and to their depiction in a work of art. The second meaning of form, and the way in which we use it in this chapter, refers to a drawing's total visual *composition*, or that quality of visual order that sets the drawing apart as a complete and unique object in its own right, independent of the real world subject matter it represents.

In other words, form is the "visual reality," the lines, shapes, colors, tones and textures, and their organization, that we actually *see* when looking at a drawing. And, by virtue of its material existence, form distinguishes itself from both subject matter and content. In this regard, subject matter exists symbolically, but not actually, in a drawing, and content exists only as an interpretation made by the viewer.

To further clarify this second meaning of the term "form," we shall examine the composition of a masterwork.

Studying the Form of a Masterwork

Our stress on the visual reality of form does not mean to imply that the form of a specific drawing may be comprehended at a single glance. On the contrary, the structural composition of a good drawing is often multileveled and requires some degree of study to penetrate.

*See Chapter 6, *Form in Space*.

To illustrate this point, we shall briefly analyze the formal qualities of a drawing by Charles Sheeler, *Feline Felicity* (Fig. 9–1). We will use a blurred state of the same work (Fig. 9–2) and the accompanying diagrams (Figs. 9–3 to 9–7) to aid us in our analysis.

FIGURE 9–1
Charles Sheeler (1883-1965)
Feline Felicity, 1934
Black conte crayon on white paper
559 × 457 mm

Courtesy of The Harvard University Art Museums (Fogg Art Museum), purchase Louise E. Bettens Fund

FIGURE 9–2

Note first the two large shapes that make up the positive image (Fig. 9–3) and the way the edges of these shapes have been controlled so the eye moves over them at varying speeds—more slowly through complicated areas, more rapidly over relatively uninterrupted stretches. Variety has also been achieved by contrasting round edges against more angular edges.

Figure 9–4 schematically depicts contrasts and similarities among the major directional lines in Sheeler's work. The main configuration created by these

FIGURE 9–3
The major positive–negative breakup of *Feline Felicity*. Note the implied interaction between the two rod-like shapes in the lower right-hand corner.

FIGURE 9–4
The major linear configuration in this drawing is an X, formed by diagonals 1 and 2. The arrows in opposite corners indicate forms pushing outward, making the format edges more apparent.

linear motives is an X, the foremost device for expressing an opposition of forces in pictorial art. Related events are seen in Figure 9–5, which shows the major diagonal being echoed by a smaller diagonal to its right, and how these movements in combination subdivide the page into three unequal zones.

Perhaps the most startling visual trait revealed by the blurred state of *Feline Felicity* (Fig. 9–2) is that the image of the cat is broken into three clearcut sections. Starting on the right (Fig. 9–6), look at how the bold arching pattern of light stripes on the cat's hindquarters creates a circular rhythm that includes the illuminated corner of the chair seat (as represented by the white "V" in our diagram).

Now, let's turn to the cat's midsection, which may be seen as a single shape in Figure 9–7. (This shape is also evident in Figures 9–2 and 9–11a.) Note that the vertical stripes throughout this shape echo the uprights of the chair. In

fact, this area possesses the most pronounced light and dark pattern of all three sections—and for good reason. It is the pivotal "central hub" of the drawing, acting as it does to join several important movements.

The head of this tabby cat differs in several important ways from the remainder of the body and from the visual character of the drawing as a whole, which, for the most part, emphasizes angular, flat areas of pattern. The drawing in general is also contrasty in its play of light and shadow and grainy in its surface texture. In comparison, the head is a more fully developed spherical volume. It also exhibits less tonal contrast and a sharper focus on topographical detail. Collectively these differences distinguish the head as the drawing's focal point.

FIGURE 9–5
Figure shows how the repeating diagonals 1 and 2 subdivide the page into three unequal areas A, B, and C.

FIGURE 9–6 (bottom left)
The repeating V-shaped angles point the eye down the right chair leg 1 toward an imminent relationship with the chair rung 2. And the movement begun at the upper right corner 3 is channeled diagonally through the depicted cat's hindquarters 4.

FIGURE 9–7 (bottom right)
1 Continues the lateral diagonal begun on the right side of the drawing, and joins the straighter movements of the front edge of the seat 2 and the nearly vertical upright of the chair back 3, all three of which intersect just below the shoulder of the cat.

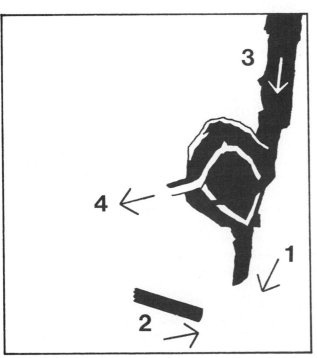

The Matter of Pictorial Invention

Although our analysis of *Feline Felicity* was far from exhaustive, it nonetheless revealed some of the compositional relationships, or interactions between parts, which underlie the almost photographic detail in this drawing. The next step is to acknowledge that the full complex of relationships in *Feline Felicity* has recast the subject matter into a new and invented totality of *pictorial* form.

We stress the word pictorial because the special network of lines, shapes, values, and so forth that Sheeler created not only contributes to the form-unity of the drawing, it also has no reality outside of that two-dimensional surface. To understand this you have only to look at the shapes plotted in Figures 9–3, 9–6, and 9–7 and realize that they have no names in the real world; or consider that the linear movements in Figure 9–4, which link-up sections of the two-dimensional surface, are not bound to the contours of individually depicted objects. These lines and shapes are in the truest sense pictorial inventions that have grown from this master artist's imaginative reworking of subject-matter information, and as such they are freed from the confines of everyday things and the everyday conventions of looking at things.

In view of all this, we may make two general observations:

1. That artists, in the process of making their ideas and emotions comprehensible to others, manipulate the visual elements beyond the service of pure description to create new pictorial entities, which for purposes of convenience, are often referred to as "pictorial shapes," "pictorial lines," and so on.

2. That the sum of pictorial invention, that is, all the created shapes, linear movements, and orchestrations of value taken together in a particular drawing, constitute that sense of form that we experience in a fine work of art.

To summarize, we have established that the form of a drawing refers to its entire structural character; or to put it simply, form refers to that compositional reality of a drawing that we may apprehend with our eyes.

We have also determined that the form of a drawing has a visual and material identity that is distinct from its subject matter source in the real world. In fact, we may say that what all artworks have in common, regardless of stylistic, media, or historical differences, is their separateness, or *abstractness* from reality.

This matter of why the form of any artwork is undeniably abstract, and how this concept may be understood in relation to the common designation of an "abstract style" in art, is the focus of our next topic in this examination of form.

What Is Abstraction Anyway?

When applied to drawing, the term *abstraction*, like the term form, has more than one meaning. First of all, a drawn image is by definition removed or abstracted from a sensory experience of actual subject matter by virtue of its physical properties. In Figure 9–1, for example, no cat is present. What does exist is a visual symbol for a cat that is embodied by a deposit of media on a flat paper surface.

Second, abstraction also refers to a multilayered *process* that is inherent to the making of all visual art. Let us clarify this by simplifying the operation of making a drawing into three steps.

1. Out of the world of experiences, which has been described by the philosopher William James as a "blooming, buzzing confusion," the artist selects something to draw. This method of singling out, or generalizing from concrete reality, is an abstracting procedure.

FIGURE 9–8
FRANZ MARC
Skizzenbuch aus dem Fedle, 1915
Pencil, 9.7 × 16 cm.
Staatliche Graphische Sammlung, München

2. Thereafter, each choice an artist makes while drawing continues to reflect the abstracting process of the mind. These include such early decisions as format orientation, vantage point, plus the character of the initial layout wherein superficial detail is overlooked in favor of summarizing the proportional and gestural essences of forms and spaces.

3. As a drawing's specific form definition proceeds toward completeness, its existence as an independent object, governed by its own pictorial order, becomes more distinct. The basis for this abstract wholeness is the essential arrangement and unity of the visual elements. Consideration for the abstract function of the visual elements is a feature of all good drawing, even if the image is a representational one.

Third, abstraction also bears upon certain styles in the history of art. The term "abstract art" gained currency in the early twentieth century when numbers of artists subordinated naturalistic representations of subject matter in favor of formal invention (Fig. 9–8). But abstraction as an image "condition" was not unknown in earlier phases of art, as we may see in this page from the *Book of Kells* (Fig. 9–9).

FIGURE 9–9
Book of Kells, fol 34r
Courtesy of the Board of Trinity College, Dublin

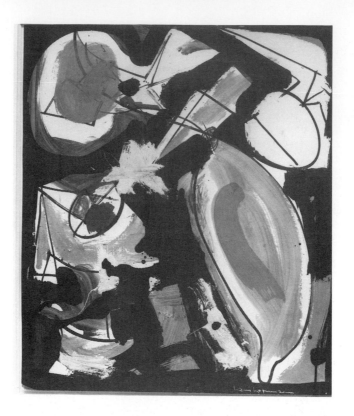

FIGURE 9–10
HANS HOFFMAN
Red Shapes, 1946
Oil on cardboard, 25¾ × 22 inches
*Private collection, courtesy André Emmerich
Gallery, New York*

Today, the designation "abstract art" is often used to describe not only quasi-representational imagery, but also works of art that are completely devoid of subject matter. More precisely, though, when an image is solely the product of an artist's imagination, and therefore without reference to an external stimulus (Fig. 9–10), the style of the work is *nonobjective*.

Exercise 9A *The benefits of drawing from fine works of art cannot be overestimated. By making penetrating, analytic studies of a masterwork (as opposed to merely copying it), you experience more intimately why certain formal choices were made by the artist, which in turn expands your general understanding about formal organization in pictorial art. Studies of masterworks are also to some extent expressive endeavors, since the formal attributes you find in a work, and the way you represent them, will depend upon your own subjective values, as witness the two student drawings of Feline Felicity in Figures 9–11a and b (see Fig. 9–1 for the original).*

FIGURE 9–11a
Student study of
Feline Felicity

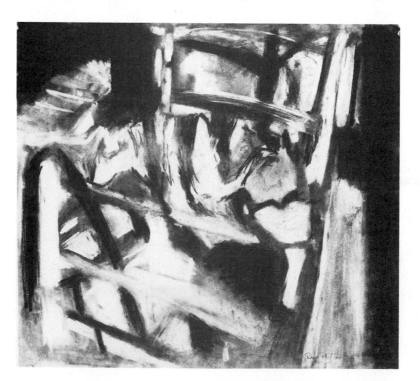

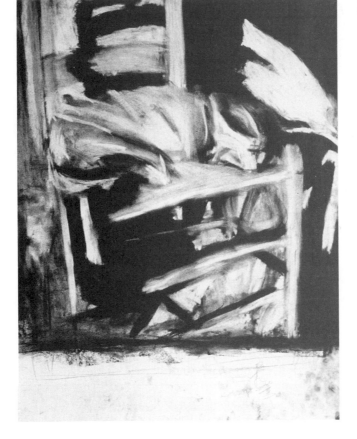

FIGURE 9–11b
Student study of *Feline Felicity*

Using Tasley's Truck *(Fig. 9–12), let us review some of the steps you'll want to take when making your own analytic drawings:*

FIGURE 9–12
MATT TASLEY
Truck, 1985
Charcoal on paper, 60¹⁄₁₆ × 84¼ inches
Courtesy, The Arkansas Arts Center, Foundation Collection

1. Sketch out the fundamental layout, or subdivision of the work's surface (Fig. 9–13).

FIGURE 9–13

2. Determine the major positive–negative arrangement (Fig. 9–14).

FIGURE 9–14

3. Locate repeating shapes, patterns, or textures that build relationships between different areas of the work (Fig. 9–15). In this case note the integration of round and angular shapes that are varied in size and tonality and are at times fully delineated, and at other times only suggested.

4. Examine the linear movements and accents that guide the eye (Fig. 9–16). Note that in Tasley's drawing the flowing movements on the left side are in contrast to the relative congestion of marks on the right.

In summary, when drawing from a masterwork uncover as many compositional relationships as you can. Part of your goal should be to discover how any one area of a work may have several organizational roles to play. If you are analyzing a work from a book or magazine, placing a sheet of translucent paper over the reproduction will suppress subject matter detail sufficiently to allow you to concentrate on the work's organizational virtues.

FIGURE 9–15

FIGURE 9–16

For this exercise you will apply what you have discovered in a masterwork to a drawing of your own.

 When you have completed an analysis of a masterwork (see the four steps outlined in Exercise 9A), find a subject in your immediate environment which exhibits some of the abstract form qualities of that masterwork. Note that the subject of the masterwork and the subject matter you choose to draw do not have to be the same.

 Lay out your drawing so its arrangement recalls the basic surface organization of the masterwork. And as you proceed to define the subject matter in your drawing, keep in mind the major compositional themes of your source material. But once this groundwork has been established and your drawing is fully underway, concentrate more on its emerging form and less on the particular design qualities of the masterwork. Finish your drawing with the aim of creating a variation on the formal themes of the masterwork.

Exercise 9B

Many artists prefer working abstractly because they are freer to invent with the visual elements of line, shape, value, texture, and color. This two-step project will guide you toward working in a more abstract style.

Exercise 9C

Drawing 1. *Select a subject that possesses a variety of forms, patterns, and textures. Emphasize these contrasts as you develop your drawing into a full-page composition (Fig. 9–17a).*

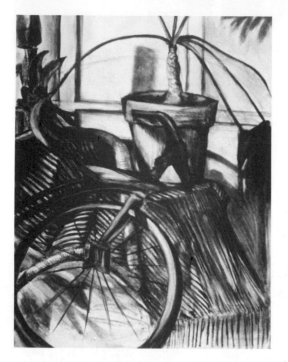

FIGURE 9–17a
Student work
Still-life drawing

Drawing 2. *Using your viewfinder, scan your first drawing. Find a section that strikes you as the most visually appealing on the basis of its overall layout, spatial illusion, and its particular combination of marks, tones, shapes, and so forth. This section will serve as the subject, or point of departure, for your second, and this time more abstract, drawing.*

Gesturally sketch in the layout of this section on another full sheet of paper, blowing up the image so it fills the entire format. Proceed to define the forms, but as you do so manipulate them to intensify both their differences and the relationships that bind them together.

By focusing on a small part of your first drawing you have already moved a step away from recognizable imagery. Continue this process by altering and simplifying the forms according to the design dictates of your drawing. Work until you have achieved a finished drawing (Fig. 9–17b).

FIGURE 9–17 b
Student work
Abstraction from Portion of Stilllife
Drawing

The Primacy of Form in the Visual Arts

Form is often considered to be at the heart of the artistic enterprise. One reason for this belief is that form is an artwork's single visual reality. In other words, and as stated earlier, form is what you see in an artwork—its lines, shapes, colors, and tones, which have been organized in a particular way. This means that in a work of art the subject matter is inevitably seen through the filter of form. Or, to put it another way, the depiction of subject matter in an artwork (or *what* has been represented) cannot be divorced from its form (or *how* the subject matter has been treated). This is why versions of the same subject by different artists may vary in content so dramatically, as in Figures 9–18 and 9–19.

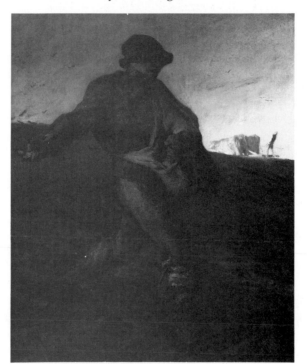

FIGURE 9–18
JEAN FRANÇOIS MILLET
The Sower

FIGURE 9–19
VINCENT VAN GOGH
Sower at Sunset
Reed pen (F 1441)
Vincent Van Gogh Foundation/National Museum Vincent Van Gogh, Amsterdam

Form is what the artist manipulates when giving expression to ideas and emotions, so it may also be regarded as the primary source of content in a work of art. In fact, properties of form are thought so essential to the meanings we take from an artwork that, for many, the terms "form-meaning" and "content" are synonymous.

Form as a Source of Meaning

That aspect of content which is derived from the form of an artwork is commonly referred to as *form-meaning*. Form-meaning is provoked by the visual character of a work of art; so, in contrast to the literary character of subject-meaning,* the content taken from form, by its very nature, cannot be expressed adequately in words.

The meanings we attribute to form in art have their origin in our experiences and associations from birth with qualities of form in the real world. For example, jagged forms belong to a large class of objects which have the potential to inflict pain and injury, such as teeth, claws, thorns, and knives. So, similarly jagged lines or shapes in a drawing (Fig. 9–20) may well give rise, at least on the subconscious level, to feelings of anxiety.

In Figure 9–21, Graham Nickson has effectively capitalized on form-meanings that are commonly attributed to horizontal, vertical, and diagonal movements. The figurative image in this work echoes our upright human condition in opposition to the flat plane of the landscape. The stability of this relationship is heightened by the way in which the clear and simple intersection of the standing figure and the horizon line repeats the geometry of the format. However, this static harmony is interrupted by the diagonal direction of the outstretched arms; a direction which in everyday life signifies action that is often unpredictable. Note that the diagonal is used to similar effect in Figure 9–22, which is nonobjective in style.

FIGURE 9–20
ED PASCHKE
His and Hers, 1977
Graphite and colored ink on paper,
29 × 23⅛ inches, Acquisition 84.46
Purchase, with funds from the Drawing Committee, Whitney Museum of American Art

*See "Subject-Matter as a Source of Meaning" in Chapter 8.

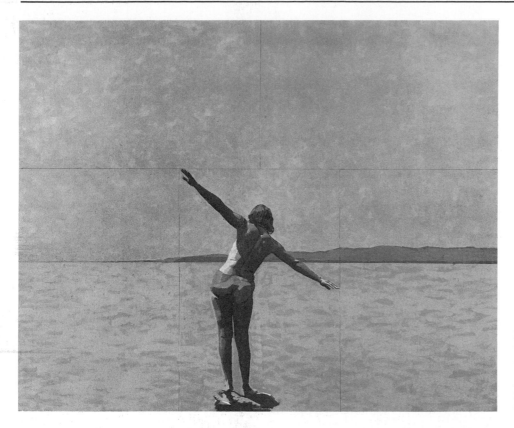

FIGURE 9–21
GRAHAM NICKSON
Bather with Outstretched Arms III,
1983
Acrylic on canvas, 100 × 120
inches
Courtesy of Hirschl and Adler Modern, New York

FIGURE 9–22
JOEL SHAPIRO
Untitled, 1984
Charcoal on paper, 43 × 30¾
inches (JS 609) (neg. #98-303)
*Courtesy, Paula Cooper Gallery, photographer
Geoffrey Clements*

Let us conclude our discussion of form-meaning with three more examples
of contemporary drawing.

Looking at the Alex Katz (Fig. 9–23), we are immediately struck by its
simplicity of line, overall paleness of tone, and general lack of strong visual
contrast. Line is reduced and understated. The eye provides the single dark

FIGURE 9–23
ALEX KATZ
Thomas, 1975
Pencil, 15 × 21¾ inches
Courtesy of Marlborough Gallery, New York

FIGURE 9–24
ROBERT ROHM
Untitled, 1975
Graphite, 19¾ × 26½ inches,
acquisition #75.50

*Gift of Dr. Marilynn and Ivan C. Karp, Whitney
Museum of American Art, photographer Geoffrey
Clements*

accent, but even this, seen as it is in profile, is nonconfrontational. So by carefully limiting visual differences, the artist sustains a mood of genteel contemplation.

Meaning in Figure 9–24 is heightened by masking out, or cropping, all but one small section of the wall. This intensifies our recognition of aspects of the subject's form, such as its density and rough physical texture, or the irregular rhythms of the bricks and mortar. From so vivid a depiction of a lively surface we might interpret an allusion to organic growth and change, perhaps going so far as to sense an inner life within something ordinarily thought of as mute and inanimate.

The structural motif underlying the nonobjective drawing by Eva Hesse (Fig. 9–25) is the grid, which we may think of as connoting order, measure, and reason. The disc-like shapes, built up with beautifully graded values, continue this theme of measure and control. But taken as a whole, we may see that these delicate tonalities and subtle variations are also the means to express a very

different kind of content. Viewed together, the discs begin to pulse or vibrate, resulting in the illusion that the entire field is fluctuating before our eyes. This unpredictably expanding and contracting movement upsets the stability and harmony first observed in the drawing, and makes the surface appear to breathe.

In conclusion, form-meaning is significant in art because it is based on memories that are innate to virtually all human beings, regardless of their geographic or ethnographic differences. That is to say, people in general are able to find meaning that they cannot express verbally in, for example, contrasts between light and dark, sharp and fuzzy (Fig. 9–26), and so on. In comparison,

FIGURE 9–27
Ed Rainey
Beef Chart, 1985
Mixed Media on paper, 41½ × 29½
inches
Courtesy of Damon Brandt Gallery

the communication of subject-meanings in a work of art is most often dependent upon a viewer's ability to identify the depicted subject matter. We may, for example, admire the form in Figure 9–27, and yet, from the standpoint of the subject matter, be left to wonder, "what does it mean?"

Troubleshooting Your Drawings

This last section of Chapter 9 provides questions you may want to ask when you are troubleshooting, or evaluating, the form of one of your drawings in progress.

CRITICIZING YOUR DRAWINGS

Most everyone who takes a drawing class is familiar with the "class critique," when members of the class comment on each other's work. Class critiques are valuable for many reasons; but perhaps most importantly, they enable you to distance yourself from your own drawing and see it with a "critical eye." However, it is also important that you extend this critical outlook beyond the class critique and apply it during the process of making your own drawings.

While a drawing is in progress, you should step back from it periodically to ask critical questions about its development. This is a natural and constructive part of the drawing process. Without this activity, you run the risk of making drawings that are structurally or expressively weak, or both. And perhaps most importantly, the critical assessments you make about a drawing are always to some extent personal value judgments and are therefore expressive of your subjective life experiences.

Finally, it can be argued that each time you examine the form of one of your drawings (or a work made by another artist), you are feeding your "intuitive

bank." In other words, what you put into your consciousness through a deliberate learning process, you will in the future be able to tap as if by second nature. This relationship between self-conscious learning and the ability to react unerringly is common to scores of other disciplines: think of the concentration necessary when someone first learns the basics of how to bat a baseball, or how countless hours of practice bear fruit when we are dazzled by the performance of a fine musician.

Critical Questions to Ask About Your Drawings

The criteria you employ when studying the form of a drawing in progress will usually fall into two categories. On the one hand you will be assessing how well you have observed and depicted the subject matter. And on the other hand you will need to determine whether the organization of the visual elements best serves your aesthetic and expressive ends.

The following is a set of questions to assist you in each of these two categories. Your use of these questions (or any other questions you might ask) should always be considered against the overall objectives you have for your drawing. Moreover, it is advisable to combine this process of asking critical questions with the practice of making diagnostic studies from your drawing. Studies of this sort can often be of invaluable assistance in getting to the crux of a formal problem and in making design alternatives more apparent to you.

Questions pertaining to observation and depiction:

1. Do areas that you want to read as three-dimensional volumes appear flat? Perhaps they are bounded by either an outline or an unmodulated dark tone that has the effect of making these areas look "cut-out"? Or, perhaps the tones are not organized according to spatial planes or are too inconsistent in their application to build a convincing volume? Figure 9–28 successfully avoids these pitfalls.

FIGURE 9–28
Student drawing with convincing spatial planes

2. Is the spatial illusion consistent? Check to see whether some areas of your drawing "pop," that is, advance ahead of their desired spatial position.

3. Is your depicted light source consistent?

4. Are all objects seen from a consistent eye-level? Do the converging lines of your depicted objects conform to a vanishing point (Fig. 9–29)?

FIGURE 9–29
Student drawing with an effective use of perspective

5. Are the scale and part-to-part proportional relationships accurate when compared to the actual subject matter?

6. Do each of the depicted objects have tonal integrity? Or are they splintered into too many tones to establish in each case a local value? Have you expressed light with essentially the same tone throughout (a common error is to have the untouched surface of a light-colored paper stand in for all the varying qualities of light in a subject); and have you made all the shadows equally dark (Fig. 9–30)?

FIGURE 9–30
Student self-portrait with tonal integrity

Questions pertaining to the organization of the visual elements:

1. Is the format subdivided so that all areas, positive *and* negative, have been given definite or implied shape (Fig. 9–31)? Generally speaking, a layout that divides the page into equal or near equal areas will reduce a drawing's impact, no matter how much attention is given to its imagery.

FIGURE 9–31
Student drawing with a bold positive and negative layout

2. Are there enough variations among the visual elements to create tension?

3. Have the visual elements been orchestrated sufficiently to create unifying relationships? Is there a cohesive pattern of emphasis and deemphasis which leads the eye at varying speeds across the surface and through the illusion of space (Fig. 9–32)?

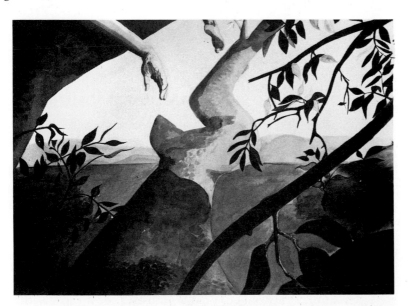

FIGURE 9–32
Student drawing that effectively guides the viewer's eye across the surface

4. Is there sufficient value range to furnish your drawing with a dynamic tonal character (as opposed to a sameness among values which may cause visual boredom)?

5. Do the marks and lines function for expressive as well as descriptive pur-

FIGURE 9–33
Student self-portrait employing a
variety of expressive and
descriptive marks and lines

poses? Do linear elements group to form larger motives in the drawing
(Fig. 9–33)?

6. Finally, where is your drawing going? Does it register clearly your aesthetic
and expressive intent? (Or, has your intent become muddled because, for
example, you've concentrated too heavily on the detail of a few areas?) More-
over, does your drawing contain visual clues which, if developed, could lead
to unexpected richness in form and content? For example, could you intensify
the mood of your drawing by consolidating the values into a lower or higher
tonal key; or could you tighten your drawing's design by stressing a particular
motif that was formerly not apparent to you in either the actual subject matter
or your drawing?

COMMON ARTISTIC BLOCKS AND THEIR SOLUTIONS

At times when you are drawing, a problem may arise which you cannot seem
to solve. As a result, you may feel frustrated and even suffer a loss of confidence.

Being stymied by a drawing in this way is one example of a syndrome
often referred to as an *artistic block*. Artistic blocks of one kind or another are
common to the experience of most artists, beginners and professionals alike.
Some typical artistic blocks and some possible solutions for them are as follows:

1. *You can't get an idea:* Ideas for drawing are everywhere. You may find ex-
pressive potential in the most modest of circumstances—your unmade bed,
the dishes collected on a sink top, or the visual diversity that has accumulated
in a closet. With domestic subject matter, try working from unusual points
of view and at unconventional hours, and see if those settings you normally
take for granted do not take on a wealth of mystery and narrative (Fig. 9–34).

2. *You have an idea, but don't know how to get it down:* Try a two-pronged attack
for this one. First, to inspire yourself, find examples by other artists that deal
with a similar idea. Second, since many of the problems will work themselves
out in the act of drawing, break the ice and start to draw.

FIGURE 9–34
Student drawing of a room from an
unconventional point of view

3. *A problem arises in a drawing and you can't figure out how to correct it:* Put the
drawing aside for a few days, even a week, and go on to another. Working
on a new drawing will repair your confidence; and when you return to the
earlier drawing you probably will find that your "mental distance" from the
work will enable you to more clearly diagnose and act upon its deficiencies.

4. *You like one area of your drawing and don't want to change it:* Trying to adapt a
drawing overall to fit one area that you don't want to lose usually results in
a fragmented image and an artistic block. To restore healthy forward move-
ment in your process it will be necessary to manipulate or change the blueprint
of that part of the drawing. Once you start to see ways to integrate that area
into the drawing as a whole the preciousness attached to it will subside, and
you will be prepared even to completely reconceive the area if necessary.

10

Visualizations: Drawing Upon Your Imagination

Many artists throughout history have relied upon their powers of recall and imagination as the origin for fresh and sometimes startling imagery. Likewise, there may be times when you will wish to turn from drawing subjects that are directly observed, to depicting things that exist only in your imagination or memory. Representations that are based on imagined or recalled material are commonly referred to as *visualized images*.

Visualized images may range from the humble sketch someone makes prior to buying lumber for a bookcase, to new and incongruous twists introduced into our popular culture, such as the seemingly authentic image of a Wild Jackalope (Fig. 10–1), to such artistic conceptions as Figure 10–2 which is based

FIGURE 10–1
JERRY FERRIN
Upper Sonoran Jackalope, 1988
Black and white photo
Courtesy, the Artist

FIGURE 10–2
GEORGE CONDO
Untitled, 1984
Conte, 11½ × 9 inches, GC-70
Courtesy Barbara Gladstone Gallery

on bizarre poetic correspondences. And in complexity and degree of finish, envisioned images may span the gamut from the gestural drawing of a sphinx by Golub (Fig. 10–3) to the much more elaborately detailed drawing by Schlemmer (Fig. 10–4).

Some of the most expressive drawings in this book were derived entirely from the artists' imaginations. But visualized image drawing is also an excellent way to test concepts in the planning stages of a larger project. In Figure 10–5, for example, the Swiss sculptor Jean Tinguely has made a series of spirited studies of a machine propelled by water power. Creative brain-storming is equally

FIGURE 10–3
LEON GOLUB
Untitled (Sphinx), 1963
Conte on vellum, 23¾ × 39 inches
Courtesy Barbara Gladstone Gallery

FIGURE 10–4
OSKAR SCHLEMMER
Study for the "Triadic Ballet," 1922
Gouache, ink, and collage of
photographs, 22⅝ × 14⅝ inches
(irregular)
Collection, The Museum of Modern Art, New York, gift of Lily Auchincloss

FIGURE 10–5
JEAN TINGUELY
Fontein, 1968
65 × 50 cm.
Rijksmuseum Kroller-Muller

FIGURE 10–6a (above)
FALLON McELLIGOTT
Set design of Victorian Clockshop
Drawing
Dow Jones & Company, Inc., Fallon McElligott
Note: a, b, and c made in conjunction with an
advertisement for The Wall Street Journal.

FIGURE 10–6b
FALLON McELLIGOTT
Actual Film Set of Victorian
Clockshop
Photograph
Dow Jones and Company, Inc., Fallon McElligott

FIGURE 10–6c
FALLON McELLIGOTT
Storyboard for Victorian Clockshop
Drawing
Dow Jones & Company, Inc., Fallon McElligott

a feature of the commercial art world. As an example of how envisioned drawing
is used at various levels of commercial production, consider Figs. 10–6 parts
a–c, which show respectively a set design representing a Victorian clockshop,
a photograph of the actual film set, and a storyboard used to plan the sequence
of the advertising narrative.

Freeing Up Your Imagination

Sometimes the toughest part of making a visualized image drawing is coming up with an idea. To compound the problem, when looking at the work of others you may surmise that the images have poured out effortlessly, making you feel in comparison as though your imagination has completely dried up.

To set matters straight, while some artists create invented imagery of the highest order in a seemingly effortless manner, most of us have to prod or "crank up" our imaginations before visualized images of merit begin to emerge. And fortunately, there are some fairly universal ways to free up the imagination.

To begin with, since you'll always be using aspects of the real world to kindle your creative thoughts (no one can get outside of nature), we recommend that you get in the habit of playing uninhibitedly with what you see in your daily life. For example, as you walk down the street have fun by projecting new and reversed relationships between things. Personify a group of parked cars making them into good or evil characters, or imagine that, for a change, a fire hydrant soaks a dog with a stream of water. In this regard, take note of the fanciful narrative in Joanne Brockley's drawing (Fig. 10–7) where backstage props cavort in a manner that may be read as either comedic or mildly threatening. You might also try concocting composite images in your imagination that could never occur under normal circumstances, as in John Wilde's portrait of "Emily Egret" (Fig. 10–8).

Uninhibited play with media can be another springboard for visualized images. For example, Otto Piene passed smoke from a flickering candle through a screen to create the pattern of sooty deposits in his "Smoke Drawing" (Fig. 10–9), and Lucas Samaras transformed his Polaroid SX-70 self-portrait by manipulating the photo emulsion as the image was developing (Fig. 10–10). In your own work, taking rubbings of surfaces to obtain textures or transferring images of current events from the popular press can be a catalyst for new drawing adventures. Or, you might overlay onto the ground of your drawing found materials, such as menus, posters, or sheet music. Another suggestion is to

FIGURE 10–7
JOANNE BROCKLEY
Untitled, 1984
Pastel and watercolor, 32 × 40 inches, JB84-9
Courtesy of Avenue B Gallery, New York, NY

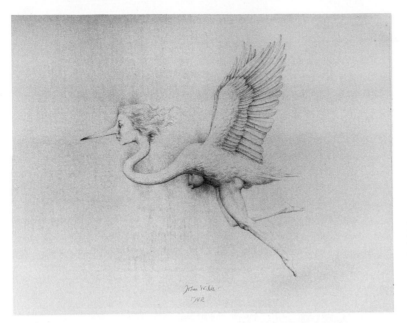

FIGURE 10–8
JOHN WILDE
Lady Bird Series #9—Emily Egret,
1982
Silverpoint on paper, 8 × 10¼
inches (sight)
The Arkansas Arts Center Foundation Collection:
The Tabriz Fund, 1983, 83.24.2

FIGURE 10–9
OTTO PIENE
Smoke Drawing, 1959
Smoke/soot on paper, 50 × 60 cm.
Courtesy the artist

FIGURE 10–10
LUCAS SAMARAS
Photo-Transformation, 1973
SX70 Polaroid, 3 × 3 inches
Courtesy Pace Gallery

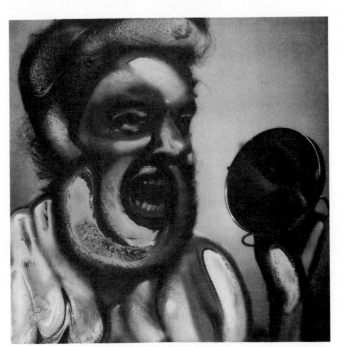

193

involve yourself for a time with drawing-related techniques from other artistic disciplines, such as monoprinting (Fig. 10–11), which is traditionally associated with printmaking. Alternatively, try extending your drawing into actual three dimensions as in Figure 10–12 where the image has been constructed within a cardboard box.

Perhaps the best known way to spontaneously generate visualized imagery is to doodle. Doodles are usually thought of as idle scribbling which help to pass the time or vent nervous energy. But for the artist, doodling represents a form of "automatic drawing" that can stimulate an outpouring of intuitive imagery.

Artistic approaches to the doodle vary. Doodles may incorporate a variety of lines and tones and even media changes, as in Paolozzi's *Head* (Fig. 10–13), which includes fragments of collage. Some artists use the doodle as a point of

FIGURE 10–11
Student monoprint

FIGURE 10–12
Student work: constructed drawing
in three dimensions

FIGURE 10–13
EDUARDO PAOLOZZI
Kop, 1950
Collage, 46 × 31 cm.
Rijksmuseum Kroller-Muller

FIGURE 10–14
JONATHON BOROFSKY
Untitled
Ink and pencil on paper,
#2,784,770, 14 × 11 inches
(JB 611 dwg)
Courtesy, Paula Cooper Gallery

departure, leading to imagery that is more intentionally developed, as in Figure
10–14.

For other artists, automatic drawing is the sole means by which they create
their imagery. This is particularly true among artists, such as Jackson Pollock,
who credit the unconscious as the source for their art. Interestingly, Pollock's

FIGURE 10–15
Jackson Pollock
Sheet of Studies, c. 1941
Pencil and charcoal pencil on
paper, 11 × 14 inches
Collection, The Museum of Modern Art, New York,
Gift of Charles B. Benenson

astonishing ability to channel his subconscious feelings onto paper is confirmed by the fact that many of his innumerable sheets of studies (Fig. 10–15) were used as a therapeutic aid for him by his psychoanalyst.

Drawing the Visualized Image

Once you have come up with an idea in your imagination, the next step is getting it down on paper. Or, if you have seen an image emerge while doodling or experimenting with media, you will need to develop and refine it. This section briefly addresses some of the crucial considerations that apply in either case to the drawing of visualized images.

Usually when drawing from the real world, we choose subjects that are stationary and clearly defined by actual light and shade. This allows us to measure the success of our depiction against the concrete objects and spaces before us. When drawing things in motion (such as a pacing zoo animal or people milling about in a public terminal), we are forced to retrieve and generalize information from a continually changing subject. But even in these circumstances we still may test, to some degree, what we've made against what we see.

Drawing from images we visualize is another matter altogether. In this case we do not have the luxury of directly comparing our effort against the source material. And in order to rough out and develop what we have imagined, we must try to capture what is often a fleeting and vaguely formed mental picture, the particulars of which may seem to disappear in translation. This is why drawing invented forms and spaces, especially when they are complex, can be a test for any artist. But in spite of the demands, the execution of visualized imagery should not be beyond the capability of anyone who has a command of fundamental drawing skills.

Drawing images from your mind depends first of all upon a utilization of the basic facts of seeing as gained from drawing real things. This is because even the process of drawing the structural properties of real objects is usually organized around an internalized image or gestalt; in other words each surface change recorded from an actual subject in a drawing is measured against what this gestalt feels like in the mind's eye.

Drawing the visualized image entails a somewhat similar operation, except for the fact that you will be plugging more directly into a generalized gestalt, without the intermediary of an observed object. This means that no matter what approach you employ (cross-contour lines, mass gesture, planar analysis, and so forth), in effect you will be "sculpting" or discovering the structural specifics of your visualized subject as you draw it. The tactile characteristics of an imagined subject may be clearly seen in Figure 10–16, where the swell of the towering ocean wave has been suggested by loose topographical strokes of paint and chalk. In Figure 10–17, cross-contour marks give a feeling of solidity to the jumbled vase-like objects.

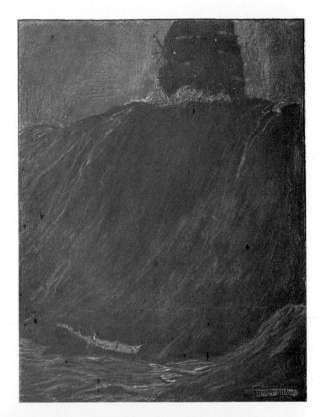

FIGURE 10–16
BYAM SHAW
The Tempest, c. 1900
Watercolor, gouache and chalk,
10¾ × 8¼ inches
*Collection, The Museum of Modern Art, New York,
gift in honor of Myron Orlofsky*

FIGURE 10–17
SUSAN CHRYSLER WHITE
Untitled 2
Dayglow, gouache, charcoal,
48 × 42½ inches
Courtesy, Rutgers-Camden Collection of Art

So, many of the methods used to record your impressions of actual space and form may be used as building blocks to guide the emergence of something recalled or imagined. The most important of these methods are:

1. The vantage point from which to draw what you have envisaged.

2. The gestural essence of visualized forms, which includes their overall proportions.

3. The spatial relationships of imagined objects. For example, note how spatial clarity has been imparted to the envisioned scene in the Yarber drawing (Fig. 10–18) by using such guidelines as relative scale, foreshortening, overlapping and linear perspective. Linear perspective is also instrumental in Figure 10–19 where the principles of convergence and eye-level invest this visionary image with the authority of actual circumstance.

4. The surface structure of imagined forms, which includes an understanding of their major planes and topography (see Figs. 10–16 and 10–17).

One thing you will want to bear in mind when drawing a visualized image is the positioning of its form in relation to the picture plane. When drawing from life, it is good practice to select that view of your subject that best reveals its spatial character (unless flatness is a specific aim of your work). But finding the most spatially dynamic view of an imagined subject will take a more concentrated effort. Typically, beginners will visualize their images in an unforeshortened view, that is, the view in which the form's profile most readily identifies the subject. But imagined forms will appear more impressive and more naturalistic if they engage space fully by confronting the picture plane (Fig. 10–20). If you find you are not able to overcome the difficulty of drawing your visualized subject in a foreshortened view, try fashioning a small three-dimensional model of it from clay or cardboard. Look at your model from a number of angles to find the view which is most expressive of what you wish to communicate.

So it is a good habit, when drawing from your imagination, to turn the subject around in your mind, making thumbnail studies as you go along, as in

FIGURE 10–18
ROBERT YARBER
Falling Shopper, 1985
Pastel on Paper, 39½ × 55½
inches, Ry-29

Courtesy, Sonnabend Gallery, photographer Jon Abbot

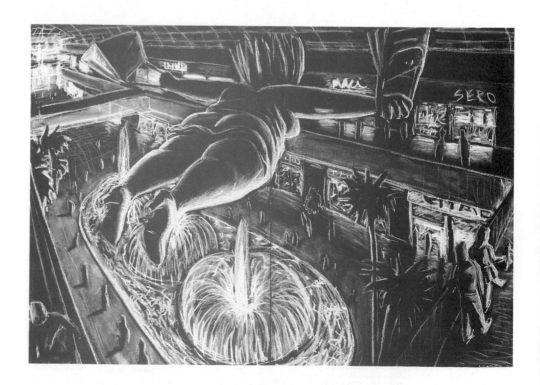

FIGURE 10–19
EDWARD ALLINGTON
The Steps or Staircase, 1985
Ink and Emulsion on paper,
25½ × 45 inches
Courtesy Lisson Gallery, London

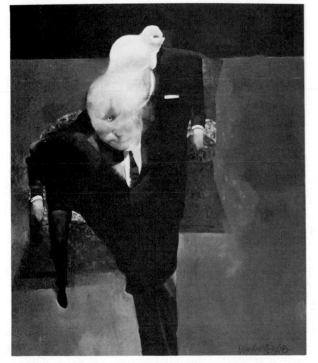

FIGURE 10–20
HIRAM D. WILLIAMS
Challenging Man, 1958
Oil on canvas, 8 feet ¼ inch ×
6 feet ⅛ inch
*Collection, The Museum of Modern Art, New
York, Fund from the Sumner Foundation for
the Arts*

Figure 10–21 where the artist has explored a mysterious headless figure in a
variety of settings and drawing approaches. In doing this you will, of course,
be depending upon both your visual memory of how similar forms look from
different angles, and also to some extent upon your powers of logic to make
the conceptual connection between various aspects of the form.

Before we conclude this part of the chapter, it is important to point out
that the two extremes of drawing from life and drawing from your imagination
can be mutually beneficial. Rigorous scrutiny of things seen through the act of
drawing can help you in realizing envisioned images because it increases the
reserve of forms that you have committed to memory. And the conceptualization

FIGURE 10–21
Daniel Quintero
Sketches of Pelele, 1974-75
12 drawings on paper, 4¾ × 4¾
inches (#31747)
Private collection, courtesy Marlborough Gallery

required for drawing visualized images can make you more adept at rapidly grasping the essential gestural and structural qualities of the real subjects you draw.

Categories of the Visualized Image

This chapter has taken a straightforward look at the topic of visualized imagery. With our common-sense approach, we have endeavored to reassure you that the basic building blocks of representing observed form and space provide the underpinning for even the most complex of imaginary images. However, in making the working processes more comprehensible, we run the risk of implying that visualized image drawing is formula-bound and mechanical.

Nothing could be further from the truth. On the highest level, the creative drawing act is a magical and unpredictable process that resists analysis or rigid formulas. Nowhere is this more evident than with the creation of envisioned images, which are conceived from scratch, so to speak, using the resources of the artist's imagination. The practical insights in this chapter are meant to empower you in discovering your own creative resources; and it is our hope that the reproductions of old and new master drawings throughout this book will be visually eloquent in communicating the depth of innovation and expressive impact commonly associated with drawings of visualized imagery.

To reinforce our theme that inspiration may be taken from studying the visualizations of other artists, this last part of Chapter 10 categorizes and briefly examines a select group of twentieth-century visualized image drawings. The categories are arbitrary; they are used purely to lend temporary structure to the seemingly endless array of imagined images in pictorial art. As a practicing artist, you are encouraged to combine these categories and even to invent new ones.

IMAGES BASED ON MEMORY

The artist's memory is perhaps the most common source for visualized images. Some artists rely heavily upon the remembrance of things past for their subject matter. Artists who work this way often take great pains to reconstruct the memory picture they have visualized. For example, they might do a substantial amount of photo research to augment their powers of recall; or they may visit sites that are similar to the one imagined, or make studio models of the scene to retrieve structural detail and lend their work an air of authenticity.

For the most part, however, artists do not so intentionally take advantage of the opportunities their active memories may provide. Instead, they will react intuitively to overtones in a developing work which trigger their memory of, let us say, the peculiar physiognomy of someone glimpsed in a bus, the striking pattern of shapes under restaurant tables, or even an unusual pairing of colors. The contributions of things impulsively remembered and acted upon can greatly enrich a drawing, or any work of art.

But whether you are consciously mapping out the visual coordinates of an event that has haunted you for years, or simply responding to whatever at the moment you are provoked to recall, it is important that you trust your memory and go wherever its unfolding narrative takes you. This is not to imply, however, that the images you draw must be rigorously controlled by your memory. The drawings you make will have their own momentum; what you recall should be considered as a basic script, or scenario, to get at deeper meanings. Thus, you should feel free to manipulate the images you visualize, to insert symbols to heighten their content, or to combine the memories of several individual events, as may be seen in Eric Fischl's "Sundeck Hoopla" (Fig. 10–22).

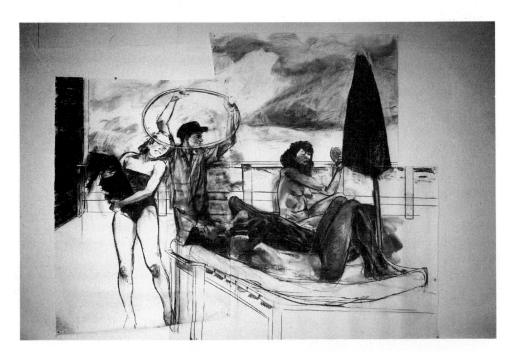

FIGURE 10–22
Eric Fischl
Sundeck Hoopla, 1985
Charcoal/paper, 105 × 129 inches
M BG #2576
Courtesy, Mary Boone Gallery, New York

TRANSFORMATIONS

In everyday life, transformation refers to a change in the outward form or appearance of a thing. There are two basic states of transformation. One is the alteration of something as we know it—think of a densely forested tract of land altered by a fire. Transformation may also mean a more complete and essential change, as in the metamorphosis of a caterpillar into a butterfly.

For artists who transform reality in order to make an envisioned image, the same two orders of change apply. At their best, transformed images seem to be the result of artistic alchemy, as if the change were magically induced. And as is the case with actual living matter, the central feature of artistic transformations is a sense of process or movement from one phase to the next, which is either apparent or felt.

The transformed self-portraits by Lucas Samaras (Fig. 10–10) and Charles Littler (Fig. 10–23) are striking examples of how an altered exterior may act as an extension of the psychological self. Both of these drawings exhibit a mastery of form improvisation which, in view of the subject matter, may be considered to have resulted in images of grotesque abnormality. But the intent of both artists was to communicate certain interior feelings more forcefully than would be possible with an objective rendering. And as you compare them, note how different is the expression in these two works: the snarling visage of Samaras is diabolical; the Littler is marked by gentility and repose in the presence of change.

The startling imagery in Fig. 10–24 depicts the metamorphosis of beggars into dogs. These mutational forms are modern parallels of the human–animal hybrids that abound in the mythologies of ancient peoples. But in spite of their fantastic bearing, these images seize and hold our attention because they seem structurally plausible, and because their swift, tracer-like lines express energy and the passage of time. Note as well that these transfigured beings embody a timeless social theme: the fate suffered by those who are cast out by society.

Transformations of the human form can have a particularly intense emotional impact upon us, because our identification is so immediate and profound. And yet one of the reasons artists are a vital cultural resource is that their transformative powers often shift and refresh our perceptions of the most com-

FIGURE 10–23
CHARLES LITTLER
Self Portrait, 1977-85
Charcoal, 36 × 30 inches
Charles Littler, collection of Arnold and Marilyn Nelson

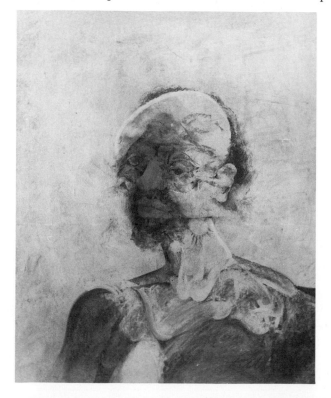

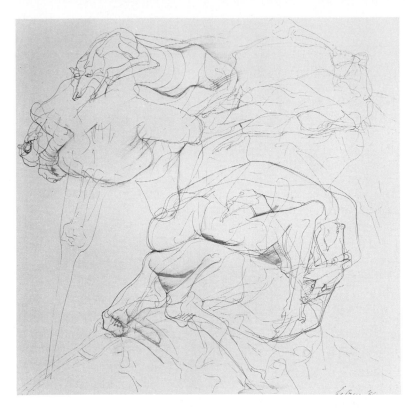

FIGURE 10–24
RICO LEBRUN (1900-1964)
Three-Penny Novel—Beggars into Dogs
Ink on paper, 37¼ × 29⅞ inches, 1969.121
Worcester Art Museum, anonymous gift in memory of Bertha James Rich

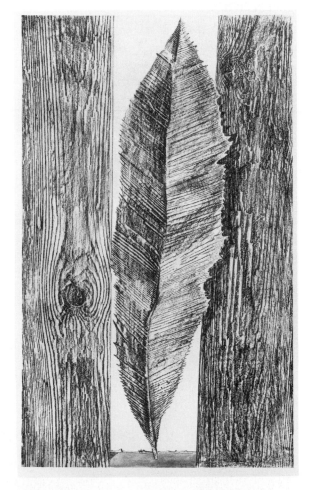

FIGURE 10–25
MAX ERNST
Histoire Naturelle, 1926
Lithograph, 19¹¹⁄₁₆ × 12¾ inches, #x547
Solomon R. Guggenheim Museum, New York, photographer Robert E. Mates

monplace things in our environment. Look, for example, at the drawing by Max Ernst (Fig. 10–25). By the seemingly simple strategy of applying the texture of wood grain to a leaf, Ernst short-circuits what is often our first clue in recognizing an object—its distinctive surface quality—and makes us consciously reconsider what we normally take for granted.

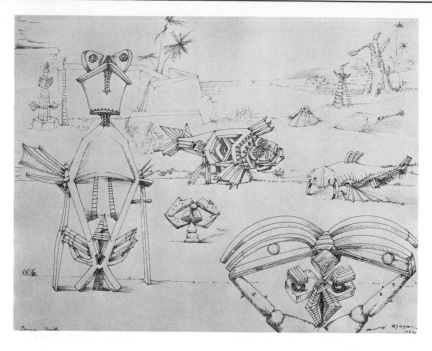

FIGURE 10–26
André MASSON
Caribbean Landscape, 1941
Pen and ink, 20⅝ × 26⅛ inches
*Collection, The Museum of Modern Art, New York,
gift of Mrs. Yves Tanguy*

INVENTIONS

The dividing line between visualized image inventions and transformations is thin and at times impossible to pinpoint. But for our purposes, it seems necessary to differentiate between those images in which a change in the appearance of something known is the critical element, and those images that are generated by the ambition to graphically portray things that either cannot be seen or did not previously exist.

Visualized image inventions are speculative adventures, inspired by a window on another world. Some illuminate visions of magical subject matter such as futuristic landscapes or miraculous plants and animals. For instance, Andre Masson populated his "Caribbean Landscape" (Fig. 10–26) with skeletons of as yet undiscovered vertebrates.

Other invented images are such baffling composites that they defy strict subject matter classification. For example, "Bio Cosmica C" (Fig. 10–27) by Renart synthesizes plant, animal, and human associations. Its overall form suggests a cushion plant (complete with thorns) or the fleshy pads on the underside of a dog's toes. The mass of bristles is reminiscent of a hedgehog's coat; and

FIGURE 10–27
EMILIO J. RENART
Bio Cosmica C, 1966
Brush, pen and ink, 30 × 40⅛ inches
*Collection, The Museum of Modern Art, New York,
Inter-American Fund*

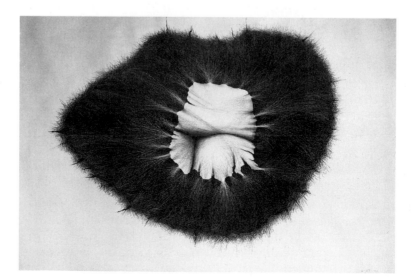

FIGURE 10–28
TODD SILER
Cerebreactor Drawing: Tokamak, 1980
Mixed media and acetate on rice
paper, 24 × 36 inches, 810614
*Courtesy, Ronald Feldman Fine Arts, photographer
eeva inkeri*

the center hints at parts of the human anatomy. Altogether, this organic mongrel both attracts with its erotic overtones and repulses with its unpleasant surface and mysterious origins; and these conflicting qualities are heightened by the actual size of the drawing which measures approximately nine feet square.

Yet another type of invented image makes visually explicit those natural forces and dimensions which are otherwise invisible. Todd Siler's drawing (Fig. 10–28), for instance, may be understood as a metaphor for the unobservable processes of the mind. It combines visual and verbal excerpts from a real neurological text, with diagrams of an apparatus apparently designed to initiate a chain reaction within the cerebral cortex and release enormous amounts of energy in the form of human thought. And finally, Robert Smithson visualized a fantastic landscape (Fig. 10–29) to illustrate the effects of entropy, or the measure of disorder and randomness in the universe.

FIGURE 10–29
ROBERT SMITHSON
Entropic Landscape, 1970
Pencil on paper, 19 × 24 inches
#7552

*Estate of Robert Smithson, courtesy John Weber
Gallery, New York, photographer Rabin*

Exercise 10A *Visualized image drawing should be practiced frequently as a complement to drawing from observed phenomena. Drawing from your imagination sharpens your ability to conceptualize and heightens your powers to express yourself pictorially.*

We suggest you begin by doing something with which you are probably already quite familiar: doodling. Using a large sheet of drawing paper (eighteen by twenty-four inches at a minimum), start scribbling over its entire surface in a seemingly arbitrary manner. As the tangle of lines and tones grows more dense, simple forms will emerge. Allow them to evolve slowly, naturally, into an image of more complexity. Where appropriate, use your eraser as a constructive drawing tool to pull form and structure out of dark masses (Fig. 10–30).

FIGURE 10–30
Student drawing: visualizing an
image from a scribble

Exercise 10B *The projects that follow urge you to express subjective responses by transforming subject matter of your choice.*

Drawing 1. *The goal here is to transform the appearance of your subject, stopping short of a metamorphic change. To do this you may choose to improvise on its form and structure (Figs. 10–10 and 10–23); to transfer onto its surface an inappropriate texture (Figs. 10–25 and 10–31); or to recompose it using an accumulation of other objects (Fig. 10–32).*

FIGURE 10–31
Student transformational drawing:
lobster with altered texture

FIGURE 10–32
Student transformational drawing:
skull composed of other objects

Drawing 2. *Choose an ordinary object that, by virtue of some visual characteristic, suggests another but otherwise unrelated object. In a set of drawings, clearly describe the metamorphosis of the first object into the second (Figs. 10–33 and 10–34).*

FIGURE 10–33
Student metamorphosis drawing:
hammer into spike

FIGURE 10–34
Student metamorphosis drawing:
hand into grenade

Exercise 10C *Inventing your own forms and the novel worlds they inhabit can be enormously gratifying. To get you started, we propose this basic, two-part exercise:*

Drawing 1. *Create a small group of unique biomorphic forms and a simple environment for them to occupy (Fig. 10–35).*

FIGURE 10–35
Student drawing of imagined forms

Drawing 2. *Make a second drawing, imagining what these forms and their surroundings would look like if you moved ninety degrees from your original location (Fig. 10–36).*

FIGURE 10–36
Student drawing of forms as if moved 90° from viewpoint of Figure 10–35

Drawing 3. A more complex option would be to combine direct observation, photo research, plus your imagination and memory to invent new forms and environments. We suggest you make thumbnail sketches before developing your final drawing, as in Figures 10–37a, 10–37b, and 10–37c, where a sheet of exploratory studies laid the groundwork for two distinct envisioned images.

FIGURE 10–37a
Student studies for visualized image drawings (see Figs 10–37b and c)

FIGURE 10–37 b
Student drawing of a visualized
image

FIGURE 10–37c
Student drawing of a visualized
image

To keep your powers of invention acute, get in the habit of visually recording in your
sketchbook unusual landscapes, creatures, and so forth, from remembered dreams and con-
scious flights of fancy (Fig. 10–38).

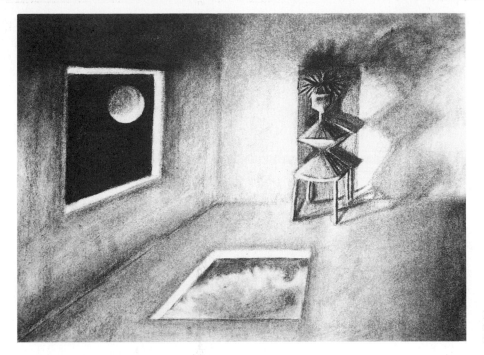

FIGURE 10–38
Student drawing of a visualized image

11

Portfolio of Contemporary Drawings

Contemporary art may best be typified by a relentless search for new forms of expression. To be sure, traditional drawing practices continue to flourish in the midst of the unpredictability of today's art. But the sheer diversity (or "pluralism") of styles and media in art today, bred by the mixed-media consciousness (Fig. 11–1), has made it virtually impossible to come up with a blanket definition of what constitutes contemporary drawing.

Our purpose in this chapter is to suggest how recent innovations in the visual arts have been reflected in the art and techniques of drawing. In order to help you grasp some of the current streams in drawing, we have grouped our selection of drawings by either subject or formal concerns. You will note, however, that these groupings are tentative at best since many of the works may fit as easily into one category as another.

The Expanded and Unusual Format

Traditionally, two-dimensional art invites the viewer to contemplate imagery in a fictive pictorial space. A conventional format, one that is small and rectangular, is admirably suited to this end. Its intimate scale entices the viewer to relinquish everyday reality in order to enter an invented world in miniature. The long accepted convention of the rectangular format aids in this transition from the real world into a pictorial one in that its clear and abstract boundary "frames" or separates pictorial contemplation from everyday existence; the viewer, as it were, looks through the rectangular shape as through a window or doorway, into another realm of aesthetic experience.

This tradition of framing the aesthetic experience continues in much of today's pictorial art, as may be seen by scanning the numerous contemporary drawings included in earlier chapters of this book. But many other artists have deviated from this tradition. Employing expanded and unusual formats, their goal has been to maximize the material existence of the art object and to minimize the viewer's aesthetic distance from real time and space. In the Murray drawing (Fig. 11–2) for instance, the primary image is to be found in the shifting movement of the format edges, which directs us to regard the drawing itself as a physical object.

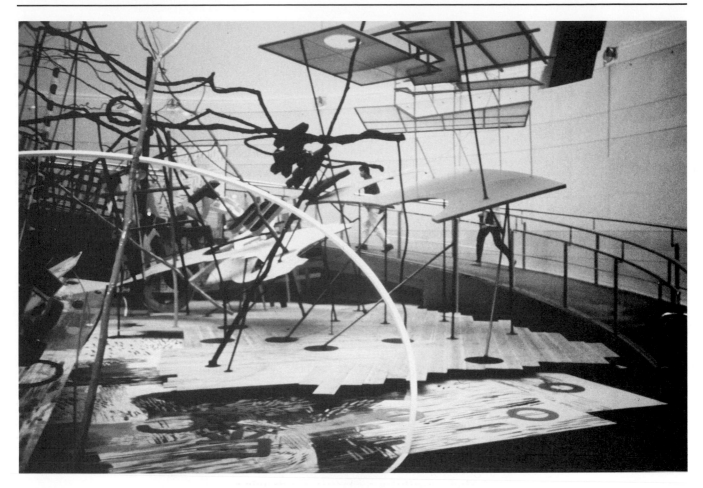

FIGURE 11–1
JUDY PFAFF
Gu, Choki, Pa, 1985
Installation, Wacoal Art Center, Tokyo, 20 × 40 feet
Photograph courtesy Holly Solomon Gallery

Jonathan Borofsky uses a much expanded format, often whole museum interiors (Fig. 11–3), to evoke a state of mind that lies somewhere between hysteria and profound meditation. The gigantic figure that appears to occupy the real space of the room is actually a perspectival illusion drawn on walls, ceiling, floor and pilaster. And just as this illusion effectively indicates a spatial continuum between two and three dimensions, so too does the number stenciled on the floor place this work chronologically in relation to the artist's total oeuvre, thus suggesting an infinitely larger temporal continuum.

The artists Michael Glier and Chuck Hitner have more politicized reasons for using expanded and unusual formats. Glier's unframed, stylistically rough, and larger than life drawings of denizens of the underclass assail the very purity and neutrality of the gallery walls, making us aware of the social discrepancy between the relatively privileged art viewing public and the subjects of these drawings (Fig. 11–4). A similar awareness comes into play when we view the work by Chuck Hitner (Fig. 11–5). Although the style of this drawing is humorous, even affectionate, it doesn't offer us the refuge from the world of real issues that we customarily seek in framed aesthetic experiences. Instead, the effect is to make us self-conscious about our role as viewers, resulting ultimately in our painful realization that we have become consumers of imagery just as we have all along been consumers of exotic animal pelts. The throwaway nature of the plastic sheeting, which is the artist's chosen medium, further underlines this theme of wanton consumption.

FIGURE 11–2
ELIZABETH MURRAY
Black and White, 1982
Pastel on paper, 3 sheets 30½ × 22 inches (EM 159)
Courtesy, Paula Cooper Gallery, photographer Geoffrey Clements

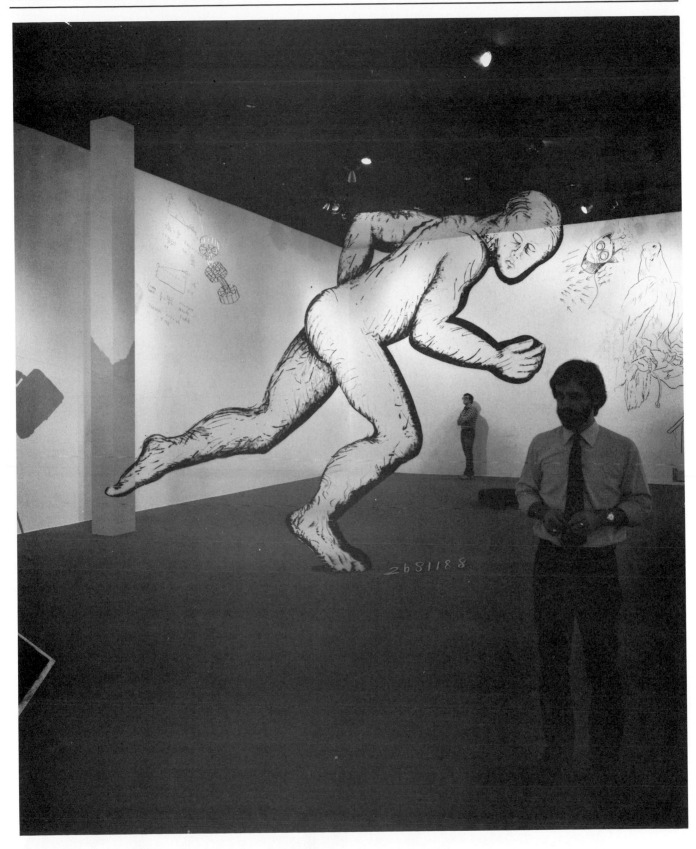

FIGURE 11–3
JONATHAN BOROFSKY
Installation: Hayden Gallery, MIT, Cambridge, Dec. 1 27, 1980
Courtesy, Paula Cooper Gallery, New York, photographer Herb Engelsberg

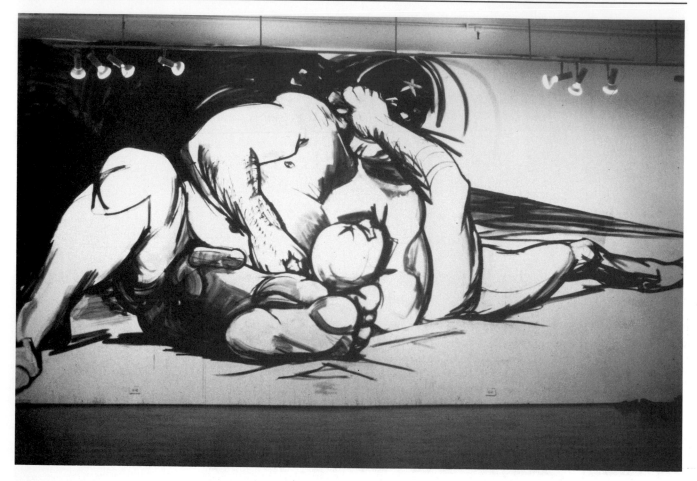

FIGURE 11–4
MIKE GLIER
Installation at BGG, detail #13, 1985
Courtesy Barbara Gladstone Gallery

FIGURE 11–5
CHUCK HITNER
Furorama, 1987
Magic marker on polyethylene,
84 × 180 inches
Courtesy, the artist

New Image Drawings

New image art (also called neoexpressionist, punk, or "bad" art) exploded into prominence in Italy, Germany, and New York in the early 1980s. Its stylistic characteristics include self-consciously crude drawing, an aggressively gestural use of media, and the primacy of large-scaled figures in an often ambiguous space. The subject of these works is frequently a heroically proportioned figure (generally male) who is pictured as a lone survivor in a world that has devolved back to a primordial state. Most of these characteristics may be seen in the Sandro Chia drawing (Fig. 11–6) that depicts the hunter Actaeon who himself becomes the hunted after discovering the goddess Diana bathing in a forest pool. In this portrayal, the tragic hero, who is half-man and half-stag, succumbs to a bestial death while in full possession of his human faculties.

FIGURE 11–6
SANDRO CHIA
Big Game, 1984
Pencil and pastel on paper,
32¼ × 23⅜ inches
Leo Castelli, photographer Dorothy Zeidman

The lone figure in the Susan Rothenberg drawing (Fig. 11–7) is so lacking in specific physiognomy that it, like the Chia, may be taken as an allegory for the tragedy of the human condition. Gestural marks in this work are employed for the sake of their unsettling effect rather than for their capacity to produce the illusion of forms moving through space. The end result is that the figure seems simultaneously caught up in excessive motion while going nowhere, a sensation many people have experienced in their dreams or during moods of extreme alienation.

FIGURE 11–7
SUSAN ROTHENBERG
Untitled, 1985
Charcoal on paper, 43 × 31 inches (#308)
Willard Gallery, New York City

FIGURE 11–8
JIM NUTT
a meek enclosure, 1977
Pencil on paper, 11¼ × 11⅛ inches
*Phyllis Kind Gallery, New York and Chicago,
photographer William H. Bengtson*

The drawing by the Chicago artist Jim Nutt (Fig. 11–8) not only predates, it also differs stylistically from most new image work in its smaller scale, spatial complexity, and meticulous craftsmanship. On the other hand, what this work has in common with new image art is its use of imagery culled from the subconscious, a near apocalyptic anxiety, and tragicomic cartoon-like characters. The work by Bonnie Lucas (Fig. 11–9) combines features found in the Nutt with those of more mainstream new image art. Like the Nutt, its eccentric, even kinky, imagery is made precious by wonderfully crafted and detailed passages. But whereas the Nutt implies real motion in finite space, this work, like much new image art, shows a single figure torn between frantic action and inaction within a space that is so unstructured it may be interpreted as either airless or infinite.

FIGURE 11–9
BONNIE LUCAS
Getting to Know You, 1985
Assemblage on fabric, 17 × 12½ inches
Courtesy of Avenue B Gallery, New York, NY

Sociopolitical Drawings

Many artists who are keenly aware of living amidst much suffering and social injustice feel it would be irresponsible to spend their lives making agreeable art objects for the relatively privileged few who have the money, education, and leisure to appreciate their art. These artists are pressed not only to bring vital issues to the attention of the public, they are also committed to expanding the audience for art, so that access to the best that culture has to offer is, ideally, available to everyone.

Street artists are among those who most radically oppose the system of private patronage. Practicing an art that is consistent with their ideology, they frequently use unofficial public spaces in which to present their work. Generally their art is inspirational, aimed at creating a spirit of community in run-down neighborhoods.

The artist "Chico" usurped a public space to encourage inhabitants and passersby to participate in the myth of New York as a dynamic, cosmopolitan, even glamorous city (Fig. 11–10). Although detractors might label this work as an act of vandalism, it may equally be said that the artist has introduced some of the magic and vitality traditionally associated with the "Big Apple" into an otherwise drab New York City backstreet. And a closer look should also make apparent that on a formal level this work is not an insensitively placed neighborhood eyesore. On the contrary, it has been carefully coordinated with its

FIGURE 11–10
CHICO
Untitled wall mural
Courtesy, the artist

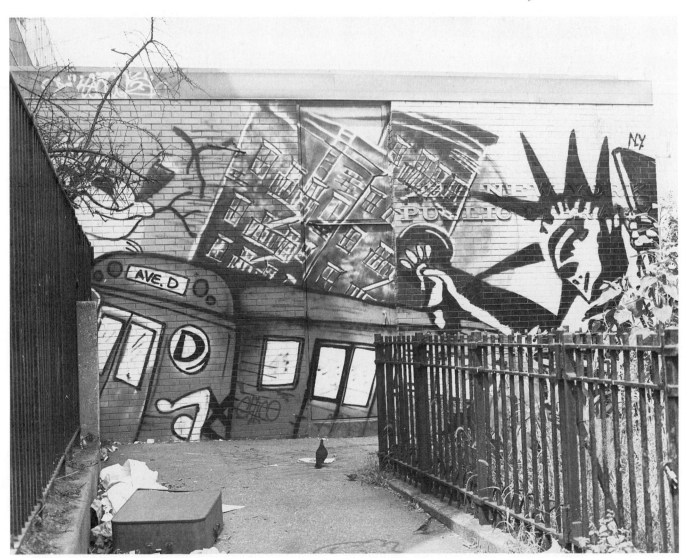

FIGURE 11–11
OYVIND FAHLSTROM
Notes 4 (C.I.A. Brand Bananas), 1970
Synthetic polymer paint, pen and
ink, 16⅝ × 14 inches

Collection, The Museum of Modern Art, New York,
given anonymously

surroundings; note, for example, how the illusion of the subway emerging from the pavement, plus the looming presence of tenements and the Statue of Liberty interact with the perspective lines in the actual wrought iron fence.

The drawing by Oyvind Fahlstrom (Fig. 11–11) may be considered within the genre of protest art. It represents with abundant scatological humor the multiple levels of corruption and political intrigue rife in Central America. The chaotic arrangement of vignettes speaks of the ubiquitous sordid goings-on among drug smugglers, fruit companies, foreign military advisors, and indigenous breeds of thieves and scoundrels.

Another category of sociopolitical artists is decidedly activist. The English artist, Conrad Atkinson, has a long history of involvement with grassroots movements fighting for the rights of the victims of thalidomide, hunger, asbestos poisoning, unfair labor practices, and violence in Northern Ireland. His work in support of these movements is often exhibited in union halls and is covered by reporters as newsworthy events rather than by art critics. The work we show (Fig. 11–12), designed to raise the consciousness of an artworld audience, uses humor to call into question the ways in which high art or "culture" is produced, distributed, and consumed within the capitalist system. Notice that the greatest Dutch painter of all, by merit of his status as a producer of cultural wealth, is represented as the natural ally of the oppressed worker majority, rather than of the Boer (Dutch) elite who are the owners and major consumers of their country's wealth.

FIGURE 11–12
CONRAD ATKINSON
Custom/Envy/Mode/Dismay/Master, 1985
Acrylic on canvas, 34 × 30 inches, Neg. #45-85-1454
Courtesy, Ronald Feldman Fine Arts, New York, photographer D. James Dee

FIGURE 11–13
HELEN AND NEWTON HARRISON
Tripping Out on the Price of Fish
Oil and graphite on canvas, 96 × 100 inches
Courtesy, Ronald-Feldman Fine Arts, New York, photographer eeva-inkeri

The work by Helen and Newton Harrison (Fig. 11–13) goes beyond the scope of public education into the realm of economic and ecological planning. This work is part of a fifteen-year project involving proposals for the use and control of flood water generated from the melting of the polar ice cap. Their research has led them to experiment with raising a species of Sri Lankan crab that could become a valuable food supply when much of the currently used farmland is replaced by lagoons.

Language-Charged Images

It is often said that the capacity for reflexive thought made possible by language is what distinguishes human nature from that of other forms of life. Language permeates every aspect of our interaction with the world, influencing how we solve problems basic to our survival, the way in which we remember things, how we picture ourselves, and even our sensory perceptions. Some contemporary artists, aware of the role that language plays in even our most fundamental insights, feel that it is unrealistic to exclude language from their representations of the world in which we live.

Ida Applebroog's drawing (Fig. 11–14) reflects the idea that there is no uniquely human action separable from verbal thought. This work gives us a peek into a domestic scene typical of those occurring behind drawn shades night after night in millions of homes throughout the world. The repeated image, or slow motion replay, serves to emphasize the universality of the theme. The deeply sarcastic "caption" contrasts sharply with the bland visual style, while the panels lacking text bring to mind all that is customarily left unsaid in households where communication is stymied by habitual behavior.

In their large format drawing (Fig. 11–15), the English duo of Gilbert and George pose as quintessential gentlemen-artists, who, like most of the British, have a great reverence for the written and spoken word. The deliberately awkward style of the drawing is somewhat reminiscent of what a schoolboy might produce; and the formal lettering, like that used on public buildings, imparts a counterfeit monumentality to the drawing. This combination, along with their deadpan expressions, lends a tongue-in-cheek attitude to the work, and heightens the roguish contradiction inherent in speaking about compassion from the priviledged enclave of an English green garden.

The work by Texas artist Vernon Fisher (Fig. 11–16) is concerned with retrieving those special moments (mostly in childhood) during which visual events were particularly impressive and plastic. These moments are usually closely linked in our minds with some story—for instance, the piling up of clouds will remind us of a particular camping trip, or an abandoned car will remind us of our earliest questions about death. Thus, by combining grass roots stories with imagery, these works recreate the process of childhood reminiscence while exposing the interrelation between verbal and visual memory.

FIGURE 11–14
IDA APPLEBROOG
Sure I'm Sure, 1979-80
Ink and rhoplex on vellum,
7 panels, each 12 × 9½ inches,
total: 12 × 75 inches
Courtesy, Ronald Feldman Fine Arts, New York, photographer eeva-inkeri, negative #810192

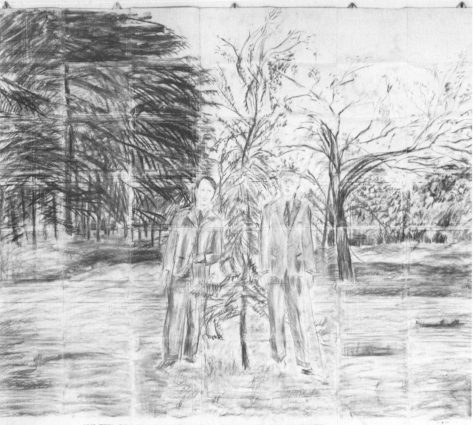

FIGURE 11–15
GILBERT and **GEORGE**
The General Jungle Series, 1971
Charcoal/Paper, 109 × 122½
inches, G & G-19 1566A

*Courtesy, Sonnabend Gallery, Photograph Zindman/
Fremont*

WE FEEL BRIEFLY, BUT SERIOUSLY, FOR OUR FELLOW ARTIST MEN

FIGURE 11–16
VERNON FISHER
Rushing into Darkness, 1984
Mixed media and bricks, 82½ × 187 inches

Collection: Museum of Fine Arts, Houston

Systemic Art

At several points throughout this book, we have alluded to the ordering impulse that underlies all artistic endeavor. Whether one is drawing from nature, creating an envisioned image, or working in an abstract style, one is primarily trying to make sense of the natural world by giving visual form (which necessarily implies order) to what one sees or imagines.

The people of many ancient cultures used geometry in an attempt to visualize the order and economy they suspected underlay the tangled surface of nature. At some point in this historical pursuit to discover the systematic premise upon which nature operates, there emerged a mathematical ratio that would for centuries intrigue both artists and naturalists. In 1503 Fra Luca Pacioli wrote a treatise on the subject (illustrated by Leonardo da Vinci) in which this ratio was dubbed the "divine proportion." Since the nineteenth century, this mathematical proportion has been commonly referred to as the "golden section."

As a general rule, the golden section is based on the recurrence of the same proportions in the divisions of a whole. It has the ratio of 1:1.618 and may be obtained by dividing a line into segments so that the longer part of it is to the whole as the shorter part is to the longer (see Fig. 11–17a). Extended, this formula may be used to arrive at the "golden rectangle" (Fig. 11–17b). The pertinence of this mathematical ratio to the natural world is revealed when a spiral is constructed using the golden rectangle (Fig. 11–17c). You will recognize this as the logarithmically increasing spiral seen in the forms of many growing things, such as mollusk shells and botanical forms in general.

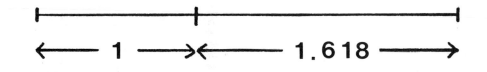

FIGURE 11–17a

FIGURE 11–17b

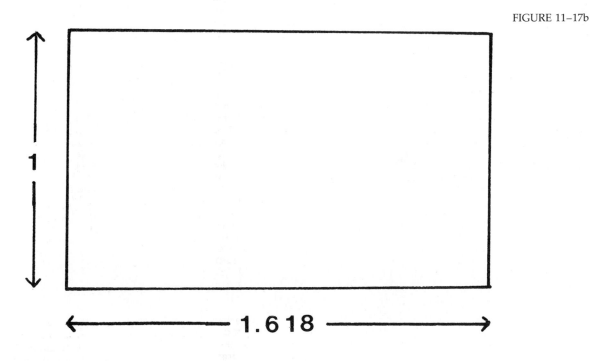

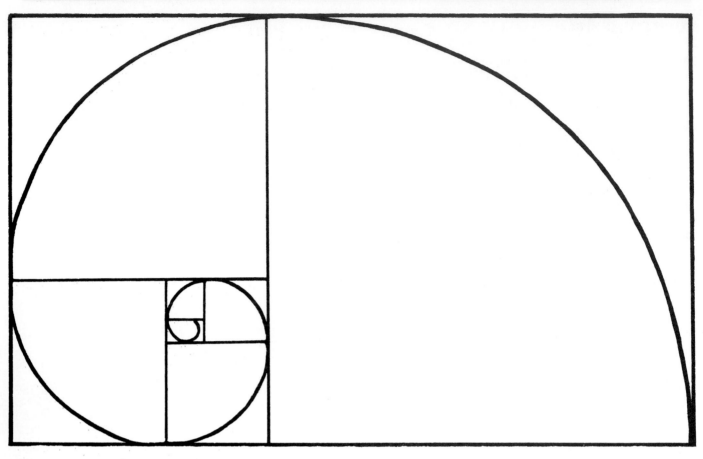

FIGURE 11–17c

It is possible that cultures as diverse as those of ancient Egypt, China, India, and Greece may have used the golden section. But it is indisputable that many pictorial artists since the Renaissance have either intuitively preferred or quite intentionally chosen the format of the golden rectangle for their drawings and paintings. Although its deliberate use is not widespread today, the golden section continues to appear as a valuable organizational device in the work of some contemporary artists, such as in the drawings and paintings of David Ligare (Figs. 11–18a and 11–18b).

FIGURE 11–18a
DAVID LIGARE
*Mercury Reminding Aeneas of his
Responsibility to the Future*, 1986
O/C, 60 × 97 inches
Courtesy of the artist

FIGURE 11–18b
DAVID LIGARE
Study for Mercury and Aeneas
Pencil, 19¼ × 26½ inches
Courtesy of the artist

In contrast to artists who use systems such as the golden section as a means for achieving aesthetic proportions, Dorothea Rockburne (Fig. 11–19) adopts purely systematic approaches for their own sake, putting aside any specific expectations of the visual outcome. The works that result from this highly structured method are generally characterized by a perplexing co-existence of visual order and disorder. In her "Robe Series" (the reference is to the robes worn by the angels in the paintings of Fra Angelico), the golden section was used to determine how the paper was folded. In the work from this series that we show, you will note that the systematic manipulation of material has yielded an image that, by virtue of its symmetrical outer contour, appears at first glance to be a product of some easily comprehended maneuvers. But upon investigation of

FIGURE 11–19
DOROTHEA ROCKBURNE
Copal, no. 8, 1976
Kraft paper, blue pencil, glue and (copal) varnish, 15⅛ × 22⅛ inches
Collection, The Museum of Modern Art, New York, gift of the Gilman Foundation

FIGURE 11–20
MARIO MERZ
Drawings for *Fibonacci's Progression*, 1971
Ink and pencil on tracing and bond paper, 11 × 8½ inches
Solomon R. Guggenheim Museum, New York, photographer Robert E. Mates

FIGURE 11–21
SOL LE WITT
A six-inch (15 cm) grid covering each of the four black walls. White lines to points on the grids.
(detail: 4th wall) 1976
White crayon lines and black pencil grid on black walls, dimensions variable
Purchased with funds from the Gilman Foundation, Inc., collection of Whitney Museum of American Art, New York, 78.1.4

the complex divisions within, the piece reveals itself to be of an asymmetrical design whose origins confound understanding.

Another artist who embraces a mathematical system for its own sake, and not as a means to an aesthetic end, is Mario Merz. The drawing shown in Figure 11–20 is based upon the Fibonacci series in which each number is the sum of the two preceding ones (1, 1, 2, 3, 5, 8, 13, 21, 34, 55, 89, 144, . . .). Interestingly, this series bears a strong relationship to the golden section by virtue of the fact that the ratio between most of the consecutive numbers is approximately 1:1.618.

For Merz, one of the beauties of the fibonacci series is that one must participate in the system in order to understand it; in this regard the system is an open invitation to the viewer to take part in a process that implies never-ending growth and change. Within the context of this process, any visible form that results may be regarded as a mere by-product of the operations of the system.

In his wall drawing (Fig. 11–21), Sol Lewitt used a predetermined system for connecting certain points on a gridded rectangle. As with the Rockburne and Merz, Lewitt does not compromise the logic of his system in the interests of the aesthetic outcome, but is, in fact, willing to sacrifice the *appearance* of order for the sake of *actual* order.

The Photo Image

Many contemporary artists utilize photographic images in their work. The primary reason for photography's appeal may be found in the widely held belief that "the camera doesn't lie," which predisposes us to regard almost any photograph as a record of the truth. A second reason is the ability of photography to record reality with great clarity of detail (usually referred to as the medium's "high resolution"). This property of high resolution not only guarantees instant recognition of the image, it is in itself very alluring and glamorous, inspiring within us an insatiable appetite for more of the same. This is why photography is often called a "hot" medium.

A third and more general explanation for the appeal of the photographic image is its status as a multiple; in other words, unlike the painting or drawing which is a unique art object, the photographic negative may be reproduced countless times without any degeneration of the image. Furthermore, the photographic medium is compatible with the mechanical means of reproduction used by the mass media. As a result, the photographic image appears not only in our newspapers and magazines, on our cereal boxes and milk cartons, but in a dematerialized form it is transmitted on airwaves to occupy the screens of our television sets. In fact, it is such a pervasive ingredient in modern life that many artists simply cannot ignore it.

In the photo-derived drawing by Robert Longo (Fig. 11–22), we are immediately captivated by the graphic clarity of the image. The peculiar flatness of the drawing and the stop-action pose are recognizable holdovers from the photographic original, and these qualities urge us to regard the image as an authoritative record of something that actually happened. In the original photograph, the seemingly contorted pose may have had a simple explanation (imagine a shot taken from directly above, of a young professional lying down in a city park during his lunch break). But in the absence of any contextual clue linking this image to ordinary workaday reality, and in our urgency to affix meaning to what we see, our interpretation tends to run toward the extreme, so that the isolated figure becomes an emblem of something bizarre or threatening. We may choose to see the figure as engaged in some absurd dance in a zero gravity field, or as caught midway in a suicide jump. Ultimately, by presenting us with such a high level of ambiguity, the artist causes us to question the ability of the photograph to record or communicate any truth, even the most obvious and fundamental one, which lies beneath surface appearances.

Arnulf Rainer is a contemporary artist who exploits features of photography, performance, and drawing in a ritualistic effort to regenerate his psyche. At the risk of transgressing socially acceptable behavior, Rainer engages in activities that apparently are meant to purge himself of the numbing influences that accompany living in a technological age. First using the camera to record a state of self-induced frenzy, he later selects those images that best express the feelings of extreme agitation he experienced during the photo session. Next, working himself into a state of emotional turmoil by undergoing strenuous physical exercise, he attains an animalistic state of being. Avoiding all conscious thought, he falls on all fours and attacks any weakness he intuitively detects in his photographic image, sometimes with a single swipe of his crayon, and occasionally working with his eyes closed. The end-product of these furious attempts to recreate himself is a self-portrait (Fig. 11–23) in which the performance in front of the camera and the action of nearly obliterating the image are both strongly in evidence.

FIGURE 11–22
ROBERT LONGO
Untitled, 1981
Charcoal and graphite on paper, 96 × 60 inches
Courtesy, Metro Pictures, photograph Pelka/Noble (MP #D-38)

FIGURE 11–23
ARNULF RAINER
Fruit Salad, 1972
Mixed Media, 23½ × 19⅝ inches
Courtesy, Gallerie Ulysses, Vienna

Technologically Produced Drawings

Ever since the Industrial Revolution when poets and philosophers prophesied the alienating effect that the machine would have upon humanity, society in general and artists in particular have been ambivalent toward new technology. Today we scarcely think twice when we utilize highly sophisticated technology to get us from one place to another, to receive and store vast quantities of information, or to heal our bodies. Regrettably, however, artists have been slow to take advantage of the new range of expressive possibilities afforded by advanced technologies.

While many artists will claim that they are temperamentally unsuited to working with high-tech machines and concepts, the barrier keeping them from doing so is primarily one of insufficient access. Most artists receive little or no training in new technological fields, and those artists who are interested in experimenting with lasers, complex computer graphics, antigravitational chambers, and the like, are generally discouraged by the prohibitive cost of these things.

But it is more than likely that artists will eventually adopt media more in keeping with the technology that has altered so profoundly the very way in which we see the natural world. Sonograms, electron microscopes, space probes, and infrared satellite photography (to name a few) have enabled us to see or visualize things that were previously inaccessible, too small, too large, or too distant to see.

Indeed the concept of rendering the invisible visible has challenged artists from time immemorial, but now some artists are beginning to use technology to realize this goal. One example is the sky artist, Leila Daw (Fig. 11–24). In the

FIGURE 11–24
Leila Daw
Beginning of Line 3
Partial documentation of *Making the Invisible Visible*, mounted photos and diagram, 28 × 36 inches
Courtesy, the artist

piece we have reproduced she used smoke trailed from an airplane to draw parallel lines in the airspace above an area transversed by several river channels. The downdrafts created by the rivers disturbed the lines of smoke so that the geography of the land, invisible to spectators on the ground, could be seen "reflected" in the sky.

New technologies have changed not only how we see the world, but also how we conceive of it. The older conception of reality was based upon the notion of unchanging relationships between things, so even those artists who could not put their entire faith in copying the surface appearance of things were confident that their more abstract static images captured the ideal essence of reality. But what we know of the natural world today has changed all that. Our knowledge of atomic physics has not only given us a picture of a world made up of constantly moving particles, but also a conception of matter in which molecular structure is largely composed of space. Understandably, these commonly held beliefs undermine our concept of solid mass and give us increased justification to distrust the reality of surface appearances. And, furthermore, theories of expanses beyond the third dimension provide substantial challenge to the adequacy of any static image to represent the world we live in.

In contrast to the preliminary sketch on paper (Fig. 11–25a), the laser projection drawing by Otto Piene and composer Paul Earls (Figs. 11–25b and 11–25c) denies the traditional expectation that an artwork, in its final form, will reach a state of static equilibrium. (Laser projections are in fact never truly static since they are produced by a scanning device with mirrors that direct the beam at a speed imperceptible to the eye, thus producing, when desired, the *illusion* of a stable three-dimensional image.) In the case of "Icarus," the image is programmed to change radically, growing and shrinking in response to musical pitches played on a synthesizer. The end impression is a poetic one of an erratic spirit whose flapping wings seem somehow to carry it in and out of material existence.

FIGURE 11–25a
OTTO PIENE and PAUL EARLS
Icarus, 1982
Marker drawing
Courtesy, the artists

FIGURES 11–25b and 11–25c
OTTO PIENE and PAUL EARLS
Icarus, 1982
Laser projection (two states)
Courtesy, the artists

A greatly increased audience for art is generally seen as a major benefit of the merging of artistic practice with technology. Otto Piene's laser drawing, for instance, could be projected onto a cloud or a plume of steam as part of a large-scale environmental performance. And the sky art by Leila Daw is by its very nature open and admission free to an unlimited public.

The same may be said about computer art. In fact, a chief advantage of computer art is that it can be circulated worldwide like any other type of information via computer networks. Imagine, if you will, the distribution possibilities for computer generated images in a future in which the computer is standard household equipment.

But a larger audience for art is not the only advantage of this new technology. Barbara Nessim (Fig. 11–26) finds the computer a flexible drawing medium because its memory allows her to make an infinite number of changes to a drawing without the danger of losing her original image. She is also attracted to the disembodied look of such graphics, which means that these images have neither the physicality of such traditional media as charcoal on paper, nor are they a record of the "touch" of the artist. But so long as one does not miss these virtues of traditional media, the incredible ease with which the computer will enable the artist of the future to make, store, and distribute images (not to mention the boundless potential it affords to creative collaboration) is a very exciting prospect indeed.

FIGURE 11–26
Barbara Nessim
Hands Up, 1983
Cibachrome photograph.
Hardware: Norpak. Software:
Information Provider, System 2.
Software: A Teletex System.
Courtesy, the artist

Glossary of Media

Papers

The following are definitions of terms commonly used to distinguish the qualities of one paper from another; see also the accompanying table, which indexes popular drawing papers according to relative cost and physical properties.

Acid Free Papers without acid content. Either 100 percent rag papers, or papers that have been chemically treated to obtain a neutral pH. Acid free papers are permanent, that is, they will not yellow or become brittle.

Block Solid pack of papers, prestretched and glued on all four sides. Suitable for direct application of wet media.

Cold Press Refers to the texture of certain 100 percent rag papers. Cold press papers have a medium rough texture as a result of being pressed with cold weights during processing. (See "Hot Press" and "Rough.")

Hot Press Refers to the texture of certain 100 percent rag papers. Hot press papers have a smooth texture as a result of being pressed with hot weights during processing. (See "Cold Press" and "Rough.")

Ply Refers to the number of layers which constitute a sheet of paper or paper board. For example, two-ply papers are made of two layers bonded together.

Rag Papers made from cotton rag or a combination of cotton rag and linen. Rag papers are acid free and permanent. (See "Wood Pulp.")

Rough A designation indicating the paper has a good "tooth." In reference to 100 percent rag papers, "rough" means that the paper has not been pressed, and as a result has a naturally bumpy surface. (See "Cold Press" and "Hot Press".)

Sizing A dilute glue that is either mixed with the wood or rag pulp during the paper-making process, or applied externally to a finished sheet of paper. Sizing inhibits the "bleeding" or spreading of wet media on paper.

Tooth Textural character of a paper due to its fibrous surface. A "good tooth"

TABLE OF PAPERS

Paper	Price	Fiber/Color	Weight	Surface Qualities	Recommended Media	Other Characteristics
Bond	moderate	usually wood pulp, although better quality has mixture of rag and wood pulp, or even 100% rag; generally white	light to medium weight in neighborhood of 50 pounds	lighter weights usually have smooth finish; heavy weights generally have more tooth; erases well	all-purpose; recommended especially for dry media and pen and ink	semipermanent, available in separate sheets and wide range of pads and bound sketchbooks
Bristol Board	moderate	wood pulp, partial rag or 100% rag; usually very white	heavy—sometimes several ply	available in plate (smooth) finish, or kid (vellum) finish; semiabsorbent hard surface, erases very well	pencil, crayon, pastel, watercolor; especially recommended for ink	can stand some wetting without buckling; better qualities are especially permanent; sold loose or in pads
Charcoal Paper	moderate	some rag content, better qualities 100% rag; wide range of color	medium	good tooth on both surfaces; one surface usually has imprinted "woven" texture and the other surface is like vellum; erases well	charcoal or pastel, conté crayon	sold in single sheets or in pads
Etching Papers	expensive	usually 100% rag, white or off-white; unsized	heavy	very absorbent; soft surface; does not erase well	dry, soft media—pastel, charcoal, crayon, soft pencil, or powdered graphite	sold in single sheets, generally in large to very large sizes
Illustration Board	moderate to expensive	two ply; consists of watercolor or drawing paper bonded to cardboard; better qualities use 100% rag paper mounted with acid free binder	heavy	varies according to paper used	all-purpose; especially good for watercolor and ink	can stand some wetting without buckling; better qualities have great permanency
Newsprint	inexpensive	wood pulp; high acid content; grayish white or yellow white	light	available in smooth or "rough"—even the rough grade does not have much tooth; soft media erase fairly easily	vine charcoal, compressed charcoal, soft pencil, conté crayon	very impermanent, yellows quickly; fragile, usually available in large pads
Oatmeal	inexpensive	rough wood pulp; oatmeal color	medium	very rough; soft, fragile surface	soft media—pastel, charcoal, crayon	not permanent
Rice Paper	expensive	rice fiber; usually white	very light	very soft and absorbent surface; will not erase easily	sumi ink and water color; also collage	
Sketch Paper	moderate	neutral pH wood pulp; off-white	medium-light	medium tooth, surface sized; withstands repeated erasure	pencil, charcoal, pen and ink	
Tag Board	inexpensive	wood pulp; yellowish tan	medium-heavy	slick; erases well	ink, soft pencil, oil pastel	available in single sheets, large size
Watercolor Paper	moderate to very expensive	usually partial rag to 100% rag; usually very white	medium-heavy to very heavy	hot pressed, cold pressed, and rough; absorbent	designed for watercolor; but hot pressed may be used for pen and ink and hard pencil, and cold pressed is good for all pencil	the heaviest papers will not buckle when wet; lighter weights must be "stretched" before use with wet media; this is done by soaking papers for a few minutes and then using gummed paper tape to fasten edges to a wooden board

is desirable for drawings made with abrasive media, such as charcoal or conté crayon.

Weight Refers to the thickness and density of a paper. Typically, the weight of a paper in a ream (500 sheets) determines its price per sheet.

Wood Pulp The chief ingredient of inexpensive papers. Papers made entirely of wood pulp are highly impermanent, unless they have been treated to neutralize their acid content. (See "Rag.")

Dry Media

CHARCOAL (FIG. G–1)

Among the most popular of drawing media, charcoal is made by baking wooden sticks until essentially only pure carbon is left. Capable of producing countless effects from thin lines to husky tones, charcoal comes in two forms, vine and compressed.

FIGURE G–1
Counter clockwise: (1) Vine charcoal, (2) Vine charcoal, (3) Vine charcoal, (4) Compressed charcoal, (5) Stump, (6) Stump, (7) Stump, (8) Charcoal pencil, (9) Charcoal pencil, (10) Charcoal pencil, (11) Carbon pencil, (12) Sandpaper pad, (13) Large rubberband, (14) Art bin, (15) Chamois, (16) Clips, and (17) Workable fixative

Vine Charcoal is easily erased so it is particularly excellent for the early stages of a drawing when a succession of rapid changes are necessary. But its fragility may also frustrate unwary students who accidentally smear and lighten their drawings. It comes in different diameters, from jumbo (⅝″) to fine (⅜″), and in varying hardnesses.

Compressed Charcoal is manufactured from powdered charcoal mixed with a binder. Capable of a broader range of tones and more intense blacks than vine charcoal it is also more permanent and harder to erase. It may be purchased in soft blocks and also in round sticks or pencils of varying hardnesses.

Charcoal Accessories include a chamois, which is a thin piece of leather used to lighten, blend, or erase deposits of charcoal; a tortillon, or rolled paper stump, which is also used for blending; a sandpaper pad for sharpening charcoal to a fine point; and fixative (see "Fixatives" in the Glossary of Media).

CHALKS (FIG. G–2)

Chalks are manufactured from precipitated chalk, pigments, and generally non-fatty binders (such as gum tragacanth or methyl cellulose). The most popular forms of chalk used by the artist are conté crayon, soft pastels, hard pastels, and lecturer's chalk.

FIGURE G–2
Left to right: (1) Conté crayon (white), (2) Conté crayon (black), (3) Litho crayon, (4) Soft pastel, (5) Hard pastel, (6) Carbon pencil, (7) Conté pencil, and (8) Lecturer's chalk

Conté Crayon contains, in addition to the usual chalk, pigments and binders, small amounts of ball clay, soap, and beeswax. It is semihard with a slightly waxy texture making it difficult to erase. It comes in both pencils and square sticks (which can be sharpened by using fine sandpaper), and may be purchased in three hardnesses. Pressed with its edge flush against the paper, stick conté achieves thick marks; when sharpened or rotated to a corner or edge, it produces thin and incisive marks. Traditionally available only in black, white, assorted grays, brown (or bistre), and earth reds (sanguine, light medium, and dark), conté crayon has recently been introduced in a wide range of blendable colors.

Soft Pastels are made with a high grade of precipitated chalk, nonfatty binder, and pigment or dyes. The buttery texture of this medium is due to the very slight amount of binder used in its manufacture. Soft pastels come in a full spectrum of colors with a range of tones under each hue. The better qualities possess a good degree of lightfastness because they are made with true pigments, and their hue is generally designated by the name of the pigment (such as raw umber, viridian, etc.). It should be noted that some pigments, such as the cadmium reds and yellows, are toxic, so breathing of their dust should be avoided. The less expensive pastels utilize dyes instead of pigments and are not guaranteed lightfast, but are probably less toxic. Pastel drawings must be handled and stored with care as their surfaces will always be fragile. The surface of a pastel drawing may be somewhat stabilized by a light application of fixative, but a heavy application of fixative will dull its color. (See "Fixatives" in the Glossary of Media.)

Hard Pastels, in contrast to soft pastels, contain a greater percentage of binder, including some fatty agents. They are not as prone to scatter pastel dust as the softer variety, but they are also more difficult to erase. (See also "Pastel Pencils" under *Colored Pencils* in the Glossary of Media.)

Lecturer's Chalk is very soft and nonfatty. It comes in large blocks and in a broad range of colors. Lecturer's chalk is excellent for gesture drawing and for rapidly applying broad areas of tone.

GRAPHITE MEDIA (FIG. G–3)

Graphite is soft, crystallized carbon, which is available in an assortment of hardnesses, from 9H (the hardest) through the intermediate degrees of H, F, and HB, to the soft pencils from 1B to 8B (the softest). Graphite is easily manipulated by smearing, smudging and erasing. But, particularly in the softer range, overworked areas can take on an unappealing shine and mottled appearance. Graphite comes in the following forms:

FIGURE G–3
Left to right: (1) Carpenter's pencil, (2) Drawing pencil, grade B, (3) Ebony pencil, (4) Drafting pencil, (5) Woodless pencil, (6) Leadholder, (7) Blackie drawing pencil, and (8) Graphite stick

Graphite Pencils, sometimes referred to as "lead" pencils, actually contain a mixture of clay and ground graphite. An "ebony" pencil is somewhat greasier than regular drawing pencils and is capable of deep blacks and lustrous tones. A "carpenter's" pencil, or "broad sketching" pencil, is excellent for layout and blocking in the large masses of a subject.

Graphite Sticks have the same ingredients as graphite pencils, but without the wooden casings. Graphite sticks apply broader single stroke marks, but are usually available only in HB, 2B, 4B, and 6B. Recently, a new lacquer coated "woodless pencil" has been introduced which may be sharpened to a point and keeps the hands from getting dirty.

Graphite Leads come in a wider range of hardnesses than do graphite sticks and are used in mechanical lead holders.

Powered Graphite may be made by crushing leads or sticks, or may be purchased in tubes from a hardware store (it is used as a lubricant). Rubbed onto a smooth surfaced board or paper with a cloth, tissue, or soft brush, powdered graphite can produce evenly blended, atmospheric values.

CRAYONS (FIG. G–4)

Crayons are either wax or oil based. Wax crayons are the kind manufactured for children; they are made with paraffin and stearic acid and are not color permanent. Colored pencils, which contain a wax binder are, technically speak-

ing, crayons. Oil crayons include lithographic crayons, China markers, and oil pastels.

FIGURE G–4
Left to right: (1) Colored pencil, (2) Pastel pencil, (3) China marker, (4) Litho crayon, (5) Colored pencil, water soluble, and (6) oil pastel

Colored Pencils are available in a wide variety of brilliant and blendable colors. Made with a wax binder, they provide little resistance when drawing, but are also not easy to erase. And due to the hardness of the binder, the value range of many brands is much more limited than graphite drawing pencils. Two alternatives are "pastel pencils," which produce a wider range of values than conventional colored pencils, and "watercolor pencils," which can be dipped in water or moistened with a brush to produce washes.

Lithographic Crayons are made for the lithographic printing process, but have become popular with artists as a drawing medium. Made only in black, they come in pencil and stick forms, and in six degrees of hardness, from #00, which is the softest and contains the most fatty acid (grease), to #5, which is the hardest and most similar to graphite in its grease content. Litho crayons are soft and pliable and make rich velvety blacks, but they are virtually impossible to erase. However, they may be scraped and flecked on heavier papers, and made into a wash when brushed with turpentine or mineral spirits. Note: Never use solvents without proper ventilation.

China Markers have an oily texture and an ease of manipulation similar to litho crayons, and they may be obtained in a broad range of colors.

Oil Pastels are oil paint in a stick form. Soft in texture, they may be applied thickly or thinned with solvents and brushed into a wash; generally they dry overnight. They also may be scraped with a razor or smudged and smeared with a soft cloth or finger (in this case it is advisable to wear a plastic glove). Oil pastels are available in a full spectrum of colors, including iridescent hues. Note: Never use solvents without proper ventilation.

COLORED MARKERS

By colored markers we refer to the wide variety of so-called "felt-tip" pens now on the market. Manufactured in fine, bullet-shaped, and chisel tips, they come in a broad assortment of colors which are bright, flat, and sometimes imper-

manent. Colored markers may be hazardous if they contain a solvent such as xylene or toulene as a vehicle for the colorant. Newly introduced, however, are acrylic and opaque paint markers which allegedly are nontoxic and colorfast.

Ballpoint Pens may be considered a form of colored markers. Long favored by artists because they are inexpensive, fluid, uniform of line and possess an aura of "Pop" culture, unfortunately many ballpoint pen inks are also highly impermanent.

ERASERS (FIG. G–5)

As corrective devices, erasers should be used in moderation, lest they become a kind of "crutch." More appropriately, erasers should be viewed as drawing tools by virtue of their ability to initiate and alter surface textures, as well as blend, lighten, smear, and even create hatched or tracery-like white lines through deposits of charcoal, conté, and graphite. Selected erasers for the artist include:

FIGURE G–5
Top to bottom: (1) RubKleen pencil eraser, (2) Pink Pearl pencil eraser, (3) Combination plastic eraser, (4) Fiberglass ink eraser, (5) Kneaded eraser, and (6) Artgum eraser

Kneaded Erasers are soft and therefore less likely to tear thin papers such as newsprint. They are easily formed into a point to pick out accents from dry media; and when this eraser becomes dirty, kneading it will produce a clean surface. When using media which does not erase easily, such as colored pencil or conté crayon, you may use the kneaded eraser to lift off the top layer of the deposit prior to using a harder eraser to finish the job.

Artgum Erasers are good all-purpose erasers. Crumbly and nonabrasive, they are particularly effective for manipulating charcoal and graphite.

Pink Erasers in a block form are serviceable for all dry media. More abrasive than the other erasers listed, they are also more effective on heavy deposits of charcoal, conté, and graphite. Not recommended for soft papers.

Vinyl or Plastic Erasers occupy an intermediate position between artgum and pink erasers, in both their ability to deal with dense deposits of dry media, and in their abrasive qualities.

Fiberglass Ink Erasers should be used on hard papers only.

FIXATIVES

Fixatives traditionally consist of a very dilute solution of shellac or cellulose lacquer; they are now being replaced by the more chemically stable acrylic lacquers. Fixative is used to protect the delicate surface of charcoal or pastel drawings by minimizing the accidental dusting-off of the media. Fixative is applied by spraying in one or more *light* even coats, and should be allowed to dry between applications.

Workable Fixative will help to stabilize the deposits on your paper, minimizing unintentional obliteration of your image and allowing you to build up deeper tones.

Nonworkable Fixative is formulated for use on a finished work. Some artists use fixative to cut down on the sheen of graphite drawings.

Caution: Solvents in fixatives are harmful to your health as are the airborne particles of the fixative itself. Always use fixative in a well-ventilated area and in accordance with the manufacturer's directions.

Wet Media

INK

Ink is a drawing medium with a venerable tradition both in our culture and in oriental cultures. It may be used in a variety of pens, or diluted with water to produce graded washes that are applied with a brush. The ink most commonly used by artists is a liquid ink called "india ink," which comes in a variety of colors under two basic categories: waterproof and nonwaterproof. Ink in a solid form, called "sumi ink," has been steadily gaining in popularity.

Waterproof Inks contain shellac and borax so that the dried film will withstand subsequent wetting without dissolving. This is an advantage when you wish to layer washes in order to build areas of tone, or when you wish to add washes to a line drawing.

Nonwaterproof Inks are more suited to fine line work and wet-on-wet techniques since the dried film will not stand up to further wetting. This may work to your advantage if you wish to make changes in your drawing. When using line in combination with washes, it is advisable to begin with your washes and add line only after the washes are dry or near dry.

Sumi Ink, an especially high grade of ink manufactured in Japan, comes in a solid block or stick. Traditionally it is rubbed with water on an ink stone until the desired intensity is produced. Both ink and stone are usually available in art supply stores or oriental specialty shops.

Opaque Inks, intended for use by calligraphers and designers, are less frequently used in a drawing context because they cannot be successfully diluted to produce graded washes. For variety's sake you may wish to try using an opaque white ink in combination with a darker ink on tinted paper.

PENS (FIG. G–6)

There are a large variety of pens on the market. Some are designed especially for freehand drawing; others, designed for lettering or drafting, may nonetheless be used by the fine artist.

Reed or Bamboo Pens do not hold much ink and become blunt quickly if they are oversharpened. They are, therefore, best suited for bold, short marks and do not lend themselves to flowing line.

FIGURE G–6
Top row left to right: (1)
Waterproof ink suitable for
technical pens, (2) India ink
suitable for fountain pens, (3) Sumi
ink and ink stone, and (4) Sepia ink
for fountain pens
Bottom row left to right: (1)
Technical pen, (2) Fountain pen
with drawing nib, (3) Nylon tipped
marker, (4) Steel pen, fine nib, (5)
Steel pen, hawkquill, (6) Steel pen,
calligraphy, (7) Steel pen, crow
quill, and (8) Bamboo pen

Steel Pens come in a wide range of shapes and sizes and are used with a pen holder. The flexible "crowquill" will give a very fine line and is excellent for small scale cross-hatch drawing. It should however, be used on a smooth, hard paper because of its tendency to catch on the fibers of a soft or rough paper. The "bowl-pointed" pen yields a somewhat heavier, smooth flowing line. "Calligraphy" pens produce a line of the most varied width. They come in a variety of styles and sizes, some of which are well suited to drawing. Because calligraphy pens use a greater amount of ink than the genuine drawing pens, they often have a small reservoir built into the nib to minimize the frequency with which you must dip it.

Fountain Drawing Pens are usually designed to accept interchangeable nibs of varying widths. They are very convenient, especially for field use. Caution: Only inks formulated for use in these pens should be used, and ink should not be allowed to dry in the pen.

Technical Pens are designed to give a line of uniform width and are used principally for drafting, as their stylus-type nib is compatible with the use of a straight-edge. They will accept interchangeable nibs which come in a variety of widths. Unlike other pens, the line of a technical pen is free-flowing in any direction, and for nondrafting purposes its use may be extended to stipling and cross-hatching. The nib mechanism is delicate so care must be used in cleaning it. Caution: Only inks formulated for use in technical pens should be used. In order to function properly these pens need to be disassembled and cleaned often, and ink should never be allowed to dry in them.

PAINTS

The use of painting media in a drawing context will help accustom you to thinking of your drawing surface in terms of broad areas and will discourage you from limiting your mark-making to linear elements. Although color is increasingly being used in contemporary drawing, you may wish to limit your palette severely at first so that you can concentrate more fully upon the tonal structure of your drawing. A tube each of black and white paint is generally thought sufficient for the student in a beginning or intermediate level drawing class. Alternatively, you may try using white in combination with one warm color, such as burnt sienna, and one cool color such as prussian blue.

Acrylic Paints are made with pigments or permanent dyes bound with an acrylic (a kind of vinyl) polymer emulsion. Acrylics are soluble in water when wet but dry quickly to a tough waterproof film. These properties, which allow you to apply successive layers of paint in a short amount of time, will also make the blending of colors upon the working surface very difficult. You may use the paints directly on paper or board, or if you prefer, you may first prime your paper or board with acrylic gesso.

Gouache (or Opaque Watercolor) is an opaque water-based paint with a gum arabic binder. Intended primarily for use by designers, these paints are tinted generally with dyes rather than true pigments and should not be considered permanent. Colors can be mixed on the palette but will not blend well once they are laid on the support. Goauche is a good medium to use in combination with other media since its opacity will allow you to cover unwanted marks; and when dry, its matte, slightly chalky surface is very receptive to media such as graphite, charcoal and pastel. Drawings made with a limited range of light and dark colors on tinted papers are particularly handsome.

Oil Paint is generally a highly permanent medium comprised of pigments bound with linseed oil. Oil paint colors blend superbly both on the palette and upon the support, and the colors dry true without darkening or turning chalky. If these paints are used directly on paper, the oil will spread through the paper fibers causing an oily halo around the color and weakening the paint film. For this reason, some artists prefer to coat their paper with acrylic gesso prior to painting with oils.

Watercolor is a transparent water-based paint with a gum arabic binder. Watercolor is especially appreciated for its capacity to recreate the effects of outdoor light and the vagaries of weather. It is generally applied in layers of dilute washes and sometimes wet on wet. When left to dry in separate patches, the areas of color tend to form crisp outlines and thus achieve the dappled effect of sunlight and shade. Although a translucent white (called Chinese White) is available, purists frown upon its use, advocating instead leaving untouched the ground of the paper where the highest values are desired.

BRUSHES (FIG. G–7)

In choosing a brush from the seemingly endless variety available, you should consider the bristle in relation to the media you intend to use. In regard to size, a good rule of thumb is to select the largest size possible for any given task. This will cut down on your work time and will impart to each brushstroke a greater immediacy.

Artist's brushes come in three major styles: "flats," which have broad, straightedged tips; "brights," which are a little less flat with more rounded edges; and "rounds," which come to a fine point when more flexible hairs are used.

Proper care of your brushes will guarantee them a longer life, so clean them thoroughly after use, never leave them standing for more than a moment in water or solvent, and store them so that their bristles are not bent.

Housepainting Brushes, with either natural or synthetic bristles, are commonly available in sizes ranging from ½-inch to 7 inches or larger. Artists use them primarily for applying gesso, but they may be used also for painting in large gestural strokes.

Bristle Brushes are made from bleached hog's bristles. The individual bristles are fairly stiff and slightly forked at the tips. These properties prevent the brush from coming to a fine point, but allow it to carry a good load of paint. They are traditionally favored for oil painting but may also be used for acrylics. The flat style is generally considered the most versatile. The round style lends itself well to drybrush technique and to the blending of dry media, such as pastel.

FIGURE G–7
Left to right: (1) Sable, round,
(2) Sumi, (3) Nylon, flat, (4) Nylon,
round, (5) Bristle, flat, (6) Bristle,
round, and (7) House-painting
brush

Sable Brushes are made from a mink-like animal. The individual hairs are tapered and in the best quality brushes are carefully arranged so that the wetted brush comes gradually to a fine point. The flexibility, resiliency, and fine pointing properties of this brush make it a favorite for use with watercolor or detailed passages in oil paint. Sable brushes range in price from expensive to extremely expensive, but if properly looked after will last for years. Use with acrylics, however, will diminish the life of a sable brush.

Synthetic Brushes generally have nylon bristles and may imitate the properties of either hog's bristle or sable hair. Less expensive than bristle or sable, these brushes clean easily and are, therefore, often used with acrylics.

Japanese Brushes come in a variety of styles suitable to water-based media. The round goat's hair brush set in a bamboo handle is available in medium to large sizes, and possesses a moderate pointing capability. It is excellent for ink and ink washes. Far less expensive, though not nearly so versatile as a sable, these brushes may also be used for watercolor. "Hake" brushes, made with soft white sheep's hair, are wide and flat. More sensitive than the housepainting brush, they are best used for laying down watercolor washes.

Other Brushes include camel's hair or squirrel's hair. These range in price from inexpensive to moderately expensive depending upon the quality of the hair and the care put into their manufacture. Although they lack the spring and fine pointing qualities of a sable brush, they will hold a fair amount of water and therefore may be used for aqueous media. They are too soft to be used with oil paints.

Glossary of Terms

Abstraction The process of selecting and organizing the visual elements to make a unified work of art. Also a twentieth-century style of art in which the particulars of subject matter are generalized in the interests of formal (compositional) invention.

Actual Grays Uniform value achieved by the continuous deposit of drawing media, such as blended charcoal or ink wash. (See Optical Grays.)

Ambiguous Space A visual phenomenon occurring when the spatial relationships between positive and negative shapes are perceptually unstable, or uncertain. (See Figure-Ground Shift, Interspace and Positive-Negative Reversal.)

Angling The process of transferring angles seen in the environment to a drawing surface.

Approximate Symmetry A form of visual balance that divides an image into similar halves, but avoids the potentially static quality of mirror-like opposites associated with symmetrical balance. (See Symmetrical Balance and Asymmetrical Balance.)

Artistic Block The interruption of an artist's natural creative output. Often accompanied by feelings of severe frustration and loss of confidence.

Artistic Rut The feeling that you are doing the same thing over and over and not getting anywhere.

Asymmetrical Balance The equilibrium achieved by adjusting different visual weights in a drawing composed of dissimilar halves. (See Symmetrical Balance and Approximate Symmetry.)

Atmospheric Perspective A means for achieving the illusion of three-dimensional space in a pictorial work of art. Sometimes called aerial perspective, it is based on the observation that as objects recede into the distance their clarity of definition and tonal contrast diminish appreciably.

Background The most distant zone of space in a three-dimensional illusion. (See also Foreground and Middleground.)

Basetone The darkest tone on a form, located on that part of the surface which turns away from the rays of light. (See Chiaroscuro.)

Blind Contour Line drawings made without looking at the paper, for the purposes of heightening your feeling for space and form, and to improve eye–hand coordination.

Cast Shadow The shadow thrown by a form onto an adjacent or nearby surface in a direction away from the light source. (See Chiaroscuro.)

Chiaroscuro In the pictorial arts, chiaroscuro refers to a gradual transition of values used to achieve the illusion of light and shadow on a three-dimensional form. The gradations of light may be separated into five separate zones: highlight, quarter-tone, halftone, basetone, reflected light, and cast shadow.

Cone of Vision A conical volume that constitutes your three-dimensional field of vision. Its apex is located at your eyes; its base lies within the imagined picture plane. (See Picture Plane).

Constellation The grouping of points in a three-dimensional space to form a flat configuration, or image.

Content The meanings inferred from the subject matter and form of an artwork.

Contour Line A line of varying thickness, and often tone and speed, used to suggest the three-dimensional qualities of an object. Contour line may be applied along, as well as within, the outer edges of a depicted form.

Convergence In the system of linear perspective, parallel lines in nature appear to converge (come together) as they recede.

Cropping Using a format to mask out parts of a subject matter image.

Cross-Contour Lines Contour lines that appear to go around a depicted object's surface, thereby indicating the turn of its form.

Cross-Hatching The intersecting of hatched or massed lines to produce optical gray tones. (See Optical Grays.)

Diagrammatic Marks Those marks and lines artists use to analyze and express the relative position and scale of forms in space.

Diminution In linear perspective, the phenomenon of more distant objects appearing smaller.

Envisioned Images Depictions that are based wholly or in part on the artist's imagination or recall.

Eye-Level The height at which your eyes are located in relation to the ground plane. Things seen by looking up are above eye-level (or seen from "worm's eye" view); things seen by looking down are below eye-level (or seen from "bird's eye" view).

Figure The representation of a recognizable object or non-representational shape which may be readily distinguished from its visual context in a drawing, such as a tree, a letter of the alphabet, or a human figure.

Figure–Ground Shift A type of ambiguous space which combines aspects of interspace and positive–negative reversals. It is characterized by "active" or somewhat volumetric negative areas and by the appearance of virtually all the shapes slipping, or shifting in and out of positive (figure) and negative (ground) identities. (See Ambiguous Space, Interspace and Positive-Negative Reversals.)

Figure–Ground Stacking A sequential overlapping of objects in a drawing, making the terms figure and ground relative designations.

Fixed Viewpoint An image depiction that is consistent with one physical position taken by the artist.

Force Lines Lines used to reveal the structure of a form by indicating the counterbalancing of one mass against another.

Foreground The closest zone of space in a three-dimensional illusion. (See also Middleground and Background.)

Foreshortening When the longest dimension of an object is at an angle to the picture plane.

Form The shape, structure, and volume of actual objects in our environment, or the depiction of three-dimensional objects in a work of art. Form also refers to a drawing's total visual structure or composition.

Formal Refers to an emphasis on the organizational form, or composition, of a work of art.

Format The overall shape and size of the drawing surface.

Form-Meaning That aspect of content which is derived from an artwork's form, that is, the character of its lines, shapes, colors, etc., and the nature of their organizational relationships overall.

Form Summary A simplified form description of a complex or articulated object, usually for purposes of analysis or to render a subject's three-dimensional character more boldly.

Gestalt A total mental picture, or conception, of a form.

Gesture Drawing A spontaneous representation of the dominant physical and expressive attitudes of an object or space.

Ground The actual, flat surface of a drawing, synonymous with a drawing's opaque picture plane. In a three-dimensional illusion, ground also refers to the area behind an object (or figure).

Ground Plane A horizontal plane parallel to the eye-level. In nature this plane may correspond, for instance, to flat terrain, a floor, or a tabletop.

Halftone After the highlight and quartertone, the next brightest area of illumination on a form. The halftone is located on that part of the surface which is parallel to the rays of light. (See Chiaroscuro.)

Hatched Line Massed strokes that are parallel or roughly parallel to each other; used to produce optical gray tones. (See Cross-Hatching and Optical Grays.)

Highlight The brightest area of illumination on a form, which appears on that part of the surface most perpendicular to the light source. (See Chiaroscuro.)

Horizon Line The line formed by the *apparent* intersection of the plane established by the eye-level with the ground plane. Often described as synonymous with eye-level.

Interspace Sometimes considered synonymous with negative space. In many works of modern art, however, it is more accurately described as a type of ambiguous space wherein negative shapes have been given to a degree the illusion of mass and volume. (See Ambiguous Space.)

Intuition Direct mental insight gained without a process of rational thought.

Layout The placement of an image within a two-dimensional format.

Linear Perspective The representation of things on a flat surface as they are arranged in space, and as they are seen from a single point of view.

Local Value The inherent tonality of an object's surface, regardless of incidental lighting effects or surface texture.

Mass The weight or density of an object.

Mass Gesture A complex of gestural marks used to express the density and weight of a form.

Measuring A proportioning technique using a pencil to gauge the relative sizes of the longest and shortest dimensions of an object.

Middleground The intermediate zone of space in a three-dimensional illusion. (See also Foreground and Background.)

Monocular Vision Using only one eye, and therefore only one cone of vision, to perceive an object.

Motif The repetition of a visual element, such as a line, shape or unit of texture, to help unify a work of art.

Negative Shape The pictorial, flat counterpart of negative space in the real world.

Nonobjective A style of art in which the imagery is solely the product of the artist's imagination, and therefore without reference to things in the real world.

One-Point Perspective When a rectangular volume is centered on your line of vision, all receding (horizontal) parallel lines will appear to converge, or meet, at one point on the horizon line.

Optical Grays The result of hatched or cross-hatched lines that the eye involuntarily blends to produce the sensation of a tone. (See Actual Grays.)

Outline Usually a mechanical-looking line of uniform thickness, tone, and speed which serves as a boundary between a form and its environment.

Overall Image The sum total of all the shapes, positive and negative, in your drawing.

Overlapping An effective way to represent and organize space in a pictorial work of art. Overlapping occurs when one object obscures from view part of a second object.

Pictorial Refers to a picture, with its actual two-dimensional space and potential for three-dimensional illusion.

Picture Plane The actual flat surface, or opaque plane, on which a drawing is made. It also refers to the imaginary, transparent "window on nature" that represents the format of a drawing mentally superimposed over real-world subject matter.

Planar Analysis A structural description of a form in which its complex curves are generalized into major planar zones.

Positive–Negative Reversal A visual phenomenon occurring when shapes in a drawing alternate between positive and negative identities. (See Ambiguous Space.)

Positive Shape The pictorial, flat counterpart of a form in the real world.

Principles of Design The means by which artists organize and integrate the visual elements into a unified arrangement. They include unity and variety, contrast, emphasis, balance, movement, repetition, rhythm, and economy.

Proportion The relative size of part to part and part to whole within an object or composition.

Quartertone After the highlight, the next brightest area of illumination on a form. (See Chiaroscuro.)

Reflected Light The relatively weak light bounced off a nearby surface onto the shadowed side of a form. (See Chiaroscuro.)

Relative Position A means by which to represent and judge the spatial position

of an object in a three-dimensional illusion. Generally, the higher something has been depicted on a surface, the farther away it will appear.

Relative Scale A means by which to represent and judge the spatial position of an object in a three-dimensional illusion. Generally, things that are larger in scale seem closer; when there is a relative decrease in the scale of forms (especially if we know them to be of similar size) we judge them to be receding into the distance.

Shape A flat area with a particular outer edge, or boundary. In drawing, shape may refer to the overall area of the format, or the subdivided areas within the format.

Shape Aspect The shape of something seen from any one vantage point.

Shape Summary Recording the major areas of a three-dimensional form in terms of flat shape, usually for purposes of analysis.

Space In the environment, space may be understood as area, volume, or distance. In drawing, space may be experienced as either a three-dimensional illusion, or the actual two-dimensional area upon which a drawing is made. (See Picture Plane.)

Spatial Configuration The flat shape or image made by connecting various points in a spatial field.

Spatial Gesture The gestural movement implied by an imagined linkage of objects distributed in space.

Station Point In the system of linear perspective, the fixed position you occupy in relation to your subject (often abbreviated to SP).

Stereoscopic Vision Normal perception using two eyes, and therefore two separate cones of vision. In stereoscopic vision two slightly different views of an object are incorporated into a single image.

Subject Matter Those things from the real world that are represented in an artwork, such as a landscape, portrait, or imaginary event.

Subject Meaning That aspect of content which is derived from subject matter in a work of art.

Symmetrical Balance When an image is divided into virtually mirrorlike halves. (See Asymmetrical Balance and Approximate Symmetry.)

Tactile Perceptions gained directly or through memories of the sense of touch.

Three-Dimensional Space The actual space of our environment, or the representation of it in the form of a pictorial illusion.

Three-Point Perspective The kind of linear perspective used to draw a very large, or very close, object that is located at an angle to the picture plane and seen from an extreme eye-level, with the result that both the horizontal *and* the vertical parallel lines appear to converge, or meet, respectively at three separate vanishing points.

Tonal Key The coordination of a group of values in a drawing for purposes of organization and to establish a pervasive mood. Tonal keys may be high, middle, or low.

Topographical Marks Any marks or lines used to analyze and indicate the surface terrain of a depicted object. Cross-contour lines and hatched lines used to describe the inflections of planes are both topographical marks.

Triangulation Angling between a set of three points on the picture plane to accurately proportion the overall image of your drawing.

Two-Dimensional Space The flat, actual surface area of a drawing, which is the product of the length times the width of your paper or drawing support. Synonymous with the opaque picture plane or flat ground of a drawing.

Two-Point Perspective When a rectangular volume is not centered on your line of vision, the receding (horizontal) parallel lines of each face will meet at two separate points on the horizon line.

Value Black, white, and the graduations of gray tones between them.

Value Shapes The major areas of light and shade on a subject organized into shapes, each of which is assigned a particular tone that is coordinated with the values of other shapes in the drawing.

Vanishing Point In linear perspective, the point on the horizon line at which receding parallel lines appear to converge, or meet.

Viewfinder A homemade device that functions as a rectangular "window" onto your subject. It is a useful aid for proportioning and layout.

Visual Elements The means by which artists make visible their ideas and responses to the world. They include line, value (or tone), shape, texture, and color.

Visual Weight The potential of any element or area of a drawing to attract the eye.

Volume The overall size of an object, and by extension the quantity of three-dimensional space it occupies.

Working Drawings The studies artists make in preparation for a final work of art.

Index